THE REAR VIEW

Dear B—
Happy 21st
(from one connoisseur
to another)

Love,

Rick X

THE REAR VIEW

A Brief and Elegant History
of Bottoms Through the Ages

Jean-Luc Hennig

Translated by Margaret Crosland and Elfreda Powell

SOUVENIR PRESS

First published in France by
Éditions Zulma, Cadheilhan
under the title *Brève histoire des fesses*

English translation first published 1995 by
Souvenir Press Ltd.,
43 Great Russell Street, London WC1B 3PA
and simultaneously in Canada

ISBN 0 285 63303 1

Typeset by Rowland Phototypesetting Ltd,
Bury St Edmunds, Suffolk
Printed in Great Britain by
Mackays of Chatham plc, Chatham, Kent

To Patrick Gourvennec

Publisher's Note

The slang of one language is rarely the same as that of another and loses all its nuances in the process of translation. With the author's consent, therefore, the chapter entitled 'Slang' (page 131) has been adapted and rewritten by the translators to incorporate the slang expressions commonly used in the English language when referring to the buttocks.

Contents

Afarensis

Buttocks date from remotest antiquity. They appeared when men conceived the idea of standing up on their hind legs and remaining there—a crucial moment in our evolution since the buttock muscles then underwent considerable development. Among the 193 existing species of primates only the human species possesses hemispherical buttocks which project permanently from the body, although some people have claimed that the Andean llama also possesses buttocks. Chimpanzees, in any case, when compared with humans, have been described as 'apes with flat buttocks'. Which is to make a nonsense of buttocks. So the emergence of buttocks coincides with the upright stance and walking on two legs which, according to the anthropologist Yves Coppens, goes back three or four million years. This was precisely the great period of *Australopithecus afarensis*, who lived in Ethiopia and Tanzania.

The event, explains Yves Coppens, probably occurred during the period of drought following the emergence of the eastern region of the Great African Rift valley which, flanked by volcanoes, runs from Djibouti to Lake Malawi. Along it Africa began to divide into two. To the west, intertropical Africa remained humid, so keeping its forests, and the apes in its trees. To the east the region dried up, savannah replaced

the forest and men ran over the ground. At the same time their hands were freed and the engagement of the skull on the spinal column was modified, which allowed the brain to develop. Let us remember this interesting idea: man's buttocks were possibly, in some way, responsible for the early emergence of his brain. More recently another hypothesis has been put forward: *Australopithecus* might have been just a large ape whose development was interrupted or retarded by the modification of a gene. The foramen magnum, which links the brain to the spinal column, possibly remained joined to the base of the skull, as in the case of young chimpanzees. Muscles would then have enveloped its bony structure and its base would have become rounded. The fact remains that this ape's buttocks did not resemble ours simply because it was upright. Much time would still have to pass before hairy and not very obvious buttocks would develop into naked, soft and smooth buttocks as we like them to be.

Lucy, the most famous *Australopithecus afarensis* known to us (although we actually know very little about her), discovered in 1974 in the Afar region of Ethiopia, is three million years old. Through her we have a general idea about the creatures who had the privilege of possessing the first buttocks in the world. We should make it clear, however, that Lucy possessed buttocks only from time to time: she still continued to climb trees to find food, to sleep and escape predators and, naturally, in order to climb she retracted her buttocks, her body swallowed them. But once on the ground she actually walked about on her two feet, something made possible by her foreshortened pelvis and the tip of her oblique femur. Lucy was a very small person. She was about twenty years old, her height was that of a child of five or six (1.05 metres or 3 ft 3 ins, with a weight of 30 kg or 66 lbs) and her general appearance was rather clumsy: huge arms and short legs, a face that was almost flat, a small skull and eyes on the lookout. She spent her time de-lousing herself, digging up termites, dreaming idly or squealing, for it is thought she had a well-defined mouth, although the location of her larynx did not allow her to utter

articulate sounds (and experts argue about this point). Since only her skeleton has been found it is difficult to form a clear idea about the shape of her buttocks, but it can be assumed they were rather like a coconut, a variety of which, found in the islet of Praslin in the Seychelles, is called precisely coconut-buttocks. In short, we have to wait at least a million years before the intermittent buttocks of *Homo habilus* become the definitive buttocks of *Homo erectus*.

As a result, the apes who remained in the forest were deprived of buttocks. Which did not worry them too much. When a female ape wanted to send a 'sexual signal' to a mate, notes Desmond Morris, she ostentatiously showed him her hind quarters. For there is the miracle: the females of many species of ape possess bottoms which light up, becoming a bright pimento red and particularly swollen as the time of ovulation approaches. And mating generally occurs when the females display their organs in the state of maximum dilation. So much so that the male baboon or chimpanzee spent his time running from one red bottom to another, which no doubt allowed him to forget his lack of success. With the human female things are different. Her bottom does not swell with the menstrual cycle: it remains permanently protuberant. So she is, *a priori*, always ready for the male and can mate even when she cannot conceive—a fact that troubled the Catholic Church for a long time.

Desmond Morris also notes that the female of the gelada species of baboon carries on her chest a reproduction of the state of her rear. And since her genital area is rose-red, edged with white papillae with a blood-red vulva in the centre, this useful device appears on her chest during the period of ovulation. The female gelada baboon, therefore, during her propitious moments, possesses a double vulva, which may cause confusion but ensures she attracts attention. A similar process, adds Desmond Morris, seems to have operated in the human female. If in fact she had to reveal her rear to the male he would see a pair of red lips bordered by two swollen fleshy hemispheres. But it is not current practice for women to

present their buttocks to males. Due to our upright gait the underneath part of the body has become the front, therefore the most visible and most accessible of the signalling zones. So there is nothing surprising about finding genital mimicry on the front of the female body. In this way the lips of the genitalia are replicated in the painted lips and the round buttocks in the breasts.

Saying that the female breast implies mimicry of the buttocks gave rise, however, to some criticism. According to this the breast hangs down too far and recalls only imperfectly the roundness of the rear. That is true, replies Morris, of breasts which are not in their first youth. Since a woman reaches her sexual peak at 23 it is therefore *before* that age that her breasts are at their firmest and fullest—although some women resort increasingly to certain artifices in order to uplift their breasts and fill them out, thus giving them a shape that does not correspond to their age. But even without such contrivances, a woman's breast resembles her buttocks sufficiently for the signal to be transmitted. Mimicry, says Morris, need not be accurate to be effective. Moreover, breasts are not the only things to be likened to the buttocks: shoulders or fleshy knees can be made to resemble them too, especially when the knees are clasped, or again when the shoulder is raised so that it touches the cheek. So much so that it can be said that the human species is the only species of primate in which the female possesses buttocks more or less everywhere.

In the *Dossier de l'oeil pinéal* (Dossier of the Pineal Eye) the avant-garde critic Georges Bataille expresses surprise at this difference, with regard to buttocks, between humans and baboons. So, he comments, the little girls who surround animal cages in zoological gardens cannot fail to be astonished by the extremely lascivious behinds of monkeys. The idea came to him one July day in 1927, while he was visiting the Zoological Gardens in London. The nudity of such anal projections threw him 'into a kind of ecstatic stupefied state'. These shameless protuberances, like excremental skulls in brilliant colours, ranging from bright red to pearly violet, the

obscene display of this bald, fringed anus, erupting like a boil, this huge anal fruit made of pink meat, appeared to him to be 'splendidly comic and suffocatingly atrocious': in short, the ape's bottom is 'as garish as a sun'. Besides, he points out, this obscenity was carried to such an extreme that the most highly evolved of the apes finally got rid of their tails which for a long time had been powerless to hide this vast hernia of flesh. And, in his view, this liberation of anal power coincided with the eruption of volcanoes. This dubious colic of nature, discharged in the humid darkness of the forests, was possibly answered by the earth with a cheerful rumbling of entrails, by the vomiting of unimaginable volcanoes. In short, says Bataille, somewhat boldly, 'the terrestrial globe is covered by volcanoes each serving as its anus.'

So what happens among human beings? Well, he says, we have witnessed a curious phenomenon of transposition between the anus and the head: the impulse that had made the anal orifice blossom and catch fire was suddenly thrown back towards the face and the cervical area, precisely because man found himself standing upright on the ground, while the facial extremity assumed part of the excretory functions formerly directed towards the opposite extremity: humans spit, cough, yawn, burp, blow their noses and sneeze more than other animals, but above all they have acquired the strange faculties of sobbing and laughing out loud. It seems likely therefore that a certain potential for display and bedazzlement suited to the nature of animals, and usually directed towards the head, was possibly directed among the apes towards the opposite extremity, while our anus, deprived of such a radiance, became the darkened centre of the narrow cleft dividing the buttocks. Which, all in all, appears to be a somewhat pessimistic view of the human behind.

There remains one thorny question: did the prehistoric female possess particularly voluminous buttocks shaped like pointed cones? Today a woman's buttocks droop like an inverted ace of hearts, but did her ancestors possess an audacious rump which stood out like a sugar loaf? Unfortunately

this cannot be verified from skeletons. But apparently the woman with big buttocks belongs to the origins of humanity, if we are to believe the primitive statuettes from the palaeolithic era, modelled in the palm of the hand more than 20,000 years ago and barely larger than a fruit kernel; examples are the Venus of Willendorf from Austria, the headless woman of Sireuil in the Dordogne or the Venus of Kostienki in Russia. The strangest of these steatopygous women, as far as we know, is the Venus of Lespugue in the Haute-Garonne, carved from a block of ivory. She is hard to understand, a real challenge to the laws of anatomy—a heap of rounded and polished masses, rather like a brioche puffed out on all sides. We are even thrown into confusion by her, for we are not sure if she has four buttocks round the small of her back or if her breasts and buttocks form just one huge glandular mass, a series of spherical globes which seem to have been cut into slices. The fatty bulges hanging down like a bunch of grapes resemble more closely the mass of cells that constitute the most elementary stage of life. From this point of view these bulges indicate not so much the development of flesh as its prehistory. But those big greedy bottoms, those rumps swollen with vanity, those buttocks which project their strength virtually everywhere with the impetuous thrust of a bulldog must have provided considerable seduction for the men of that bygone period.

Why this abnormal enlargement? Did it correspond to an anatomical reality or did it fulfil a magic function in hunting or fecundity? Many experts in prehistory, looking at these mixtures of clay, crushed bones, carbon and ash see them as maternal rumps, a fact which has caused much reflection, for it has been observed that only one third of these statuettes represented pregnant women. Were these women priestesses of archaic religions? Or were they images of some 'immodest' Venus, like those of Laugerie-Basse, Grimaldi or Monpazier, rhomboidal creatures reduced to the shape and dimensions of their vulvas? Women merely emphasising the opulence of their shapes and their nudity in attitudes that were often very pro-

vocative, their thighs apart or their knees bent and their but-
tocks raised up like a cupola? In short, were these meteoric
bottoms from prehistory swollen with lust? Apparently so. In
some extreme cases the swelling of the hips seems to be con-
fused with testicles while the elongation of the neck evokes
the erect penis, which occurs in certain drawings by Picasso
from 1927. Obviously women exerted magic power only over
the abundance of the catch or the progeny of man: it was also
a votive offering for erection.

Desmond Morris puts forward a hypothesis concerning such
an accumulation of buttock fat. Like all primates, he says, the
men of the period coupled from behind and the sexual signals
from the woman were transmitted through her rear, as among
the apes. The larger the rear, the more seductive the woman.
But she was also very cumbersome. So much so that men
adopted face-to-face coupling. As a result the breasts swelled
in order to reproduce the broad hemispheres of the buttocks,
which led to a much better balanced and more agile version
of the woman. It remained. In the south-west African bush
there are still some women whose buttocks are shaped like a
crater; they belong to the Bushmen tribe and these full outlines
are found in the rock paintings of Zimbabwe and South Africa.
It is tempting to interpret them, all the more so since many
people have pointed out that in Africa the beauty of a woman
resided in a bottom of regal proportions—it recalled the
rolling gait of a lioness. For a long time there existed in
Mauretania establishments for fattening up young women;
staff were appointed to stuff girls with food and make them
obese on their way to the marriage market: 'To be a woman
of quality,' it was said, 'one must be a woman of quantity.'
In Nigeria, wrote Mungo Park, even a woman without preten-
tions to great beauty should be unable to walk without being
supported under each arm by a slave girl, and a perfect beauty
is a suitable load for a camel. Which is what Darwin had
already said in *The Descent of Man and Selection in Relation to
Sex* of 1871: 'Sir Andrew Smith . . . once saw a woman who
was considered a beauty, and she was so immensely developed

behind, that when seated on level ground she could not rise, and had to push herself along until she came to a slope . . . and, according to Burton, the Somal men "are said to choose their wives by ranging them in a line, and by picking out the one who projects farthest *a tergo*".'

Which proves one thing at least—that man, once he stood upright, was fairly pleased with the result. Overwhelmed by the fullness of female flesh, he tried to retain the memory of it as long as possible. But since woman had preferred to minimise her curves and draw in her buttocks he contented himself with substitutes—a fact which, throughout the history of fashion, led to that avalanche of puffed-out bouffant effects aimed at enhancing the posteriors of the ladies and calming the nostalgic ardours of the gentlemen. The start of the Third Republic saw the appearance of unbelievable and somewhat sumptuous buttocks, reminiscent of those from prehistory, although they were totally artificial: the bustle, the balloon effect (no doubt to show its connection with its namesake) or more simply the 'false bottom'. Descended from the farthingale and the crinoline, the false behind was certainly no more than an extrapolation of the buttocks, a fuselage made up of metal armatures and various forms of padding, usually horsehair. Nobody was taken in, but at least it gave women the undeniably flattering equivalent of a rump. It was a triumph of padding, frills and fripperies.

Some people then had the bad taste to compare women to fat geese. In fact this S-shaped silhouette was more reminiscent of the swan. Woman, an unnatural and sensitive creature, who moved among tints of sky-blue, scabious blue or tea-rose, was visibly sacrificed to that aesthetic concept of the evanescent which delighted Mallarmé. Others invoked the female centaurs, fabled animals that had never been seen anywhere and whose front legs would have had to be removed. In fact no longer did anyone know what a woman resembled, or whether she was still a woman. For her rig-out of draperies, bows and frills meant that she did not walk, she glided along. Her very pale complexion increased the anxiety she caused and if her

artificial buttocks delighted the gaze of ordinary men, they also caused much concern, for men wondered anxiously what there *really* was underneath. It was the period of the worst ruderies. The poet Jules Laforgue wrote that every woman was 'a farthingale of emptiness' and the diarist Edmond de Goncourt said she was 'a zero in a crinoline'.

Women got rid of the bustle, but they immediately abandoned themselves to the craze for the 'serpentine corset'. Below the deep curve of the lower back women became sinuous. With her bust thrown back and her stomach almost horizontal a woman could boast of an unlimited rear and discourage any attempt to classify her as a member of any human species. Jacques Laurent, in an entertaining history of female underwear (*Le Nu vêtu et dévêtu*: The Nude Dressed and Undressed), notes with much relevance that it was precisely at the period when underwear attempted for the first time to oppose any amorous onslaught that Freud elaborated his theory of repression and the whole of Paris rushed to see *Le Coucher d'Yvette* (Yvette at Bedtime), the first striptease show during which, to the sound of piano music, a lady in day clothes began slowly to undress. The ordinary man of 1905, says Laurent, must have been at the end of his tether. He was. At least he could persuade himself that as the woman shed her outer leaves, a body appeared to him that differed in certain details from his own, but was not as radically strange to him as it had seemed. By chance cubism caused the warped silhouette to go completely out of fashion. Some sportswomen repeated the sacrifice of the Amazons, whose right breast impeded their use of the bow and arrow, and sacrificed both of them. And, in their enthusiasm, they also had their buttocks removed. During the years 1925–30 there appeared a completely new type of woman, almost entirely flat. She was called *la garçonne*, the urchin-type.

And the horsehair was kept for mattresses.

Bathing

Over the centuries painters have recorded one of the great preoccupations of life, the washing of the buttocks. This activity appeared sufficiently interesting to painters such as Jacob Vanloo in his *Coucher à l'italienne* (Bedtime Italian style) adapted from *Candaule and Gyges* by Jordaens, but the painters of the second half of the nineteenth century in particular offer us a vast panorama of buttocks at the bath. After inventing the intimacy of the personal toilet (from the start of the eighteenth century, when the use of the bidet and localised ablutions were discovered), there seemed to be nothing more urgent than revealing its curiosities through breaking and entering. This explains why so many of these painters were denounced as voyeurs and even dirty pigs, for they seemed to relish so deeply the indiscreet exploration of this aspect of femininity. The male buttocks, in contrast, have not been much painted at the bath, apart from work by Frédéric Bazille, Thomas Eakins or recently David Hockney, a strange aspect of history that has upset a fair number of people.

Bare buttocks had already been brave enough to venture out into the garden, but mythological or biblical themes meant that their indecency was forgotten. Those nymphs eyed by fauns, those platoons of Susannahs spied upon by elders, those

squads of Dianas observed by Acteons were soon frightened by the importunate gaze of spectators. Their fears did not make them give up bathing but they were offended enough to ensure that the epilogue was always moral.

Why are most painters so obliging? Perhaps, says Gilbert Lascault, because the masculine dream about women has a lot to do with liquidity. The women in fact are not always as frightened as one might think. Look at *Diana at the Bath* by Clouet (1515). Her buttocks are well fleshed, attractive and perfectly at ease, in the midst of the forest, surrounded by playful satyrs. Or again the *Tepidarium* (The Warm Bath), also from the school of Fontainebleau: the intrusive gaze has disappeared and the women's buttocks seem to frolic among themselves. We can observe, *en passant*, that buttocks that are warm are much more attractive than when they are cold, for as they shrink they seem to disappear and even become concave. Buttocks that are warm, on the other hand, can give themselves freely and fill out like a sponge.

Renoir used to say: 'The naked woman will emerge from the sea or from her bed: she will be called Venus or Nini, nothing better will be invented.' This is more or less the distinction drawn by Plato in *The Symposium*. He explained that there were only two kinds of Venus, the Celestial and the Vulgar. But it's not always easy to decide which is which. Degas, for example, is clever enough to surprise attractive buttocks in the intimacy of the bathroom in a disarmingly natural way. He seems to have climbed onto a chair or lain down under a table in order to caress, in the best sense of the term, all those round shapes in order to create extraordinary fields of curves. 'I show girls free from any coquetry,' he would say, 'like animals keeping themselves clean.' What precisely are they doing? Well, they're scratching their toes, brushing and combing their hair, washing their bodies once, then again, over their lower backs, round their necks, more or less everywhere, and then they begin once more. The buttocks they are washing are not there for day-dreams or for letting them be seen by watchful eyes. They are not there for anybody. Which

is a pity, for one would like to see them linger a little or acquire some feeling. But no. These buttocks don't reveal themselves in their finest state, nor at their best moment, but they really don't care. For the buttocks of the working-class Venus can't waste any time.

'A painting,' said Bonnard, 'is a very small world which should be self-sufficient.' Precisely. For buttocks painted by Bonnard know that they are loved, which makes all the difference. Their tranquil state is disarming, they illuminate the bedroom with their nonchalant grace. They are obviously not the buttocks of a prostitute posing for him on a lean day, these buttocks belong to Marthe. His wife. Buttocks with no history, soft and discreet, as in the *Nude in the Mirror* of 1933. Marthe's buttocks are radiant, but their thoughts are elsewhere, for they spend their time looking at themselves in the glass. Why so anxious? What is there to worry about? The buttocks are condensed into warm tones of terracotta, they palpitate, patter and ripple down like a rain of pomegranate seeds. Remarkable things happen: the face disintegrates and the buttocks seem to laugh.

Buttocks painted by Courbet obviously do not belong to any nymph. Courbet is a force of nature, a man of the open air, and his women show it. Poor Courbet has had bad treatment all round. 'Leader of the school of ugliness', 'painter of the vile' or, as Zola says, 'fabricator of flesh'. Courbet in fact wanted to vulgarise the nude. And the nudity he preferred was that of the solid countrywoman, whose buttocks were still young but chubby, rustic-looking and creased, as in *The Bathers* (1853). These young girls abandon themselves to the pleasure of being together, to the invasion by light of their too pallid bodies, and close their eyes in the ecstasy of it. This strange light in the cavernous shade has even something satanic about it. The Empress Eugénie, visiting the Salon of 1853, was not taken in. After she had been struck by the way Rosa Bonheur endowed her horses with large rumps, it had to be explained to her that these were sturdy percherons and not slim-built chargers like those in the Imperial stables. When

she reached *The Bathers* Eugénie indicated the one who was removing her chemise and revealing her buttocks, asking with a smile if she was a percheron too. Napoleon III was delighted with the joke and took advantage of it, apparently, by cracking his whip over this magnificently plebeian rump. Mérimée was more unkind: he alleged that the said rump would be especially prized in New Zealand, where human forms were appreciated for the amount of flesh they would supply for a cannibal feast.

This did not upset Courbet too much, he offended again in 1868 with *The Spring*. What buttocks! Extraordinarily compact, firm and tightly clenched. The cleft is barely indicated and the flesh is again just as luminous. This young woman, who has just taken her clothes off, displays a rear about as attractive as a cauliflower. We do not know if this rear is a miracle or a monstrosity. It is at least five inches too high, a lot for a pair of buttocks. Kenneth Clark speaks of the painter's 'overflow of a colossal appetite', referring precisely to the 'bovine unselfconsciousness of Courbet's women [which] gives them a kind of antique nobility.'

As for buttocks painted by Renoir, which one would like to see as celestial, they can be recognised anywhere: they are plump, podgy in fact, but they are a long way from the affected-looking buttocks painted by Rubens. 'Their skin,' says Clark . . . 'fits them closely, like an animal's coat.' Renoir liked to paint his dear little sillies, as he called them, by the Mediterranean. They dry themselves, they splash each other, they reveal their buttocks, but they don't seem in any way embarrassed. Far from it, they seem to be dancing. They tease each other, they play with their hair or their toes, they think of nothing, they simply reveal animal-like happiness as they wave to each other in the heat of a summer afternoon. They are bathing not in water but in light. They are also much more cheerful and girlish than Courbet's bathers. Madame Renoir used to complain that in her household the women servants were chosen because 'their skin attracted the light well'. Certainly a legitimate motive for recrimination, but servants' buttocks can have good qualities. To sum up:

between 1850 and 1914, on the whole, painters depicted buttocks being washed. After that it was thought they had been washed enough—there was no need to go on. So buttocks returned to the bed, which has always seemed their true destiny.

Embrace

'The Middle Ages produced illustrations of nudity,' remarks the writer Bataille in *Les Larmes d'Eros*, 'in order to reveal its horror.' In fact, when we look at Rogier van der Weyden's *Last Judgement* or Dirck Bouts' *God's Judgement*, we may be astonished by this avalanche of buttocks cast naked into Hell, and somewhat disappointed too, unless we see in this the buttocks of sin, the accursed buttocks condemned to eternal darkness. Which means we can understand the strange reciprocal attraction between the devil and the buttocks.

There have been long arguments over whether Satan had buttocks. In the thirteenth century Caesarius d'Eisterbach (in Book III of the *Dialogus Miraculorum*), even while offering his posterior to the tympanum over the stalls and capitals of churches, made demons say that when they assumed human form they had no buttocks. All the more disturbing then that the imprint of his buttocks has been found at Moisdon-la-Rivière, chief town in the canton of Loire-Atlantique. As God's mimic he apparently wanted to imitate Jesus in this way, for He had left the same imprint behind the high altar at Rheims cathedral. We shall not compare the merits of these two sets of buttocks. We shall merely say that this tradition of a devil without buttocks can explain, according to Desmond Morris,

that simply showing one's buttocks to Satan is enough to remind him of his weakness and force him to look away.

It was a stratagem often used by Luther who believed himself permanently tortured by the demon. The latter would even come to tempt him in the flesh in the form of a succubus, more skilfully and more often than his dear Katerina von Sora. He would see him virtually everywhere, in his bed, while out hunting and even in the monkeys, budgerigars and parrots kept by the aristocrats of the period. In 1532 Luther noted in his *Table Talk*, collected by Johann Aurifer: 'Last night, the devil, in discussion with me, accused me of being a thief, of having robbed the Pope and many religious orders of the monies that came into them: "Lick my arse," I said to him, and he fell silent.' Desmond Morris adds that in medieval Germany, during a particularly violent storm, at dead of night, it was usual for people to show their buttocks through the door, in order to send thunderbolts and the powers of evil away.

In the same way there was a firm belief that the mirror was 'truly the devil's backside', for this instrument seemed to incite people so strongly to vanity, sensuality and pride. Venus, totally nude, looks at herself in a mirror, the Beast of the Apocalypse does the same and so does Idleness in *The Romaunt of the Rose*. The first appearance of the satanic posterior in a mirror goes back to the book composed by the Chevalier de la Tour-Landry for the education of his daughters in 1370. Engravings from Ulm, dated 1483 and 1485, show the mirror being brandished before sinful women surrounded by the flames of Hell. And in an engraving from Augsburg of 1498 the woman looking into a convex mirror, described as a witch's mirror, sees the tail and posterior of a young devil writhing and grimacing behind her back. In Hieronymus Bosch (*The Garden of Earthly Delights*, c. 1500) a mirror of steel also covers the buttocks of a monster-like creature crawling under Satan's throne, while a woman whose hands dangle beside her, with a toad between her breasts, is in a state of collapse in front of her confused reflection. There can be no doubt, then, about the existence of the devil's behind, nor about the spiteful

behaviour of mirrors. All the more so since the devil is, literally speaking, he who cuts in two, *le di-able*. But the tradition of a demon with buttocks was stronger and the evidence from trials of sorcerers often refers to the particular pleasure enjoyed by the devil in exhibiting his posterior and demanding the homage of his worshippers during the sabbath. For it had to be kissed. In this way we learn that Satan's buttocks, like his hand and his sperm, were cold. There is certainly something ecstatic about a kiss on the bottom. For it is a kiss bestowed in the dark: the eyes are buried in the flesh, entirely swallowed up by this dark orifice. In fact it is a kiss that is blinding. And the kiss bestowed by witches was perhaps just the unlimited love that caused such blindness. We cannot confuse the two orifices, the one above which takes in—the mouth—and the one below which gives out—the anus—which is why the kiss on the buttocks was considered degrading. It is also why the anus became the great bugbear of the Church. The soul could not be compromised in such a kiss, it should not join the buttocks in this embrace, which has surely contributed to its great attraction for free-thinkers.

What exactly happened? The devil, we are told, heard confessions from witches (and magicians) about 'disgusting sins of chastity' and made them kiss his anus, or the mask which sometimes covered it, as a sign of allegiance. But Satan also liked to meet neophytes, preferably young, who would increase or strengthen his forces, and the demons of the Sabbath, indicates Sylvain Nevillon, 'bowed down to those who brought them children, as though to thank them, and kissed the said children on their bottoms.' The new arrivals were then told to renounce all the advantages of baptism and paradise, and the demon gave them a new name, which was often ridiculous, and marked them painfully with his claw on various parts of the body, but preferably in the area of the genitalia. This was called the mark of the devil.

As the magistrate and writer Pierre de Lancre says in the *Tableau of Inconstancy* (1613), it was especially in order to escape justice and its officers that the devil 'Puts his mark on

them often in parts so dirty that one dreads searching for them there, either on a man's bottom or a woman's private parts, instead of on the most noble and valuable parts which everyone possesses, such as the eyes or the mouth.' So much so that judges constantly gave themselves the pleasure of searching out these marks with a stiletto, after all the hair had been shaved off, even in the most intimate areas. Any mark indicating dishonourable sexual intercourse was subject to death by cremation. This formed a triple crime, for it came close to sorcery, sodomy and bestiality, since the devil frequently possessed helpers in the form of goats.

So, in the course of this sabbath, according to Antoine de Torquemada's *Hexameron* and the countless reports by judges in sorcery cases, demons, fine ladies and gentlemen 'mingled together in perverse fashion, satisfying their disorderly and filthy appetites', and the demons did not hesitate to demand of the humans that forbidden pleasure which condemned them to immediate damnation. However, the devil undertook not to deflower girls below the age of twelve and only to impregnate women who insistently demanded it. He preferred to enjoy married women, in order to surprise them in adultery and force the husband at the same time, so that a double adultery would result from his painful and icy-cold coitus. He also sodomised girls, whose virginity he respected, while sparing them the inconvenience of a possible pregnancy; in this way they returned from the sabbath virginal but bleeding. For most of the evidence about *copula cum daemone* emphasises the suffering caused by the diabolic member due to its extraordinary size and consistency. Some women, like Françoise Fontaine in her confessions dated 1591, speak of a member 'as hard as a pebble and very cold', while others, like Jeannette d'Abadie, found that it was 'made up of scales like a fish', and that it was 'about an ell in length' (1.82 metres or 1½ yards) when fully extended, but he 'held it in a twisted sinuous shape like a snake.' Perry de Limarre adds that the devil's member was 'made of horn, or at least, that is what it looks like: that is why it makes the women cry out so much.' De Lancre, who

quotes these accounts, thought it useful to state that witches used an ointment to facilitate the insertion of the devil's member, which some practical minds have seen merely as a dildo made of leather, wood or metal. For Michelet it was a clyster-pipe. In short, the thing that Saint Augustine described as *turpissimum fascinum* was possibly no more than a sex aid, more or less well polished, whose rough edges would explain the wounds inflicted on the witches' vaginas and the men's posteriors.

But the Middle Ages, until the time of Rabelais, were also acquainted with buttocks that were much more amusing, although just as lewd—those that can be described as grotesque. At that period the popular taste for the comic (as Mikhail Bakhtine has shown), was aimed at protuberances, excrescences, lumps and orifices of the body: staring eyes, the nose, stomach, wide open mouth, the male member or the bottom. This was at the root of all types of gesture which play a part in insulting, disparaging or teasing: fingers to the nose, cocking a snook, showing your bottom, spitting and other obscene gestures. In circus displays the body turns somersaults and it is that wheel-like movement that causes laughter, when 'the bottom strives obstinately to occupy the place of the head, and the head, that of the bottom.' Showing one's bottom, like the sibyl of Panzoust in *Gargantua, XV*, in front of Panurge and his companions, or kissing the backside are famous examples of this kind of joke. Legend even says that Rabelais, when received one day by the Pope, is supposed to have offered to kiss the bottom-face of the sovereign pontiff, provided it had been well washed. In the Fourth Book the inhabitants of Papimany promise to carry out this rite if the Pope were to grant them an audience.

Then there is the plot of that erotic fabliau entitled *Bérenger of the Long Bottom* (Garin, 13th century). In Lombardy a knight had taken as wife a noble lady, daughter of a rich châtelain. He himself was the son of a peasant, 'a wealthy usurer possessing many riches'. How had this unequal marriage been possible? Because the châtelain owed the usurer so much

money that he could not repay him and had to give his daughter in marriage to his creditor's son. After which he 'created him a knight with his own hand'. The young people lived like this for more than ten years, but the knight soon showed that he was lazy and greedy (he was particularly fond of warm tarts and flans), that he despised poor people and in particular that he was timid and cowardly. 'He would have preferred to rake hay rather than brandish the shield and the lance.' Faced with such a boastful husband the lady realised he was not a knight by birth, nor of good lineage. She reproached him about this, recalling the merits of *her* family, to which he responded that he surpassed them all in courage, valour and prowess, and that he was going to prove it to her.

The next day at dawn, he caused his arms to be brought to him, still unused and brand new, mounted his horse and left for a nearby wood. There he hung his shield on a tree, unsheathed his sword and beat on the shield like a madman. Then he took his sturdy lance and broke it into four pieces. And so he returned home, with a fragment of his lance and a quarter of his shield. The lady remained speechless, while he held forth and boasted. Certain of his strategy he then renewed his weaponry, but the lady noticed that he was neither wounded nor bruised, that there was no damage to his helmet and that he showed not the slightest sign of exhaustion. She decided therefore to follow him, equipping herself like a true knight. She set out just after him and appeared suddenly while he was beating his shield as loudly as all the devils in hell. When she had heard enough of this she spurred her horse on towards her husband and called out to him: 'Vassal, vassal, are you mad,/cutting my wood into pieces?/If you escape me without being torn apart/then I am worth nothing!' The husband was amazed. Clearly he did not recognise his lady wife. 'The sword fell from his hand,/ he collapsed.' She then offered him a cruel choice: either they would joust together or he must come and 'kiss his opponent's buttocks, right in the middle and at the side.' The choice, in fact, was quickly settled. The lady dismounted and, crouching down in front

of him she unfastened her garment: 'Sire, place your visage
here!'

The husband contemplated 'the cleft made by the bottom
and the cunt: they seemed to him to form a whole.' He said
to himself that he had never seen such a long bottom in all
his life. 'He kissed it then as a sign of shameful reconciliation./
like a good for nothing coward/near the orifice, even precisely
there.' Then the lady told him her name: Bérenger of the long
bottom, 'who brings shame upon all cowards', and returned
home. Since she kept a cool head in all circumstances she
immediately undressed, summoned a knight 'whom she loved
and who was dear to her,' led him happily into her bed-
chamber, embraced him and had intercourse with him. At
this point the knight her husband returned from the wood.
Furious at seeing the lady with her lover he began to shout
and threaten her. To which she replied that he could go and
complain to 'Monseigneur Bérenger of the long bottom, who
will mortify him.' The husband then felt beaten and totally
vanquished. As for the lady, since she was neither stupid nor
ugly, she proceeded to do as she pleased. In short, concludes
Garin, 'when the shepherd is weak the wolf shits on the sheep.'

There is another kind of embrace, the embrace of tranquil-
lity. In *La Fabrique du Pré* the poet and critic Francis Ponge
tells how sometimes, in a meadow, one can observe a simul-
taneous bending, caused by the wind, a single unanimous
undulation, a relaxed unanimous acquiescence. The undulation
of the meadow is a way of saying yes. But yes to what? To
the breath of the wind, to the earth, to life, to the immobility
of its roots? Yes perhaps to sleep, for the curving of the
meadow grass, like the curve of the buttocks, is an invitation
to sleep on it as though on a pillow. Jean Genet often returns
to this idea, regarding the nearness of his lovers' buttocks as
a highly suitable place for death. In *Funeral Rites*, referring to
Paulo's buttocks, 'slightly hairy, but with blond and curling
hair', which he explores as far as he can with his tongue, he
observes: 'I searched for the groin, I sank into it, I even bit
into it, I wanted to take the muscles of the orifice apart and

achieve total penetration, like the rat in the famous act of torture, like those rats in the Paris sewers who devour my most handsome soldiers. And suddenly my breathing grew calmer, my head sank down and remained motionless for a moment, leaning against one buttock as against a white pillow.' And later, still describing this kiss of sleep, but this time with Decarnin, he wrote: 'My tongue grew softer, forgetting to penetrate more firmly, my head buried itself again among the damp hairs, and I saw Gabès' eye blossom with flowers and leaves, become a deeply cool arbour which I entered with all my being and fell asleep on the moss, in the shade, ready to die there.'

Blazon

Buttocks do not play a very active part in life. They do not
often need the use of transitive verbs. Buttocks need only
pronominal or intransitive verbs, otherwise they need nothing
at all. They don't have much of an existence as a subject. They
are usually described in their modality of being, if one dare
say so. We speak of them more easily with reference to their
shapes, their movement, their metamorphoses. Buttocks need
only one indispensable accessory, the epithet. Which does not
change the buttocks in any way. The buttocks are there, the
epithet differentiates them. The epithet confers on them the
dimension of sculpture or poetry, that's all. In these circum-
stances we can understand that the buttocks demand ecstasy,
adoration, extreme love or, on the contrary, vengeful irony
and unkindness. And they were naturally suited to a literary
genre that was wildly successful in about 1535: the erotic
'blazon'.

Blazons were extremely widespread in the first half of the
sixteenth century. Absolutely everything was 'emblazoned'.
But Clément Marot then wrote two comic little poems, *The
Beautiful Tit* and *The Ugly Tit*, which had enormous influence,
and the poets of the period began to emblazon the different
parts of the female body which they divided up and took to

pieces with delight. The term 'blazon' originally referred to armorial bearings. In heraldry blazoning consisted of separating the elements that make up a coat of arms. But the specific usage soon spread to other areas, the details of a person or a reality were all set out for purposes of praise or satire. For the nature of the blazon was two-fold. 'The blazon,' wrote Thomas Sébillet in *L'Art poétique français*, 1548, 'is perpetual praise or total condemnation of what one proposes to emblazon. For ugliness is emblazoned as much as beauty, and the bad as well as the good.' Sometimes blazons have been described as praise and counter-blazons as mockery or satire, but in fact the nature of the blazon was always equivocal. It is near-sophisticated and its only value is through its form: learned or popular, a blazon could praise or blame at will, when not doing both at once. The object described is only a pretext: the essential thing is the virtuosity of the blazon-writer and his art of paradox. Marot proved that the human body inspired as much adoration as teasing, but in particular, only detail could attract and fix desire.

So, when Marot became unpopular after the anti-Catholic 'affair of the placards' in October 1534, he went into exile in Ferrara, to the court of the Duchess Renée, and it was there, following the example of the Italian *strambottisti* (who took emblazonment to the point of indecency), and also the epigrams in the Green Anthology, he published his blazon of *The Beautiful Tit*. It led to a craze both at the Italian court and that of François I in France. Writers began to emblazon women from the roots of their hair to the tips of their toes. A thigh, a sigh, a tear, a big toe, a tongue or a knee—every aspect of the female body was meticulously catalogued. It is to Eustorg de Beaulieu that we owe an attractive piece about the bottom.

> O woman's bottom! Pretty girl's bottom!
> Little round bottom, good shapely bottom,
> Ringed with a fringe of curling hair
> There where the entrance is always closed
> Except when you feel a need for change.

Well creased, well rounded, charming bottom,
It often bumps against your man,
Quivering, when his love he would embrace
To endow the game with better grace . . . [Etc.]

The poem was published in 1537. But at the end of his life
Eustorg de Beaulieu, who had become a reformed priest, pub-
licly repented: the former Catholic organist reproached himself
for having composed a 'lewd' blazon and, in 1546, published
in expiation a spiritual blazon in praise of the very worthy
body of Jesus Christ, which had indeed lost much in lewdness.
The success of the genre led Marot to launch immediately the
idea of the counter-blazon. He composed *The Ugly Tit*, but it
disgusted people. Besides, most of the counter-blazons which
were published then, including a counter-blazon about the
bottom, were not signed. We know today that they were
written by Charles de La Hueterie.

Rare were the periods when writers explained in such detail
which ideal of feminine beauty tyrannised their desire, and
rare too were those when poets admitted so crudely the kinds
of repugnance that the female body aroused within them.
What was the criterion of feminine beauty during the Renais-
sance? And, in this connection, what rules governed the beauty
of the bottom? What caused the emotion provoked by a
bottom that was beloved? In fact beauty at this period was
determined especially by colour and consistency. Cheeks, for
example, had to be alabaster white, or else 'clear and brown'.
Not too pale nor too dark, and lightly tinted on occasions like
peach-blossom, without redness or artificial colour, 'rounded
but drooping towards the mouth, firm and replete, neither
plump nor limp', and if I emphasise the cheeks it is because
they often provide a clue about the buttocks, and vice versa.

So everything had to be *rondelet*, nicely rounded, as they
said. The mouth, for example, was always small, coral-
coloured and ruby-red, thick and soft, smiling, with full lips.
The breast must be firm, white and pink, a little ivory ball
topped with a strawberry or a cherry, small and firm. The

space between the breasts must be wide and the buttocks 'nicely rounded', their flesh delicate and soft to the touch. The rear had to be broad, the thigh white and unwrinkled, full, firm and hard as marble, adorned with the fine silk of 'tiny silvery hairs'. Every female organ, or most of them, had to be white, therefore, polished, firm, solid and slender. The ideal of beauty implied a firm and sensuous quality. The Renaissance woman clearly embodied no dream of fluidity, she would possess rather the 'set' appearance of the Italian beauties. There had to be a full, robust quality about the cheeks, breasts or buttocks which attracted the hand. This was an extremely young woman, with a rounded stomach and springy buttocks, in short a woman who embodied all the ambiguity of her adolescence.

The blazon style naturally acquired a literary vogue, but the writers who emblazoned the buttocks had a problem: how were they to deal with the subject? For buttocks are not only something intimate, they are fleeting and unstable, rather like mercury. The Marquis de Sade, for example, found it very difficult to talk about the beauty of the buttocks. The reader can see him struggling, repeating himself, stumbling over his words. Besides, for him, buttocks are not an accessory to love, but an object of worship, he is on his knees before that adorable little bottom, he kisses it, fondles it, opens it and becomes ecstatic. But how can one describe ecstasy? The ecstasy of a divine bottom? The ecstasy of the most voluptuous anus? Sade does not know. For example the monk Severino finds in Justine 'a distinct superiority in the shape of her buttocks, a warmth, an indescribable narrowness in the anus'. So the perfection of the buttocks is indescribable. At the most Sade lists three features: they must be white and shapely, sometimes with a slight touch of redness which has not been mentioned before, they must also be young, round and full; finally they must be firm and well cut. As for the 'arse-hole', he often compared it to a strawberry, a flowery hole or a little rose, which is charming but evasive. In fact it is not so much the sensory disturbance which forces Sade into not knowing what to say,

it is simply that beauty, even that of a bottom, is always *insipid*. And praise is stupid.

On the other hand, he shows incomparably more enjoyment when he has to describe the ugliness of a bottom, when it is a question of libertines and their drooping buttocks, worn out by vice, or the hideous ruined behinds of the aged madames. For you can belabour the buttocks when you want to relish their decadence. Crumpled bottoms which have been beaten too often, an aged bottom like boiled leather or a dirty flabby cloth, a torn, scratched bottom more like marbled paper, a bottom lacerated with wounds, buttocks eaten up by an abscess, buttocks so incredibly limp that the skin can be rolled round a stick, a wrinkled old bottom looking like an aged cow's udder, the crater of a volcano, a real privy seat, a disgusting sewer: buttocks find their apotheosis in abjection and their grandeur in infamy.

In his *Oeuvres libres* the poet Paul Verlaine describes himself in his turn as moved and vanquished by the bottom. He returns to it on several occasions, visibly dazzled by these 'resplendent, glorious buttocks,/So raging with fury/In their youthful frolics' (*Filles*—Girls) or that 'Discreet Mignon, gentle little Object/With its faint slender shadow of gold,/ Opening to you in apotheosis/To my hoarse and speechless desire' (*Femmes*—Women). But he is particularly overwhelmed by the power of the buttocks, saying he is vanquished for ever by their colossal impudence, by the triumph of flesh. This surrender is just as valid for the female bottom as for the male one, although he swore by all the gods that one was a thousand times preferable to the other, and vice versa. Posterity will remember in particular that he modified in a singular way one's perspective of the anal orifice, which is not the least of his poetic inventions. Verlaine buries his face in it. In the depths of all the hollows of the body he searches for fermented odours, like stagnant water warmed by the sun. He immerses himself in this ambush of darkness and spicy perfumes. 'I am lost. You have conquered me/. Only your big bottom will remain to me/So much kissed, licked, inhaled . . .' (*Femmes*—

Women) He is lost in this 'special sweat/Smelling both good and bad,/Shit and moisture, and arsey-holey.' His tongue burrows and stammers into the miraculous hole, it becomes intoxicated with this odour that is 'bitter and cool, like an apple', his tongue becomes cheerful, greedy and giddy, it is in love.

But the embrace, as Proust told us, is always disappointing. As a result the buttocks, for some, have assumed the appearance of a ghost. And describing ghostly buttocks is a complicated operation. 'If I tell you,' says Patrick Grainville in *Le Paradis des Orages* (Stormy Paradise), 'that this bottom is bigger, that another one is small and slim, that one is slim, rather yellow, another beautifully dimpled and pink, with full round cheeks, proudly fissured, modestly tight . . . no reality emerges from these words.' What's to be done? Grainville extricates himself from the cleft and, in order to describe Mô's buttocks has recourse, by chance, to an eclipse. He was lucky enough to see them one day during a flash of lightning, in the bathroom. 'I closed the door again at once, for Mô can be terribly angry if she feels she is being seen, taken, destroyed.' But this trigger allows him to imagine Mô's bottom as a splash of colour. 'It is greyish white. The colour is highly important. Broken white. Dazzling whiteness is supreme, but a fainter whiteness, just a little duller, makes the flesh more carnal, infiltrating it with a tint of desire. It looks like snow, but snow imperceptibly misty white like a quivering movement of chilly grey over all the cone-like summits of the skin.'

In the end the emblazonment of the buttocks is not so much a surgical and fetishist operation as a somewhat clumsy technique for understanding the buttocks in however small a way and mitigating the sorrow of never being able to embrace them.

Brothel

When Toulouse-Lautrec settled in Montmartre in 1882 he was only eighteen but people called him Little Tyrant. And Little Tyrant brought his friends with him, led by Emile Bernard, to enjoy everything that 'could make your mouth water'. The rowdy women with the red and yellow petticoats dancing the quadrille at the Élysée-Montmartre: La Goulue, Nana-la-Sauterelle, Grille d'Égout with her gap-toothed laugh or Rosa-la-Rouge who became his favourite model and gave him syphilis. And he also saw other women, the 'residents' as they were called. We know Manet's *Olympia* and Degas' *Nana*. Degas, too, in about 1879, showed us the shadowy outlines of clients in front of the naked girls. But Lautrec was really the only one to lodge in 1873 in the rue des Moulins, in a smart right bank establishment where he was referred to as 'Monsieur Henri'. 'I am always hearing the word brothel,' he used to say. 'So what! There's no other place where I feel so much at home!'

In the 1890s there remained in Paris barely sixty or so of the two hundred 'houses' listed in 1856. The brothel was in decline. You might think in a naive way that if there was one place in the world where you could have a good look at women's buttocks, it would be there. Not at all, in fact. In

Lautrec's work the buttocks are not obvious. It wasn't that the girls were wary; they liked him, they no longer took any notice of him, he would come across them on a staircase with their skirts up or find two of them in bed together, kissing greedily, or else snuggling down under the blankets with their faces turned towards each other, in each other's arms, half asleep. For lesbianism was becoming usual, especially after years spent in a brothel. What Lautrec liked about these girls was precisely the sentimental side, the feeling that they had been abandoned. In his paintings they don't hide but they don't display themselves either. They pass by. Between two doors, between two mirrors, between the salon and the bed-room, between one man and another. They stretch out on sofas, they collapse amid women's laughter, they play cards, they dispel boredom. Lautrec never showed them, as the pho-tographer Brassaï did in the 1930s, with a client in the bed-room. In the bedroom they are alone or with another girl. Sometimes they let themselves be seen naked, from the front or the back, but it is from the back that they seem most moving, because they are looking at themselves in the mirror. Lautrec drew them in secret, very quickly. His pencil outlines were caustic. And since he liked red-haired girls with white skin he drew them all that way.

Brothel buttocks are buttocks that are paid for. Idle but-tocks, tired buttocks. Lautrec often sees them as lopsided but never swollen or inert as Rouault saw them. These buttocks always keep some hint of alertness and speed. They are buttocks which have nothing more to lose, we feel they don't give a damn, they are what they are and you can draw them if you want. 'Lautrec paints the centres of pleasure in the colours of the grave', as someone said about *Dance at the Moulin-Rouge*. He has been described too as the 'Goya of tarts', he is said to have painted 'fleshy sluts, common tarts on red sofas', critics have seen 'vice in his very colouring, male colour-ing, strong and spicy'. But *Nude in front of the mirror* of 1897, for example, a woman who has kept her stockings on and leaves her chemise lying on the floor, is a long way from being

the triumph of vice. Her body is in total splendour, with full buttocks and feverish breasts, but a woman who looks at herself for so long can't fail to draw certain conclusions. And the conclusions are always the same: the flesh is superb, at the peak of its beauty and already undermined by death. As Cocteau used to say, in every photograph of a beautiful woman you can see death at work, like bees in a glass beehive. Naturally she can see it too.

On the other hand one really wonders why Lautrec painted his *Crouching Nude with Red Hair*. She is obviously posing. In violent colours, reddish and harsh, all concentrated by Lautrec in the globe of her undeniable rump. She is kind-hearted, she is crouching on all fours on a bed, having taken care to spread a sheet beneath her. She is even breaking her back in order to exaggerate her closely-observed rear. But this has nothing to do with a girl lost in her dreams. It's he who is fascinated, that's the point! The real subject of the painting is the nymph and the club foot. The Milky Way seen through the cripple's telescope.

Surgery

Some buttocks remain young longer. It is as if they did not age at the same rate as the parts that surround them: the curve of the back may still be fine, the thighs also, but the stomach ruins everything. From the back a person may remain attractive, thanks to the central surge of the *derrière* and also to the linkage of buttocks and thighs, that fold at the rear which is like a faint smile. Some elderly buttocks are still soft, very white in colour, as they might be imagined beneath the habits of nuns, astonishingly smooth and tender buttocks. Which explains why some people have more confidence in the buttocks than in the face. Others deduce boldly that this makes the polygamy of certain peoples more understandable.

Yet the skin may droop like a tunic or a piece of old sacking, it appears limp and discouraging or, on the contrary, much too pasty and weighed down with fat. How can the ugliness of flabby or swollen bottoms be corrected? The answer is simple, they have to be rebuilt. Some women who are anxious about their silhouette have their over-large buttocks reconstructed through the technique of liposuction. It consists of removing, by suction, with the help of cannula tubes as fine as straws, the underlying fat. It is usually, but not exclusively,

women who have recourse to liposuction in order to model the posterior of their dreams. The buttocks can be reduced either overall or in certain areas, the most difficult thing being to make them slimmer while preserving their roundness. Although this technique can correct buttocks where exaggerated curves or excess obesity make them protrude too far, it is in no way suitable for those that are too flat or too soft. Recourse must be had then to the prosthesis of the buttocks with solid silicone, which usually leaves scars, or to injections of fat by means of a syringe, recalling Rossini's method for stuffing his noodles with foie gras. This is what Dr Pierre Fournier calls the 'buttock-lift'. Naturally the injection is made with the patient's own fat. There is only one drawback to this method—the fat melts away. In the long run only about 25 per cent of it remains in place, so every two or three years the buttocks must be blown up again to restore the muscular tone they need.

Buttocks which yield to the surgeon's knife are not immune to accidents. The silicone technique appears to be extremely delicate and some women have suddenly found their buttocks slipping down to their thighs. They discover that instead of buttocks they have a somewhat compromising pair of saddlebags. In medical terms this is known as 'silicone migration', or more simply as the downflow of the buttocks. Which is annoying, for the shape of the buttocks remains the same but they are no longer where they are expected to be.

Japanese women, who are shaped like tubes, ward off this problem by lining their bras and briefs with foam rubber, which gives them the illusion that they can put on their buttocks and breasts every morning. Padding, or prosthesis, as it is called, inside or outside the body, allows the buttocks to develop late in life. Which proves that if everything in our bodies does not die simultaneously it is not born simultaneously either. On the other hand, buttocks cannot be recovered, like the heart and the kidneys, and live in another body. Our buttocks belong to us, we shall never find them again anywhere else. They are unfailing allies. They are not

immutable, certainly, but how can one complain about some of their indiscretions when their particular nature is so docile, so understanding, and so delightfully adaptable?

Curves

'Every shape within the human body is convex,' Matisse used to say to one of his students, Dubreuil, 'there is no concave line to be found in it.' Which entails the rapid omission, as Gilbert Lascault points out in *Boucles & Noeuds* (Curls & Bows), of the hollows formed by armpits, dimples, ears, the cleft in the female body, the arching curve of some waists, etc. The remark also omits to mention that before the buttocks can be totally protuberant, the lower back must be concave. The buttocks in fact describe two inverted arcs: the more curved the spine, the more extended the rump. And, as Corneille said, 'desire increases when facts recede.' In short, we believe in the satisfactory nature of the convex outline and we seek it everywhere. But what we look for most of all is the convex outline of woman.

That is why one has to be a mathematical genius in order to detect in the shape of buttocks the equivalent of a painting by Mondrian. Here therefore is an unexpected definition of buttocks expressed in straight lines: 'The section of the human back situated between two imaginary lines parallel to the ground, when the person is standing upright—the first or upper line runs above the separation between the two masses of flesh (that is to say the bulges formed by the muscles leading

from the back of the hip to the back of the leg) and the second, or lower line, which runs at the lowest level of the lowest possible point of this separation or from the lowest point of the curving part of the fleshy protuberance—and between the imaginary lines situated on each side of the body, the lines perpendicular to the ground and the horizontal lines described above, the said perpendicular lines being drawn towards the point at which each mass rejoins the exterior part of each leg.'

Some jokers have even believed in good faith that certain conclusions can be drawn about the buttocks of film stars, and that they would only obey three sets of rules: the square, the horizontal rectangle and the vertical rectangle. The square containing the perfect circle is the privilege of classical beauty, as in Louise Brooks and Marilyn Monroe; then there is the vertical rectangle framing buttocks resembling a gourd or a retort, superb buttocks, although they quickly become too heavy, as with Mae West, Jayne Mansfield, Jeanne Moreau or Béatrice Dalle; and lastly the horizontal rectangle, indicating the buttocks of a very young girl or the adolescent style of some athletic types such as Brigitte Bardot or Juliette Binoche. This is regarded as the least usual of the three types.

It is preferable to keep to a notion of curving buttocks which is certainly retrograde but much more usual, 'alternately taut and slack, like the strings of the lyre and the bow', indicated earlier by Heraclitus. And if buttocks are defined in the first place through their curve, it is because they are close to baroque aesthetics which harmonise with clouds and garlands, shells, domes and scrolls. The statues of saints on certain Swabian altars, who seem to be transported by an irresistible mirth, uplifted by a frenzied jubilation, look exactly like swaying buttocks. Ever since Raphael's *Judgement of Paris* the female nude has predominated in painting, because the female body facilitated the elliptic, sinuous or undulating outline, and to a lesser extent because the painters found women more pleasing. Besides, do not the buttocks alone surely express all that is curling and rounded in the female body: locks of hair, cheeks, vulva, eyes or nails? Is it not the ideal metaphoric expression

of a body enclosed within a shell, like that of the lamellibranchiate mollusc, and do they not convey also its hyperbole, in a superabundance of fullness?

'E, the artless form of mists and tents/Spears of the proud glaciers, white kings, quivering umbels . . .' The poet Arthur Rimbaud's sonnet *Voyelles* (Vowels) surely appeared sufficiently obscure for Robert Faurisson, better known for his revisionist theories, to suggest an erotic interpretation. For him the shapes of the vowels express certain female attributes, and their evocation should take place *in coïtu*, from the point of departure to ecstasy, from the beginning of the sonnet to its climax. And as for the letter E, precisely, which he agrees should be written like the Greek epsilon, Faurisson writes as follows: 'White and misty breasts which swell slowly, then thrust forward with pride, until finally they reign in majesty, their nipples quivering in haughty pleasure.' To this bold analysis, for after all Rimbaud's knowledge of the matter was derived entirely from books, a reader of *Le Monde* replied with a uranian version of the sonnet—that is, an emblazonment of the male body—seeing in the E nothing more nor less than the 'joyful buttocks' described by Verlaine in the purified and divine shape of the same epsilon.

In support of this interpretation, which is not entirely ridiculous, one need only look at a 1933 drawing by Matisse entitled *Sinuosity*, in which the woman's buttocks are reduced to a line, a pure vibration, the trace they leave in the atmosphere. Incidentally, Desmond Morris is not justified in maintaining that the universal symbol of love, the stylised heart, was inspired by the buttocks, 'a woman's buttocks seen from the back'; in the slang of the nineteenth-century pimps, when the ace was used to signify the bottom it was certainly not the ace of hearts but the ace of spades or clubs. ('In Rome they tease the little abbés, going for their ace of clubs', wrote Théophile Gautier in *Lettres à la Présidente* of 1850.) To return to the epsilon-shaped buttocks, let us refer to a pose that often occurs in modern painting: that of the woman lying on her side, facing us, which means that her legs are bent at 45

degrees, and one buttock is on top of the other, forming two storeys, and opening on the sexual slit. As in *Faun unveiling a Woman*, by Picasso (1936). The pose is certainly very satisfying to the eye, which at one glance can take in the entire woman: her face, breasts, vulva, the gigantic globular mass of her buttocks, and her feet. In addition she reveals a part of the body rarely visible, the haunches, shown by Courbet, for example, in *Sleep* (1866). So this is a situation which makes capital from going too far. But going too far where flesh is concerned is always flattering.

Yet it is in its movement that the curve of the buttocks justifies its existence. In this quivering dance, this backwards and forwards undulation, this curious sinuosity which gives women an S-shaped outline. Alfred Delvau, in his *Erotic Dictionary* of 1864, states fairly frankly that women move their bottoms in front of men in order to arouse them. And Balzac spoke of the 'lascivious twisting' of their rears. 'Your bottom reveals your style,' Léo Ferré was to say in more lyrical fashion. Slang was particularly rich in this area, regarding this significant activity as one of the characteristics of femininity. She waggles her rear, swivels her bottom—there is no end to the slang expressions which attempt to describe or enumerate all the variations of bottom-activity by women. Marcel Aymé summed it up when he said that their hip-swaying was decidedly not unpleasant. And when Rimbaud unequivocally evokes a woman's buttocks he always returns to the frenzied activity of her rump. From this point of view buttocks described by Rimbaud are much more plebeian than those described by Verlaine, for they jump up and down, they flutter. Here is what Rimbaud wrote in 1870, in *Un coeur sous une soutane* (A Heart beneath a Cassock), about the buttocks of Thimothina Labinette: 'I saw your shoulder-blades protruding and lifting your dress, and I was pierced with love before the two big and graceful twisting arcs of your lower back.'

What is the precise nature of this swaying movement? It is quite different from bouncing breasts and also from the hysterical little movements by pigeons when they extend their

necks and peck in empty space. It is a swaying movement going from left to right and from right to left, like the movement of eyes or testicles. Besides, the latter are shaped like small creased buttocks, when they are firm, moving backwards and forwards, coming and going, perpetually in motion, which is always surprising when it happens for the first time. But this swaying of the buttocks is also conveyed indirectly to the outline of the entire figure, so much so that few women who put their sex appeal into their buttocks fail to attract attention. This was so in the case of Mae West, who obviously overdid things a little with her hips and breasts. Mae West embodied the recurrence of rounded shapes, the splendour and vanity of the S-shaped woman. From her corset to the feather in her hat, from her boots to her décolleté she was just one vast sexual organ. Marilyn Monroe, on the other hand, had adopted the horizontal way of walking, still called 'on ball-bearings', due, it was said, to wearing shoes with very high heels, one heel being slightly lower than the other.

Naturally such a walk was helped by dresses one size too small for her, often backless, which had to be sewn on to her, for the fabric was as transparent and thin as the peel on a fruit. It was precisely the type of dress which drove half the women who saw it into a frenzy of anger. And as an admiring rival in *Niagara* said, 'Before you can wear a dress like that you've got to start thinking about it when you're thirteen.' Paradoxically, apart from a few shots of her in a bikini in *The Misfits* (1961) and the midnight bathing in *Something's Got to Give* (1962), by George Cukor, Marilyn was never seen completely in the nude. The cinema took her anatomy to pieces, in particular her breasts, hips, stomach and buttocks, but it never undressed her. Some attempts have been made to explain the secret of this ideal appearance through a cabalistic interpretation of the actress's measurements: 36-23-33½. In this way they arrived at the sequence 2-3-4. And, subtracting her chest measurements from her height, they obtained the figure of 70 (in centimetres, that is), a perfect number, a multiple of 7, the number of days in a week, the colours of

the spectrum or the chieftains ranged against Thebes, and 10, the total of the magic tetrahedron. But others have contested these results and maintained that Marilyn's magic number was in fact nine, 'nine being the symbol of perfection, to which one can add nothing without lapsing into the void.' But naturally the perfection of her person was due not so much to the perfection of her buttocks as to their harmonious proportions in relation to her entire structure. Which is no doubt what the English aimed to convey when they called her simply Mmmmmmm.

Unlike the case of Marilyn, writes Alain Fleischer in *An Encyclopaedia of the Nude in the Cinema*, the career of Brigitte Bardot can be seen as a striptease serial, very complete in fact, extending over three decades. But it was certainly her buttocks which appeared first. In *The Light Across the Street* the young wife abandoned by an impotent husband undresses in front of the window. The buttocks were shown against the light, and the lighting was arranged to show them from the front, in the dark. The same year Bardot appeared in *And God Created Woman* . . . And the film had hardly begun before the actress's buttocks felt the need for sunbathing on the balcony, protected by the washing drying on the clothes line. Bardot then created the image of optimistic buttocks, unaware of their sex-appeal, without embarrassment or taboo. 'I'm not immodest,' she said, 'I'm natural.' In 1958 came *Love is my Profession*. Bardot, still shown from the back, but perfectly well lit, pulls up her dress and reveals herself to her lawyer (Jean Gabin), who remains very phlegmatic, with his hands in the pockets of his double-breasted suit, before giving her a resounding slap on the face. It would be hard to do better. She was to dance, again in the nude, in *The Truth* in 1960, to the rhythm of a mambo; then came the famous scene in bed at the start of *Contempt* in 1963, when Camille asks persistently if her buttocks look good. Godard is known to have filmed this scene at the express request of the producers, and he placed it at the start as though to get it over with. Rather as a maître d'hôtel shows his client a fresh lobster, pink and whole, before taking it off to the

kitchen. In any case Bardot's buttocks, which are perfectly up to the standard of *la qualité française*, were already known to the whole world. Insolent, sulky, animal buttocks, they turned the heads of all the young people of the time, for whom they represented one of the peaks of creation.

'I like round things,' Niki de Saint Phalle used to say. 'I like round things, curves, undulation. The world is round, the world is a breast.' Dali also liked round things, but not the same ones. 'Of all the beauties of the human body,' he wrote, 'it is the testicles that impress me most. In looking at them I feel metaphysical enthusiasm. My teacher Pujols used to say that they are the receptacles of unconceived beings. For me therefore they evoke the invisible and incorruptible presence of heaven. But I hate them when they hang down, looking like beggars. I need them to be neat, compact, round and hard like shells.' This amounts to saying that breasts, testicles and buttocks encapsulate the perfection of roundness, for they add volume, that is quantity, to curves and taut arcs. In this sense western culture, which sees holes only as an absence of something, a kind of deterioration, remains faithful to Parmenides who identified the universe as an unbroken sphere, a harmonious round sphere, which Orpheus preferred to call an egg of brilliant whiteness. In fact the very convexity of the *derrière*, its mass and oppressive equilibrium, like a rock overhanging the void, render it almost inaccessible and yet close at hand, rather like the vault of heaven. With the one difference, of course, that the celestial sphere of the buttocks opens along a cleft, a crack, a secret wound, and that is the paradoxical conjunction of an abyss and a vault which expresses the entire mystery.

In short, buttocks are pleasing. There is something cheerful about their portliness, especially during difficult moments. They are comforting, heartening, they make you want to believe in the future. Having your fill, gazing your fill, having your hands full: it all leads to a pleasant feeling of euphoria. Which explains how for a decade now, the shape of domestic objects has constantly been reminiscent of buttocks, linking

smoothness to comforting roundness. In 1979 Roland Topor summed up the style of the period in a slogan: 'It's sleek, it's smooth, it's beautiful.' Adding too that the smoothness assumes 'its transcendent aesthetic value—as Dali would say about his rhinoceros horn—when it is linked to an idea of penetration.' So what is sleek is pleasing, because it favours insertion. Provided of course that it is not too pointed or resembles an ogive. No, what is sleek should be round, oval if need be, in order to avoid shocks and irremediable destruction. And today, roundness is everywhere. In mushroom-like precincts, spherical vacuum cleaners or cars shaped like round tablets of soap. Roundness makes us believe that the world can be worn away like a pebble or sucked like a sweet. These fluid shapes have even led to the uplift bra which makes the breasts protrude, thus distancing them from the feet. In this way women's décolletes have begun to look like their buttocks, which is unexpected. This excess quantity of elastic which raises rubbery shapes to the limits of their possibilities, could be called pneumatic. But creating in this way a woman with four buttocks can only delight anyone who likes the *derrière*, for women can henceforth be seen from the front with equal satisfaction, which we owe to the proven technique of underwiring linked to padded cups.

Rump

Do animals have buttocks? Can one speak of buttocks in connection with the rear of certain animals? The dictionaries are highly confused. They mention the croup, the posterior or the behind, but what about buttocks? This is what Buffon says in his *Natural History* (1740–1789): 'Buttocks, which are the lowest part of the trunk, belong only to the human species; none of the quadruped animals have buttocks, the parts regarded as such are thighs.' That seems clear, but in fact it isn't. The lexicographer Antoine Furetière spoke in 1690 of buttocks in the horse, not in the ox or cow, whose buttocks are called the rump, nor for the sheep—haunch in that case— nor for the pig, whose buttocks are known as hams. Who would think of confusing buttocks and ham? Madame de Sévigné, on 31 August, 1689, said that ham, cut into large thin slices, was used by the late Monsieur de Rennes to mark the pages in his breviary, with the result that 'his face was a true luminary of the Church'.

For Littré and his *Dictionary of the French Language* (1863–1872) buttocks belonged only to men and apes, which leaves one bewildered, and for Pierre Larousse (*Great Universal Dictionary of the 19th Century*, 1868–1876) it is perfectly in order to accept that a horse or an ox has buttocks: besides, he says,

the beauty of an animal's buttocks resides in their length, in the volume and firmness of the muscles. 'We say that a horse has sound legs, that his buttocks are well developed and full.' We may wonder then why horses have such opulent buttocks, since they don't often stand upright. We know hardly any more about the subject today, but it is obvious that the buttocks would like to be 'ecumenical', so to speak, there is no longer any taboo attached to them. They are found in the ape, the sow, the cow and even in the bitch. This is how Colette evoked the fine appearance of Pati-Pati, who came from Brabant: 'she was broad across the lower back, with full buttocks, her chest was like a portico', and she resembled a tiny guinea-pig.

But there is little point in searching obstinately for buttocks among animals since everyone has agreed, since the eleventh century, to endow them (especially horses, ponies and llamas) with a croup or rump—that is to say with hindquarters shaped like a goitre, a hump or a paunch, which is obviously not flattering. This is why, a century later, people began to apply the term ironically to certain men possessing a particularly expansive bottom, and in about 1690 it was applied, especially in an erotic sense, to the female species as a whole, no doubt in order to indicate their animal nature. Although, on this point, one should make distinctions. 'You will observe,' writes Marcel Aymé in *The Miraculous Barber* (1941), 'that the word croup or rump is hardly ever used except in the case of women or animals. People talk of a woman's rump as they talk of a mare's rump. In short a woman's body is rather like a transition between that of a man and that of an animal.' Let us stop there, and note that in the past peasant society judged a woman's health, and even her beauty, by the breadth and fullness of her rump. Emaciated, skinny buttocks were depressing, just like the drooping hindquarters of a horse or the over-bony rump of a mule. Only heavy shapes would fill a man's arms, and women who had 'something soft about their roundness' were preferred. Moreover, as the Curé of Claquebue thought (*The Green Mare*, 1933), 'there's no refuge for the

devil in that fleshy part.' In which he was surely mistaken: 'The power of the devil resides in the lower back,' as Saint Jerome had already said. But the Church, in granting absolution, authorised caresses of a rather risqué type, light blows which could certainly be felt or moments of straightforward fun. Only God, after all, could be accountable for impure thoughts which rose from women's buttocks into men's brains.

In the absence of women one can always make do with other rears which resemble theirs so closely as to cause mistakes. In this way Sartre, in *Roads to Freedom*, whenever there is a little pervert, or simply a youth of 18–20 close to Daniel, likes to give precise details about his rump. In *Iron in the Soul* he mentions a young man called Philippe, encountered in the Tuileries, with rounded, near-feminine shoulders, narrow hips but a firm and rather prominent rump, while in *The Age of Reason*, referring to a little rent-boy met at a fair in the boulevard de Sébastopol, he describes a chubby backside and full peasant cheeks, grey, but darkened by a light growth of beard. '"Women's flesh," he thought, "you can knead it like bread dough."' But the most sumptuous pervert's rump undoubtedly belongs to Palamède de Guermantes, Baron de Charlus. It was an 'undulation of pure matter', a kind of artistic muscle of the rump. Charlus had a woman's pair of buttocks and that is what betrayed him. In *Sodom and Gomorrah*, outside the waistcoat-maker's shop Jupien had already uttered a few undistinguished remarks such as 'You've got a big bum!', but when Charlus was over sixty it was then that his rump assumed its monstrous size and people were astonished to see this 'titified chest', this 'over-developed rump' on a body entirely given over to vice. It was precisely at this moment that Monsieur de Charlus began to look more and more like his sister, Madame de Marsantes, and took himself for the Sarah Bernhardt of the brothels. Such a metamorphosis of a rump is certainly unique in French literature.

There is one curiosity, a somewhat misunderstood rump, belonging to the serpent, for it is not clear what is meant. But the image one finds in Book IX of Milton's *Paradise Lost*,

and also in Racine's *Phèdre*, where Hippolyte fights a raging monster whose 'rear twists back in tortuous coils', was already to be found in Virgil's *Aeneid*, Book II, 208. It is precisely this kind of detail which used to fascinate schoolboys, leading to so many impure thoughts. But we must be careful here: the rump has no connection with the parson's nose, one of the most tender parts of a chicken, although often neglected by those who do not know about it. This rump, which supports the tail feathers, is the extremity, the farthest point in a bird's body, corresponding to the last vertebrae, known as the sacral vertebrae, that is the 'temple' of the bird. Sometimes people speak of 'a mouth like the parson's nose,' which can cause confusion. As for the coccyx, it is little more than a small triangular bone in the area, shaped like a cuckoo's beak, as shown by the Greek origin of the word. In this sense the coccyx is the stem of the rump, its ultimate skeleton, its infinitesimal unity. Beyond it is the void.

One crucial question remains: if we can distinguish without too much trouble the buttocks of a cow from the buttocks of a man, we can then speculate about the exact nature of a woman's buttocks. Alfred Binet, who lived from 1857 to 1911, noted that in a man the morphology of the buttocks is dominated by the relief of the buttock muscles, whereas in a woman, on the contrary, it is the harmonious distribution of the gluteal tissue that dictates the aesthetic quality of the buttocks. There is one simple reason for this: men have 20,000 million gluteal cells and women have 40,000 million. While in men the cells surround essential organs, like the heart or the liver, women accumulate this tissue beneath the skin, mainly round the hips and thighs. This adipose mass certainly has some disadvantages, but at least it allows women to have more resistance than men to cold water, a fact which too often remains unknown, and just as they can float better, they can also glide along better. But this doesn't mean that we have to agree with Desmond Morris (*Gestures*) that women's fleshier buttocks and shorter legs make their movements 'more clumsy', making her more like a duck in fact.

To sum up: male buttocks are very different from female buttocks, although not everyone agrees. The former are small, narrow, hard and in general more muscular. The latter are more extensive, wider and softer. From an aesthetic point of view it is a question of choice. The surplus of gluteal tissue in women has sometimes been described as 'supplementary emergency rations', rather like the camel's hump. But more fat also means more protuberance and more swaying, which some see as an advantage. Not the novelist Michel Tournier, who finds it heartbreaking to be forced into choosing between large soft buttocks and hard small ones. However, he glimpses a happy solution in the buttocks of the horse: 'For the horse gives you that wonderful thing: vast hard buttocks, a dream for someone who appreciates them. What's more, the horse has something else that goes very well with vast hard buttocks, an ideal type of defecation, admirable through its ease, its shaping, even its smell. Horse manure is one of the finest things in the world.' This idea preoccupied him for a long time, he returned to it in *The Erl-King*, in connection with a gigantic black gelding 'with hump-like muscles, the hair and buttocks of a woman', which he calls Bluebeard. For Tournier it's very simple: 'the horse is a rump with organs in front which complete it.' This makes it the Genie of Defecation or the Anal Angel. 'The obstinate persistent rider places his small, sterile and flabby rear on the gigantic and generous rump of the horse. He hopes vaguely that through some sort of contagion some radiance from the Anal Angel will bless his excrement.' But obviously it is only total identification between the rears of horse and man that will allow the latter to acquire the very organs which ensure the horse's defecation. This is why the ideal of man is in fact the Centaur. Only the Centaur shows 'the man carnally blended into the Anal Angel, the horseman's rump inseparable from that of the animal and in his delight moulding his scented golden apples.'

A similar admiration for the brutal and powerful excrescences in both men and horses can be found in the work of Michelangelo (in *The Conversion of Saul*, for example), but

it is Géricault, one of the French painters most responsive to the art of Michelangelo, who has shown most appetite for buttocks. 'I like men with big buttocks,' he used to say. It is pointless to recall the many male buttocks and horses' rumps which occur in his drawings or paintings, rumps that he would go and observe in the Imperial stables at Versailles; and he is certainly the greatest painter of horses that France has known. But one can't fail to notice the resemblances between horses and men. There is the same physical strength, the same sculptural modelling, the same explosion of energy, as though there is a kind of contagion between the buttock muscles of horse and groom. In Géricault's work the weight and volume clearly reveal the strength of his feelings. 'It is the animals,' notes Lorenz Eitner in his book *Géricault* (1991), 'which he dominates completely, as a committed horseman, but his artistic imagination remains mysteriously enthralled by them.'

Géricault painted a vast number of rumps: massive rumps of horses without heads (1813), rumps of athletes, trapeze artists or even, rarely, women. In his *Lovers Embracing* (Jupiter and Alcmene), for example, it is rather curious to see the woman literally twisting herself round in order to show us almost her entire buttocks. We see neither her face nor her breasts, nor her stomach, but essentially we see her bottom and her loose-flowing hair, she is like a mare's rump imbued with her beauty. Sometimes even bottoms and rumps are shown in postures that achieve complete mimicry, as in the *Officer of the Chasseurs, charging* (1812) and *Kneeling Man raising his Right Hand*: man and horse are seen from the back, their legs apart, one as taut as a spring, the other kneeling, and between them the perfect representation of the anus, the cleft between the buttocks and the genitalia. In fact these naked Hercules figures throw out their buttocks almost as far as the horses do. This is even more obvious when the man and the animal are engaged, as they often are, in a furious combat, a heroic confrontation which takes place with horses but also with lions, bulls or tigers. Struggles with horses rearing up, with terrified grooms, wild horses which slaves attempt to

control, rebellious horses which they are trying to tame: all the buttock muscles are galvanised by the strain and drawn together into a wild imposing mass.

And look at the *Wild Horses Running* or the *Horse held back by Slaves* (1817). Once again man must succeed in taming the horse's passion, as though he wanted to absorb it or be absorbed into it. Géricault also made a few drawings of hairy satyrs and centaurs: *Centaur carrying off a Nymph* or *Satyr and Nymph*, for example. The bodies are entwined in a voluptuous struggle closer to a dance than an abduction. A unique moment of happiness, which Géricault was apparently never to know again, for he usually saw this passion in the animal body in a divided, violent and tragic way. It was only perhaps at the end of his life, when he was in England, that he rediscovered some kind of calm in the massive and powerfully constructed bodies of carthorses, athletic and proletarian members of the equine species, as though they summed up the magnificent mares in the Versailles stables and all the men of the people, butchers, knackers, wrestlers and carters, who fascinated him. But for Géricault, as for Tournier, the horse remains the ideal for man. For its belly, its coat, its knotted muscles, its dilated buttocks, are truly filled out. Géricault is fascinated by the way this creature reflects the light, subduing all its splendours and subtleties and particularly by the way it holds open its body to receive them. Perhaps the painter's secret lay in his crazy desire to transfer into the human body that animal strength, with its gentle and marvellous passivity, contained in the fabulous buttocks of a horse.

Botty

Why become so ecstatic about a little *derrière*, a little child's bottom, a puerile and useless botty? When a mother shows us baby, she immediately exhibits his or her virginal and delightful buttocks. And everyone around her exclaims, they sigh, they contemplate, they become ecstatic about such a round and glorious rear. So I think it is time to evoke the brief history of the mother and the bottification of baby.

'Does there exist anywhere on earth, beneath the scorching botty of heaven,' says the Polish writer Witold Gombrowicz in *Ferdydurke* (1937), 'anything worse than this vague feminine warmth, these happy, confident, adoring embraces? True, there's no moment in existence when one can find in the human being a more tender, fresher, more deliciously childlike botty. Like a little warm potato. It's the moment when the elasticity of muscles and inborn naiveté are at their peak. It is therefore the ideal moment for dimpling, prodding, fingering, tapping, pawing, sucking, sniffing this little tender downy botty, accompanied by cretinous laughter. Oh, those mothers who feverishly seize hold of baby by its botty, this botty as delightful as it is innocent! For you can be sure about it, baby's botty wants mother, and nobody else. Nurse, if mother is not there, but the nurse is a foster mother. Any other link

with the botty, with the beatific property of the botty, would be perverse, shameful, unnatural. The botty is to the mother what butter is to the frying-pan: constant intimacy, impatient sizzling, a necessary connection. Besides, a mother without a botty is no longer a mother, she is a deviant, unnatural woman. So it is the botty that also makes the mother: how could she reject this excrescence from her womb? A mother cannot defend herself against the botty, she can only offer it her congratulations.

What a splendid little botty her darling treasure now possesses! Oh, this supple, virginal botty in its half-sleep! This kind of moving torpor among the dribbling and all the excretions of the dear little kiddy! For childhood is the moment in history when everything released by the body is valorous for the mother. Her affection even extends to the cereal baby sicks up. This, then, is also the moment when a man is reduced to his diarrhoea, slavering, discharges and waste. His pooh. His botty. Oh the cherub's little botty! Belittled and infantilised by this adored mother, who becomes twice as tall as a result. Because the botty makes the mother grow. She becomes huge. The botty is the foundation of the mother, of her greatness, her hugeness. Through the botty the mother becomes the ideal of motherhood. She becomes a madonna. That is why the mother dedicates herself to making baby's botty into the absolute perfection of all botties. Baby will be completely bottified by the mother. This good-natured immaturity, this attractive clumsiness, this stupidity in the face of life, this ignorance or this impotence, it is to her that he owes it. The one vocation of a mother is to make the whole world regress into childhood, thanks to bottified-style teaching. She, in fact, aspires only to one thing, to be bottified by baby. Oh, the delight of this universal bottification! The music of the spheres! Oh, this botty, she murmurs, this botty beyond compare!

'The fundamental part of the body,' Gombrowicz also says, 'the nice little familiar botty, is basic, it is through the botty that action begins. As for the face, it is at the summit, at the

top of the tree that grew from the botty: the botty cycle ends like this in the throat.' So the throat really is irrigated through the botty. You can't escape it. As soon as the botty is well in hand, the throat is already destroyed. The botty breaks through, makes its advance, as surely as Caesar's army, it infiltrates everywhere, into the ears, the shins, the laugh, the eyelids, the knee, the feet. Baby in his or her turn becomes huge, a gigantic botty, an infantile and transcendent botty which one day, he or she hopes, will be able to conquer the world.

FIAT LOOSE AND FANCY FREE

The Fiat 500, a tiny motoring masterpiece, is enjoying a revival. Perfected in the 50s by car designer Dante Giacosa, it was a minimalist answer to Citroën's 2CV and the Volkswagen Beetle. Thousands of *Cinquecenti* are still cheerfully humming their way around Italy, but in Britain they're relatively rare, and cheap enough (about £2,500 for a restored one) to be an irresistible bargain. A collectable classic, it manages over 50 miles per gallon and turns heads, but slowly. If one takes your heart, have a leisurely cappuccino and catch it at the lights. Or look through *Parliamo*, an eccentric monthly magazine from the Fiat Motor Club.

DAN CONAGHAN

The *Fiat Motor Club*, tel (0458) 31443.

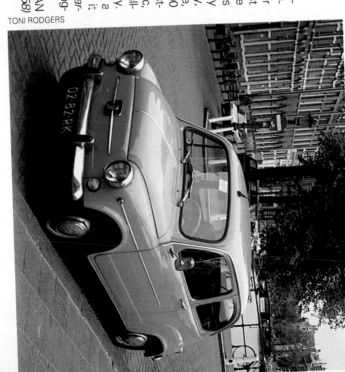

TONI RODGERS

		Seek A New Life	nair and Tom's twinkly leprechaun smile, this is fairly bursting with hammy peasant quality. Can't *wait* for the accents
Call It			
The Mick	Kevin Costner – who will also direct	Our Kev is early 20th-century Sinn Féin revolutionary Michael Collins (yes, *really*)	With a title like that, should have lashings of PQ, though Kev will no doubt speak Californian as usual. But where will he do his customary Naked Bottom Scene? Those peat bogs are *cold*, Kevin
The Playboys	Robin Wright (Sean Penn's girlfriend) after Annette Bening dropped out	Set in 1950s. Travelling players descend on a small rural community	Opening scene set in a potato field, need we say more…
Untitled	Mickey Rourke – Sean Penn rumoured to be directing	At present exists mainly in Mickey's head – story of IRA hunger striker Bobby Sands	Hmm – maybe not so high. Bobby Sands will probably ride a Harley-Davidson and indulge in torrid soft-focus bonking sessions with a succession of surfer-babes. Still, we always did think Mickey had a bit of a potato face…
Untitled	None as yet – Isaac *Young Soul Rebels* Julien to direct	Several hundred year-old story of gay Irish revolutionary Roger Casement	Probably mercifully low – maybe Kevin could do his bottom scene in this one…

Dancing

When there is dancing the buttocks are no longer depressed, bored or seeing no future in life. For dancing creates something miraculous within the buttocks: they shake. This shaking is a sudden movement which makes the buttocks jerk, twitch, even register seismic shocks. Shaking in a way is a storm within the buttocks. From the maenads of ancient times to the *Dance* by Matisse of 1910, buttocks direct their aerodynamic fuselage everywhere, and they really go at it. Emotion from dancing is certainly the most pleasant movement felt by the buttocks, the most vibrant, the most irresistible. Only then do the buttocks become aware of their appetite and the appetites of others and only then do they swell with subtle tingling sensations. You might think they are going to catch fire. In the rhythm of the dance the buttocks become even more frantic, more wild, more desperate still, aware of painful and pleasurable jostling. The Church realised quickly enough the danger that such a disturbance represented for them, and a council meeting in Paris in 1212 decided that dancing was a worse crime than ploughing the soil on Sunday. For dancing was the spark that ignited lust.

This was already clearly understood in the Hellenistic world of the first century BC. Satyrs, maenads, fauns and nereids

leapt into the air, banging on tambourines, during the feasts of Dionysos, as if they were trying to escape from the laws of gravity. The maenads in particular, in their floating draperies, furiously tossed their hair back and created a kind of tidal wave in which their bodies floated. This wild fervour allowed the buttocks to arch a long way back in their raging ecstasy. On the walls of the Villa of Mysteries, to the south of Pompeii, buttocks reappeared a century later, in very private erotic ceremonies with explicit poses, aimed at provoking desire, like the whip. There were still Dionysian rites which took place before the eyes of a severe and majestic matron, probably the mistress of the house; the mural shows a flagellated woman, on her knees, her hair still damp with sweat, and beside her another woman, completely naked, shown from the back, no doubt a bacchante who had already been initiated. She is spinning round in a circle, clashing cymbals. She too has bare feet, her hair tied back in a pony tail, and she has a fantastic bottom, one of the most beautiful bottoms in the world, stormy, quivering buttocks. As she dances her veil describes an all-powerful rainbow around her, tracing a line reminiscent of the cleft between the buttocks. She dances and her buttocks appear to take flight. She is no more than a vast crescent moon.

At this period also, Juvenal tells us, an entertainment took place in Rome that was much sought after for banquets. This was provided by a dancer from Cadiz. She had small feet, castanets, and performed lascivious jerking movements. She uttered obscene cries and the swaying of her lower back was fabulous: encouraged by applause she would slide along the floor, twitching her bottom, and turn over boldly, ready for voluptuous assaults. And Juvenal was furious: 'Those clattering castanets,' he says, 'those words that the naked slave girl at the brothel door would be ashamed to utter, those obscene cries, that art of self-indulgence is the entertainment of those whose vomit stains the mosaics of Sparta.'

When the buttocks began to engage with braided hair, as in India, this led to something more subtle and somewhat

hypnotic. For there the performer of sacred dances is exactly like an *apsara*, a celestial nymph born from the churning of the sea of milk, along with the sacred cow, the tree of Paradise, the moon that Shiva placed in his hair, and the elephant. These *apsaras* danced in the kingdom of Indra to entertain the gods. Hindu statuary represents them with a very slim waist but also well rounded breasts and substantial buttocks. And even today, if a performer of sacred dances lacks any of these attributes she must resort to artificial padding to fill out her buttocks. 'Indian dancing,' says Menaka de Mahadaya, 'which accentuates the three great curves of the female body— shoulders, buttocks and legs—is not a summons to sex like Arab dancing, but a demonstration of a woman's personal blossoming, her aura of sensual pleasure.' There are two indispensable accessories to this dance: the circlets of little bells fastened around the ankles (the *kinkini* or *ghunguru*) and the braid of hair with pompoms attached which must toss against the rear in time with its contortions. Which leads to those small leaps, pauses and amusing somersaults by the braid which apparently exert much erotic power.

In Senegal, on the contrary, eroticism is less of a hallucination. There is a torrid dance, dating from the 80s, called the *Ventilator*. It is also the dance of the *tatous*, the buttocks. All you have to do is crouch down, support yourself on your bent knees, lift your head a little, arch your back and follow the rhythm of the *tama*, the little drum. You move only your lower back and your buttocks, jerkily, like the rotations of a ventilator. Some immodest people don't hesitate to lift their outer loin cloth and move their buttocks under the inner cloth, while shaking their *djal-djali*, the beads which hang down over the lower back. The buttocks have everything to gain by surrounding themselves with accessories suitable for punctuating their jolts while producing irritating, feverish little sounds.

Decorations

The matador, of course, is very much afraid of the bull's horn.
The horn can gore his flesh anywhere, in particular his but-
tocks. The writer Jean Cau, in *Les Oreilles et la Queue* (Ears
and Tail), describes how the matador, before getting into his
taleguilla, that is his trousers, displays his scarred buttocks to
the company of men surrounding him. 'Look at his body before
the women come in to wish him luck. There's a hole in the
thigh here and a scar on the right buttock there; here there
are other scars on his legs and there's a scar here which runs
from the neckline to the ear.' The horn causes an honourable
gash but it is also a mark of love, a signature, an irreversible
mutilation. A sign of belonging. Besides, the matador finds
it fearfully difficult to put his trousers on, they are very close-
fitting and must cling tightly to his hips, buttocks, thighs
and shins. The bull, who sometimes embraces them closely,
can hardly fail to be attracted to such an exuberant display of
pink, black or gold flesh. And this is exactly what happens.
But in a spiteful way the horn does not always penetrate the
flesh, it does not tear the buttocks, it tears the trousers. Which
is rather ridiculous but it does not necessarily cramp the mata-
dor's style. There is a story about Chinito, a French bullfighter
of Chinese and Polish origin, who one day was wearing a

costume in midnight blue. The bull took an interest in him and nipped his buttocks. The costume split open and Chinito, remaining indifferent and majestic, fought with bare buttocks. The horn frequently tears the trousers. I remember a photograph which appeared in *Le Monde*, showing trousers that had been very badly torn open in a V shape, from which the buttocks emerged in charming fashion. The newspaper had added the sober caption: *Paquiri's hand*.

So the buttocks can be knocked about with panache. They can display their gashes or scars proudly. They can also be perforated, but that is rarer. The recent fashion for piercing the body has shown that it has been fairly common to perforate the nostrils or the navel, the top of the ear, the breast, the upper lip, the lower lip, the penis or the vulva (that is, usually, the orifices which, as France Borel says, constitute the most primitive parts of the body) but rarely the buttocks or the anal orifice. So much so that the area of the body often thought the most shameful turns out to be the most untouched of any. Nothing is attached to it. However, in the seventeenth century John Bulwer noted this curious fact in *Man Transformed*: 'Among other strange decorative practices in various countries I recall a certain people, who, with a kind of absurd bravura, pierce holes in their buttocks from which they hang precious stones. Which must be a very uncomfortable fashion and highly prejudicial to a sedentary existence.' Bruno, one of the most famous tattooers in Paris, also quotes a woman client who wanted to have two gold rings attached to her breasts and, since she had a fairly prominent clitoris, she wanted a little gold chain, ten centimetres long, fixed on to it, ending with a small weight in the shape of an olive. To complete her equipment she then decided to have two other rings fixed to the lips of the vulva 'and to have fitted into her rectum a spiral shape in gold linked to a chain hanging down freely from the anus with a clasp at the end'.

However, the buttocks are regularly tattooed, for they form an area which is fairly discreet, fairly wide too and sufficiently fleshy for the operation to be less painful than on the feet and

hands. The word tattoo comes from the Tahitian *tatau*, an onomatopoeic expression indicating that incisions are made in the skin by means of repetitive little taps. So tattooing is a kind of tap-tapping, resembling the action of the sculptor's chisel, the skin is marked and perforated with thousands of tiny holes. When Captain Cook visited Tahiti in the eighteenth century he noted the great variety of designs used but added that everyone agreed that the buttocks should be entirely black. Black smoke was used to obtain this colour, and the other colours chosen were mixed with walnut oil. A piece of well sharpened shell or bone was used to make the incisions. Since this operation is painful, especially when the buttocks are tattooed, it takes place only once in life and is never carried out before the age of twelve or fourteen.

During the council of Nicea, in 787, the Church, having taken over from Leviticus the Jewish ban on this type of mutilation, forbade it as a relic of paganism. For tattooing implies something of fetishism and the worship of idols. This is even the case in Japan where the entire body is tattooed, with the exception of the head, the base of the neck, the forearms and the ankles, which apparently makes the skin as cold as the scales of a fish. In Europe, in what are called sentimental tattooing or pledges of love, the motifs, their choice and positioning, are fairly stereotyped and vary according to sex. Bruno found that boys prefer tattoos on the forearm, the biceps, the top of the shoulder or the left chest, that is high up on the body and clearly displayed. Young men can also turn their narcissistic gaze towards their own thighs, biceps or penis, followed by the words *I love me*. A girl, on the other hand, will choose to be tattooed on the hips, buttocks, stomach, pubis, thighs or sometimes the breasts. And rather than snakes, eagles, daggers and dragons she prefers swallows, sirens, sea-horses or palm-trees. The difference is clear: the boy wants to make his arm into a weapon, the girl aims to turn her buttocks into jewels, intimate and indelible jewels. So intimate that sometimes, in Japan, the vagina—lips and clitoris—is tattooed all over. Sometimes the private parts form

the jaws of a dragon whose body winds over the stomach. This is called concealed tattooing. It appeared at the end of the Edo period and remains rare. It is reputed to be extremely painful, for the clitoris can barely tolerate more than 600 or 700 needle-pricks a day.

Only the back, the largest single area of skin on the human body, makes monumental compositions possible. For example, a giant octopus in two colours, its tentacles grasping his legs and arms, once covered the back of an American doctor. But usually the buttocks are tattooed only because they are on the way to somewhere else, which does them no credit. Why not use the bottom's special layout, its mountainous slopes and its central cavern? Some tattoos show packs of dogs rushing over the shoulder-blades down to the lower back and plunging into the anus, or even a long black snake which winds its way into it. William Caruchet, in his book about tattooing and tattooed people, quotes the case of an inmate in a penal establishment who had arranged to have tattooed on each buttock a zouave in full dress uniform, their swords crossed. These two soldiers illustrated the patriotic slogan: No entry. In his novel *Mon frère Yves* (My brother Yves) Pierre Loti also describes a fox hunt that he saw tattooed on a crew member of a whaling ship which sailed across the southern ocean. It was traced in blue ink: the dogs and horses, the pack and the riders ran across the shoulders, galloping in a circle round the torso in pursuit of the creature, who had already half-disappeared into his earth. '"Ah, there he is, the fox!" cried the captain at the top of his voice, collapsing in satisfied laughter.' Buttocks are always delighted when anyone falls back in ecstasy and surprise at the sight of them.

Some tattooings could also be marks of servitude, signs of punishment. At the time of the slave trade a distinctive sign was branded with a red hot iron on each person's flesh, so that they could be recognised after any escape. 'They use a thin silver-bladed knife,' reports Father Labat. 'They heat it. They rub soot onto the place where they want to apply it. The flesh swells, the letters appear in relief and never fade.' Mutinies

by slaves were suppressed in the same way. 'Yesterday, at eight o'clock,' a French officer recounts, 'we tied down the most guilty slaves by their arms and legs, face downwards on the deck, and we had them whipped. Also, we had scarifications made on their buttocks in order to make them more aware of their misdeeds. After making their buttocks bleed we applied gunpowder, lemon juice and brine, all crushed and mixed together. We rubbed their buttocks with this to prevent the onset of gangrene and also to make their wounds more painful.' As for prostitution, it could only be exercised in secret during the whole of the Middle Ages, hidden from the authorities. The town of Ghent was particularly strict. Prostitutes and the women who organised them, the *maquerelles*, had their noses cut off, and the women's foreheads were marked with P or M. This badge of infamy could also be added to the arm or the buttocks.

Like scarification or body painting, tattooing aims at artificial emphasis, separating this or that area from the rest of the body. This fetishist concern can only be of benefit to the buttocks and their entire area. In Benin the inner thighs of little girls reveal delicate lozenge-shaped scars: they are markings destined to protect their virginity, and in the local dialect they mean 'keep hold of me', for the tattooing mounts guard round the sexual area. This is not always the case, as shown by the spiral-shaped decorations painted directly onto men's buttocks by the American painter Keith Haring. These decorations do not merely enhance the buttocks, they invite you directly to pierce them with an arrow. However, the Makasin people, who live in the south of Kordofan, in the Sudan, do not give the buttocks any special treatment. They decorate the entire body for ritual purposes with large abstract motifs, but the buttocks can be picked out at first glance, as though these decorations enlarged them.

For it is the custom of the Makasin to cover them with ash. This applies to the men, obviously, and among them the wrestlers, the *kaduma*. The women apply groundnut oil to their buttocks, especially during the full moon period, when

the *okou* dances begin. Facing these protuberant hard buttocks, which look like bronze kidneys and can be seen in profile against the sky, the men's buttocks look dusty, resembling pieces of pottery. They have the same hard, dry, dense quality and resemble their heads, which are as smooth as a pebble. The Makasin men rub their bodies from head to foot with shrub-ash which adds a delicate grey-blue tone to their anthracite-coloured skin. Each man becomes a tall statue of pumice stone, on which he draws a whole series of lines and ornamental motifs, using milk beaten up into cream, which restores the original colour of the skin, as though it had been painted on chalk. The Makasin buttocks rely on illusion. The sight of a tall man working in his sorghum or tobacco field, with his back bent and his bottom facing the sky, causes deep artistic emotion. For while ash is invigorating, cleaning the skin, warding off insects and parasites, it also confers beauty. Ashes are given to victorious wrestlers in tournaments, heroic ashes. In this way the buttocks become the idol of all the Nuba tribes and are close to divinity.

Phantom

Although the buttocks may swell or shrink, grow heavy or hollow, these are not the ups and downs of a saturnine temperament. They express no state of mind, like hands, lips or eyes, they reveal no particular emotion, they are in fact fairly indifferent. Is it due to some particular indolence, or some kind of profound *accedie*, the word they used in the Middle Ages to describe a 'paralysis of the soul faced with an insolvable situation'? The reality is this: they trot along, they quiver, sometimes too they collapse, they might seem discouraged, but no, they have no pride, no jealousy, no sulkiness, they have nothing. The buttocks are silent and even rather stupid. What they express is precisely their indisputable presence, their monstrous opacity. And we are really stupid to fall for something that gives us back so little. We are stupid to glorify them with unimaginable mysteries which do not exist, to see in them countries, swelling seas, packs of animals, deserts and what else?

That is the verdict of those who are no friends of the buttocks.

And that is not all.

Since the buttocks are deaf and dumb, they never know how much they are liked or how far they are detested. Some

of them, but not many, have a soul. Some people believe that buttocks which have a soul are the most alarming of all, but analysts do not share this opinion. Their secret preferences are for buttocks that are stupid, ignorant, unaware of themselves, crudely carnal. That is how they want buttocks to be.

Should one believe in their fidelity? What a mistake! They always escape you, they always betray you. Sometimes hands try to cling together, as on a rock face, and then they slip and scratch themselves. Of course there will always be extremists who want to prove they can attack the north face of humanity and win their bets. But most of them prefer to give up, or what is worse, persuade themselves they have vanquished the buttocks. But it's not true.

Yes, they are compact, smooth, flattering masses, and we don't know precisely what they are made of. Some people think they are nothing in themselves, they are only an illusion of our senses and don't exist any more than the 'ghost-mushrooms' dear to the writer André Dhôtel. Might the buttocks be phantoms? Observe, for example, a pair of haughty and well-shaped buttocks; their owner turns round and the face above them is mediocre. The buttocks have disappointed you. They no longer have so much charm. Buttocks suffer greatly from the face, but the reverse is never true. So buttocks are not always necessary for love. As Michel Tournier remarks, 'there is an infallible sign by which you can tell that you're in love with someone, it's when their face fills you with more desire than any other part of the body.' So one can only regret that fine buttocks do not match the head that is above them. If in fact the buttocks constitute a second face, one should sometimes avoid the first one.

In fact the buttocks are inconstant, scatterbrained. When you see them at close quarters they can look stupid, unsure of themselves or even a little worn. And then they move away, you can't catch up with them and the crafty things suddenly come to life, they take off, they become dishevelled, they behave like a compass dial. You might also think they are glad to have escaped your glance and your ascendancy over

them. But not at all, they're walking away. And what you see most clearly, from a distance, are the lines of force, two vertical, two horizontal, the shaded lines that model their shapes. So buttocks are much more attractive from a distance, for they make you believe in their mystery. Only they are far away.

Buttocks play with light in a rather skilful manner. They play with the weather. They play everywhere. And we are utterly silly to be moved by them. Think of poor Honoré, in *The Green Mare*, faced with Adélaïde's illusions. She was kneeling on the floor, with her back towards him and her posterior raised, concealing her head which was low down between her shoulders. Honoré was surprised by such a large rear, which he now saw for the first time, since he had always deplored Adélaïde's lack of flesh in that part. 'The black petticoat moved slowly, with vague undulations, causing the dark shadows at the back of the kitchen to move slightly. Honoré looked hard at the dim shape which he could not see in detail because of the darkness. He was disturbed by a strange presence, an unhoped-for substitution. Adélaïde had picked up her brush again; she suddenly relaxed both arms in order to scrub the floor; at the same time her posterior vanished as she leant forward, but reappeared again at once through a rapid movement in the opposite direction which brought her back onto her heels again. Honoré couldn't get over it.'

These are to-ings and fro-ings that drive you mad.

In the same way, when a woman is bent double, the part of the body between the head and the waist doesn't correspond to the part between the waist and the feet, so there are two women in one, and the extraordinary volume of the buttocks is suddenly reminiscent of Mallarmé's 'crazy elephant'. Some people get out of this situation by a kind of mental pirouette, finding something poetic and legendary in this disproportion between the upper body and the behind, the powerful thighs with their strangely animal quality and the slender torso, long-drawn out, vegetable in nature, stippled to a point. These people say they are bewitched by this blend of unicorn and

lioness. But those who do not like buttocks refuse to become half-witted through looking for the woman. For them the buttocks are not the first requisite of happiness, nor even the path to wisdom. So they prefer to forget them.

Cleft

What are buttocks?

The Greeks defined them mainly through their density, their mass, assimilated to a ball (*gloutos*) or a tubercle (*pugé*). The Romans saw things more or less the same way, describing the buttocks by the word *nates*, which has been compared to the Sanskrit *nitambah*, signifying the slope or rear side of a mountain. It was the Latin word *nates* which led to the terms *naches* or *nages*, used in France until the sixteenth century and long afterwards by the leather-dressers. The term was used to describe the part of the skin which goes from the paw to the tail. Butchers used the word also: in Normandy it meant the buttocks, in beef, and in Paris the slice called 'the little bone'. In fact, since the Byzantine Empire, there had been a serious competitor, the vulgar Latin *fissa* which produced the French word *fesse* (buttocks) about 1200 and came from the classical Latin *fissum*, the cleft. Modus, in the fourteenth century, distinguished the *naches* (the fleshy masses) from the *fesse*, which is simply the cleft between the two *naches*. But the *fesses* won and the word which since earliest times had usually been considered as meaning full and globular came to signify the void.

Which seems to defy common sense, particularly since the

buttocks constitute the biggest mass of flesh in the human body. But that is how it is: the buttocks (*les fesses*), through their exorbitant positive quality, have taken on the word *fissa* which mistakenly described a totally discreet and negative reality. If you consult the dictionaries you will not find a word about the cleft in the definition of the buttocks, which is unfair, to say the least. Furetière speaks of the 'fleshy part which is at the back of the human body', and the recent *Trésor de la langue française* (Thesaurus of the French Language) of 'the two fleshy eminences formed by the muscular-adipose tissue situated below and behind the iliac crest.' To sum up: the French word for buttocks, *fesses*, was derived from the word for a cleft, but has done everything possible to deny it. And since it has succeeded, nobody utters a word. Does that mean that the buttocks are ashamed of their origins?

It was surely difficult to deny the existence of this primordial cleft and the official term *entrefesson* was used. This should not be confused with *entrefesses*, which according to Littré is a term used in butchery to signify the part of the cow between the buttocks, behind the udder. Some nicknames have been found, such as the groove or the furrow between the buttocks. These are agricultural metaphors, for the furrow was originally the furrow traced by the plough, which at least shows that it is really the cleft that creates the relief within the buttocks. Before there can be mounds and projections some importance must be given to the depressions, hollows or excavations. The cleft moulds the buttocks. Without it the buttocks would be a blind man, an opaque conglomerate. The cleft therefore is not an irregularity in the terrain, it is the origin of its geography.

The best things in the human body always come in twos. This is at least a commonly held belief and it is precisely the case with the buttocks. There are of course cases of physical monstrosity, in which the buttocks are not simply twinned but Siamese. The story is told of a Chinese emperor who fell in love with a woman who was double: she had two heads, two breasts, two hearts, two arms and two buttocks, which

may sound harmonious but is nonetheless horrible. Yet nobody has ever seen a human being with three buttocks and it is not clear where such an anomaly could be placed, even by Dali. So if it is not wrong to speak of a fine pair of buttocks, it is rather silly. There remains the case of the missing buttock, as though the *derrière* has lost an eye. The single buttock has disappeared, but we know that it existed in the past, its ghost is still visible. This single buttock creates an irritating lack of balance in the mind. The phrase *n'y aller que d'une fesse*, as though moving with only one buttock, is employed in the French language to signify limping, but also to mean doing something without enthusiasm, without much conviction, showing an ill grace. 'All enjoyments are not alike,' wrote Montaigne, 'there are some that are etic (=etiolated) and languishing: a thousand other causes beside good will may provide us this favour from the ladies; this is not a sufficient testimony of affection. Treachery may lurk there as well as elsewhere: they sometimes go to it by halves, *d'une fesse.*'

If the buttocks exist in twos, the right buttock is not usually distinguished from the left. There is no 'inverted symmetry', as they say, as in the case of the hands or feet. Buttocks are identical sisters, regular protuberances which provide an impression of order and balance. They are not an anarchic excrescence like the penis, which is more closely related to the narwhal's horn. Like the breasts, the buttocks make their appearance immediately, contradicting all the platitudes of the body and asserting proudly that one could not exist without the other. The central cleft which separates them (the deepest cleft in the human body) throws a kind of bridge between the two hemispheres, thus allowing the hand to travel from one pole to the other across the planet.

The avant-garde Spanish writer Ramón Gómez de la Serna (1888–1963) told how a rich connoisseur was looking for a pair of breasts which did not need to be identical but had to be at least similar to each other. He was shown a vast quantity of 'beauties, subtleties, agilities'. The seller of breasts became impatient and suggested in the end that he should 'call in an

expert who would make geometrical calculations and prove that they were as equal *as the two halves of God.*' Do there exist, like the breasts on offer, unequal buttocks? It is something to think about. The Madrid writer notes further that the left breast is close to the heart and therefore more lively than the other and is always the first choice. The same is not true of the buttocks, naturally. The left buttock is a very long way from the heart, it may never have heard it mentioned. Therefore it inspires nothing in particular. When you grasp the left buttock you have only one wish, which is to grasp the right one too. You like to have both hands occupied. All the more so because they are just at the level of the buttocks, they need make no effort to take hold of them and burrow into them in amorous fashion. So if there is any inequality between the buttocks these cannot be natural inequalities, it is because they have not led the same life. In a passage in *Noa Noa*, written between 1891 and 1893 in Tahiti, Gauguin, who only ever loved women, was suddenly disturbed by the beauty of his young friend Maori. He used astonishing phrases about it, even if in Tahiti sexual differentiation is less marked than in most places. 'I had a kind of presentiment of something criminal, the desire for the unknown, the awakening of evil' and 'His little animal-like body was graceful in shape, he walked in front of me in a sexless way . . .' If breasts supply evidence of femininity—although in the recent past there have been many imitations—buttocks on the other hand supply no identification for anyone. They might even introduce doubt and ambiguity. What exactly is involved? That is precisely the question one asks when confronted with the mass of a beautiful bottom. For if buttocks differ globally between men and women they often have no specific type. So much so that certain people, like Sade, made a religion of going from one bottom to another, without paying any attention to the sex, provided they had the bottom. In short, the bottom excludes any preference for one type. And if you make love by means of the buttocks you never really know where you will end up.

People have often moved mechanically from breasts to

buttocks and from buttocks to breasts, as in that famous scene in *Le Chien Andalou* (1928) in which the man who has been blinded shapes the breasts of a naked woman, which then turn into buttocks, then again into breasts, like a living statue which dissolves beneath a caress and constantly vanishes. But nobody, before Pierre Molinier, had thought up this disconcerting simultaneous image, this incredible synthesis of a vision in black stockings revealing buttocks and breasts at the same time. Rather like cathedral gargoyles or the vegetable-men by the nineteenth-century French caricaturist Grandville, Molinier had produced trick photographs (in which he posed himself in disguise), puzzle-pictures of women cut in two, then put together again the other way round, their chests and rears superimposed on each other. An unexpected comparison which places women's posteriors in front and restores to their bodies that enthusiasm and turbulence which some people find 'indecent to see'. Molinier's woman is tortured but at least she is complete. With her buttocks representing a gigantic swollen heart, one can even allege that she has feelings. He gave her the delightful name of *Flower of Paradise*.

One detail that cannot be overlooked is that, unlike the breasts, the buttocks have no knob or nipple at their tip. They contain no special milk that can be sucked. They are dry. Deprived of those little curls resembling the tendrils of the vine which taste bitter, like nipples. Even 'half-blind tits', as Rousseau used to call them, that is to say the slight breasts which are retracted or concave, leave something in their wake. Buttocks, however, leave no trace of this kind. They are bare slopes which invite us to descend them, thanks to this crevice or crack which actually has another equivalent in the human body. Not the vulvar cleft, which is more similar to the mouth, since it separates the inside from the outside, air from earth, but the furrow between the breasts, *l'entre deux seins*. This is simply because it is not so much a cleft as a corridor, a pass. But if there is nothing at the end of this furrow between the breasts except bone, the buttocks announce a subterranean well which some people have compared to a rose of flesh,

erectile and vibrant. While we would find it ridiculous or even ghastly if breasts and buttocks appeared to turn their backs upon each other, we are aware that they mass and jostle against each other in order to bury their secrets and emphasise the fullness of their shapes.

There is another thing that allows comparison between breasts and buttocks—the fact that they stand half-open, ajar. There is a notch at the estuary of the breast and buttocks, a sinuous, disturbing and smooth outline to the joint, that subtle depression at the edge of the perilous abyss. Michelangelo was one of the painters who paid most attention not only to the cut of the buttocks but also to that gulf-like cleft, its entrance marked by the celebrated flight of a black seagull or else by the circumflex accent in reverse. And then there is the shadow of this slope, where you can slip. For between the soft and granular skin, as smooth as a child's cheek, there is that humus-like cleft, that shadowy cleft which serves as a mane to the buttocks. 'Pubic hairs,' Pope Gregory used to say, 'are the visible sign of carnal sin which make the soul bristle.' And is it not already a sin, that profound darkness, the darkness of the orifice, darker still than the shadow within the eyes of sculptured marble heads, the shadow of the iris?

Why are men so attracted to women's legs, if not because they tell themselves quietly that higher up, at their juncture, they open out? The arms are joined to the trunk in the same way, but the arms do not separate like the legs over a kind of circular mystery. Circular because it is closed off. There is a mystery precisely because there is a closure and we know nothing. We have a presentiment but we do not know. And it is the buttocks which surround and clothe this mystery in a particular way. A mystery that is sealed in. What is beyond that seal? The origin of the world, which is the title of a famous painting by Courbet, executed in 1866 for the Ottoman ambassador Khalil Bey, who had made the painter himself conceal it behind a landscape showing a church in the snow. What do we see? A headless woman's vulva. A beast without a head. A sublime inter-thigh space—belonging no doubt to

Joanna, the beautiful Irish girl—sufficiently wide for the fold which prolongs the cunt as far as the bottom to open out. The scandalous thing about this picture is precisely that 'seraphic cleft' described by the French anthropologist and writer Michel Leiris. That continuation of the rectal fold to the narrow slit of the vulva; that enormous cleft going round the female body, shown by Picasso in drawings between 1965 and 1971 as an exclamation mark formed by the juxtaposition of the fissure and the rosette of the anus.

In his novel *The Man Who Looks*, the Italian writer Moravia tells us that the voyeur eyes not only what is forbidden but what is unknown. What he looks for in the cleft or the gap, with 'ardent curiosity and profanatory challenge', is very close to what the scientists are searching for. Look, he says, at the comparable terms of fission and *fente*, or cleft. The scientific operation which led to the discovery of atomic energy implied an initial 'splitting', a term which can be applied equally well to the atom as to the female sex. In both cases there has been the discovery (in the literal sense of uncovering of something that had so far remained covered up, hidden) of a solemn mystery of nature. The mystery which from time immemorial has enveloped the composition of matter as well as the origins of life. So it is not entirely by chance if the profound mystery of the buttocks (and of the vulva) arises precisely from the split they embody. Except that in the case of the buttocks there is an inverted mystery, a *trompe-l'oeil*, diabolical mystery that concerns not the origin of things but their end. Apollinaire, in a poem dedicated to Madeleine Pagès, called it the *ninth door*, more mysterious than the others, the 'door to magic spells that one dare not name'.

Spanking

The verb 'to spank', meaning to beat the buttocks with the hand or an instrument such as a cane or a slipper, dates only from the early eighteenth century and probably derives from the sound of the action being performed. The French word, *fesser*, however is derived from the Old French *faisse*, or *fece*, which came from the Latin *fascia*: a bandage, a fillet on a column, a ribbon, a brassière, webbing on a bed, all the things that restrict humanity. *Fesser*, in 1489, meant quite simply to beat with rods. It is only later, through its similarity with *fesse*, the French for buttocks, but also through the situation, that *fesser* came to mean spanking. This is suggested in Max Ernst's painting entitled *The Virgin Punishing the child Jesus in front of three Witnesses: André Breton, Paul Eluard and the Painter* (1924), where the Holy Mother of God is going at it hard. But after all, as one of the songs by Gaultier-Garguille ran: 'Spank away, spank away, the mother said, the skin on the bottom always grows again.'

For the writer Anatole France, spanking was the best way of 'inculcating virtues through the bottom'. It is true that if the hand appears better placed than anything else for this enterprise, some people have not hesitated to resort to other expedients: nettles, handfuls of thorns or the knout. The

nineteenth century French children's writer the Comtesse de
Ségur obviously remembered the moujik victims of the knout
in the Russia of her childhood. In one of her stories, *Un Bon
Petit Diable*, the illustrator even improved the situation. The
little boy is wearing a kilt and we are allowed to visualise a
skirt pulled up by the unpitying little whip. The Comtesse,
who had not anticipated this improvement, apparently
accepted it quite easily. She is not very explicit about her
punishments. 'The suffering was brief but terrible,' she writes
in the same book, when Maria Petrovna, another great
spanker, became the victim of the smiling Captain Ispravnik.
Unlike the Divine Marquis the Comtesse did not describe her
thrashing in detail, she preferred simply to announce it. But
the humiliation and fury that were felt were always extremely
deep. She wanted the beating to go on for a long time, until
the rod broke across the back and the buttocks were covered
with red stripes. It is a good thing, one reads in *Les Petites
Filles Modèles* (The Good Little Girls), that other children, a
long way off, should hear 'the howls and pleas of the little
girl who has been a thief'. That at least is what is called a
spanking. Some teachers (whom Leiris calls the profiteers of
spanking) found in it the source of a vocation: in the old Jesuit
establishments there were Brothers responsible for the public
beating of schoolboys who had behaved badly. They were
called *les frères fesseurs*, the spanking monks or the bum-beaters.
 As one of Béranger's songs said:

> We are the men who spank,
> Who spank them again and again,
> The dear little things, the dear little boys.

Spanking and bottoms clearly felt a close affinity with each
other. Truly love at first sight, one could say. What is more
tender, more passive, more blindly confident, more destined
to blows and obscure devotion than the buttocks? A smack
on the bottom is like a blow (French *gifle*) on the cheek, and
in French the connection is very close, since the word *gifle*,

from the thirteenth to the seventeenth century, meant the cheek. So the *gifle* emerged from the cheek, like a boil. So much so that the *gifle* expressed quite naturally a blow on the cheek with the palm or the back of the hand. This close connection between the buttocks and the cheek is by no means accidental. They are often brought together in the same act of admiration: 'cheeks like buttocks' or buttocks like cheeks waiting for a blow. Spanking knew its greatest vogue in the seventeenth century. Everything was spanked, beaten or thrashed: schoolboys beat their copybooks, coachmen thrashed their horses, unscrupulous abbés beat their breviaries, if not the Requiem, while young women, charming but slightly intoxicated, beat their champagne bottles wonderfully well, Regnard tells us, and at the end of the meal they became very affectionate. As for the heavy drinkers, they would beat their lady friends, which was less compromising than strangling some young girl or suffocating a negress. Society in Louis XIV's time was in a hurry, they let it be known in impertinent style and preferred to thrash life rather than wait for it.

A majestic thrashing, like a patriotic thrashing, is invariably presented as a pleasure for the person who carries it out. It is a modern feeling, dating apparently from the eighteenth century, that it can also cause pleasure to the person who undergoes it. Consider Catherine de' Medici and the use she made of spanking within her flying squad. In May 1577, at Chenonceaux, she had given a banquet at which, Pierre de l'Estoile tells us, the most beautiful and honourable ladies of the court, who were half naked and had their hair loose like brides, served at table. Brantôme, always on the lookout for this sort of detail, explained things: this queen who was not satisfied with her natural lasciviousness, for she behaved like a prostitute, 'in order to arouse herself and feel more excitement, had the most beautiful among her ladies and girls undressed, and enjoyed looking at them very much; then she spanked them on the buttocks with the palm of her hand, with great blows and fairly rough handling, while the girls who had committed any wrong were beaten with sound rods;

she then enjoyed seeing them move, their bodies and buttocks writhing in strange and entertaining ways under the blows they received.' On other occasions, added Brantôme, 'without having them undressed she had them pull up their skirts, for at that period they wore no drawers, and she struck and whipped their buttocks according to the effect they had on her, to make them either laugh or cry. And after seeing all this her appetite was so much sharpened that she often passed them on advisedly to some very strong and gallant man.'

What a way for a woman to behave! sighed Brantôme.

During the Revolution the bottom-spankers may have had the same ulterior motives. For example, a print dated 1791 shows the flagellation of a Grey Sister. The crowd are standing round, some of them equipped with lorgnettes, others prostrate before what we have to call a bottom 'in majesty'. For the nun, whose face has disappeared into the dust, offers people her buttocks as a monstrance, embellished with a radiant sun, or like a sunflower, or quite simply a miracle from heaven. As a little couplet underneath points out, the nuns were pursued everywhere, in the dormitory, from cell to cell, in the chapel and in the cellar so that they could be flagellated unashamedly and unscrupulously, sometimes until they bled. This type of public humiliation was very widespread during the Terror. It is known that the early would-be feminist Olympe de Gouges had a lucky escape, but Théroigne de Méricourt, whose ideas were similar, was truly whipped, in May 1793, on the Terrasse des Feuillants in the Tuileries by 'Jacobin shrews'. The untimely arrival of Marat, the god of the citoyennes, interrupted this dismal episode, but as the historian Michelet said, Théroigne had become a 'disgusting creature', went mad and was locked up in the Salpetrière.

Anticlericalism fitted in rather well with lewd behaviour, and if some people, as the *Père Duchesne* said, really wanted to introduce patriotism into the souls of these old women and young bigoted nuns, as they had wanted to teach aristocracy to young schoolgirls, the public were there for the entertainment. Some of them even drew up a very bawdy inventory of all those

accumulated bottoms. Here then is the list of the ecclesiastical behinds whipped by the ladies of La Halle and the Faubourg Saint-Antoine in 1791:

'The Recollects [nuns] of the rue du Bac presented sixty dried-up, yellowish bottoms; they looked like mouldy pumpkins.

'With the Daughters of the Precious Blood things were very different: bottoms as white as snow, well rounded. A citizen who was in the crowd was certain that the prettiest bottoms in the capital were whipped here. The Grey Sisters from the parishes of Saint-Sulpice, Saint-Laurent, Sainte-Marguerite, La Madeleine and Saint-Germain l'Auxerrois were not spared, and rightly so, since those Béguines were tactless enough to display only bottoms that were terribly ugly, as black as moles.

'As for the Daughters of Calvary, they displayed in broad daylight plump brown bottoms, which one could really have assumed to be patriotic, if they had not been covered with a black petticoat.

'According to an exact account, 621 buttocks were whipped; total: 310 bottoms and a half, since the treasurer of the Miramiones had only one buttock.'

Can grace be received through the bottom? Apparently yes. It is to Rousseau, it seems, that we owe the first spanking to cause pleasure. It happened in 1723. He was eleven years old then, living at Bossey, near Geneva, with Pastor Lambercier, when one day the pastor's daughter spanked his bottom. And strangely this punishment made him even more affectionate towards the girl who had inflicted it on him. 'I had found in pain,' he wrote in the *Confessions*, Part I, 'even in shame itself, an element of sensuality which made me want rather than fear to experience it again from the same hand.' But the second spanking by Mademoiselle Lambercier was also the last, for when she saw that the punishment inspired so little fear, she

declared she would not carry it out again, it made her too tired. Which upset Rousseau deeply. For he felt he was the victim of 'this strange taste, always there and taken to lengths of depravation and madness.' There followed a whole page of intimate confessions during which he admitted that this childhood spanking was to determine his tastes and passions for the rest of his life. 'To be on my knees before a commanding mistress, to obey her orders and ask her forgiveness were very delightful pleasures for me and the more my lively imagination inflamed my blood, the more I looked like a bashful lover.' In this kind of situation the progress of love is fairly slow, but the heart matures slowly also, its mortifications are infinite and its sufferings countless. Freud, as we know, described this painful stimulation of the buttock area as 'one of the erogenous origins of the passive tendency to cruelty.'

During the eighteenth century flagellation was current practice. Not only in the convents where 'the saintly sisters delighted in punishing their pupils, just as the saintly fathers usually dealt with theirs', but most of all in libertine circles, where it became part of the arsenal of sensual pleasure. During the Marquis de Sade's lifetime there was in Paris the Club des Verges, the Rod Club, and women flagellated each other with 'a delightful elegance'. We know that it was after an incident of this kind with a beggar woman called Rose Keller, who was locked in, undressed and beaten with rods, that Sade was imprisoned in the Château de Saumur. With Sade spanking always leads to the worst kind of disorders, but unlike the case of Rousseau it did not create a destiny. It even tended to shorten life fairly quickly. Sade moreover worked out a theory of spanking. 'There is no passion,' said Clairwil in *The Story of Juliette*, 'more delightful to me, there is none which inflames my entire being with more certainty.' We must distinguish between passive and active flagellation. Clairwil said she approved of both varieties. The former was more effective in 'restoring strength reduced by excess of sensual pleasure', it quickens the blood, supplies warmth to the organs of generation, greatly invigorates the emission of sperm and even

increases lewd enjoyments beyond the natural boundaries. As for the second, it is a form of torture which allows the person who inflicts it on 'a young, attractive and gentle creature' to be 'entertained by their weeping, have erections caused by their misery, to be angered by their leaps, inflamed by the jerking of their bodies, by the voluptuous twists and turns provoked in the victims by their pain, drawing blood and tears'—in short to 'relish the contortions of pain on their attractive faces, and the muscular spasms caused by despair' while 'drinking with his tongue those floods of red blood contrasting so well with the soft lily-white skin'.

With Sade one doesn't know where spanking ends and crime begins. For the buttocks are torn, bitten, lashed, flagellated and cruelly mauled, beaten with thorns until they bleed, beaten too with a small whip, its thongs tipped with steel, caressed with great stiletto blows, spanked with red-hot tongs, cut with an iron comb, in other words there is no escape. Beating is short for murder. Sade even imagined, in *The New Justine*, a 'very ingenious' machine which dilated the flesh in order to shed the blood profusely. 'There, with the women tied down full-length, by means of a spring you could push their legs and thighs as far apart as you wanted and bend the upper part of their body down to the ground. You placed them on their stomachs, then their lower backs and their buttocks were raised to a great height, and the skin was stretched so tightly that after fewer than two strokes with the rods the blood poured out.' Spanking, at its worst period, had no other aim: 'blood [had] to ooze out from everywhere.' The flesh had to be turned into a pool of blood. Since that time we have come to regard beating as a much drier operation.

Presenting one's buttocks humbly forward has always been described as a gesture of appeasement, even among the apes. But in some cases a humiliating posture is not enough, sometimes one needs to display obvious signs of humiliation. It is mainly children who have experimented with this concept. And they do so still, here or there, despite certain legal precautions. Spanking has divided world opinion in two for a

long time. The question is, how should the spanking be carried out? With the hand, insists the writer Tony Duvert. 'A bare hand and bare buttocks achieve perfection in this field.' It is not usual to spank each buttock separately. It is not a question of beating one and then the other, you beat across both of them at once. The blows administered should compress and shake up both buttocks with firmness and speed, 'with all that is beneath them and everything that imbues their fat and skin with this pleasant and fluid grain, this luminous perfection that has killed off all the painters who have contemplated it.' In fact these smacks, slaps or shakings are concerned principally with the cleft, the division between the buttocks. And willy-nilly they come together like a seismic shock or the trembling of a jaw over the child's anus, which is a ring like the tyre on a little car, its suspension at that age being especially adaptable and labile. The entire nervous system will be stimulated by these stinging vibrations and the genital organs will be definitely aroused, sometimes even calmed. So, Duvert concludes, spanking is or should be a pleasure. It is close to sodomy. Only the axis of the blows is different: spanking is tangential, sodomy is radiant. In both cases it is a form of passive masturbation. Someone is interested in your fate, in your body. And in current slang punishment is called *une branlée*, wanking. Which is to say that beating is not always as barbarous as people maintain and can even seem particularly cordial.

No, not at all, in any situation and on any pretext, should one spank children, replies Jacques Serguine, in *Eloge de la fessée* (In Praise of Spanking). And why not? Well, in the first place there is no room. 'Their bottoms, which are very attractive, are still so small, you see.' In the second place, it hurts them. It has to be said that Serguine is a monomaniac about spanking. He too has evolved a delightful theory about it, which applies particularly to the woman he loves and who loves him. Of course he has not adopted this habit of spanking in order to punish her, and he objects strongly to the proverb which runs: 'Beat your wife, even if you don't know why: she

knows why.' No, it's not to silence her, triumph over her or humiliate her, it's in order to love her more. This beating is not for restraint but for acquiescence. A beating, says Serguine, is only one of the gestures of love. For the *derrière* in general, and that of his wife in particular, dazzles him, amazes him. 'It could be said that it leaves me thunderstruck, it's sparkling and soft, it unleashes my hunger and thirst, in fact it drives me into a rage. It turns me into a madman, a creature who has been turned inside out, like a rabbit being skinned, a cannibal.' That is what he says. As for knowing whether he would agree to being beaten in his turn, Jacques Serguine notes somewhat soberly and without great enthusiasm: 'If ever the woman I love decides to do so, well, why not?' In any case he doesn't believe that one should carry out a spanking just like that, on the spur of the moment, on an impulse. It should be done in accordance with extremely precise rules which he has drawn up in order to transform spanking into a work of art.

In the first place, when should you spank? The best thing is not to spank in a moment of anger, for spanking depends on feeling, not ill-feeling, and you should not spank in too irregular a fashion. So he decided to spank his wife every Friday. Friday, he says, is a good day.

What position should one adopt? Simple: the woman has only to turn over, or he can turn her over himself, like a warm pancake. He places her on her stomach across his knees. In this position her wonderfully spherical little *derrière* stands up in an unforgettable, harmonious and provocative fashion. As for her, she tries to get things on a more equal footing but in fact she is secretly delighted.

What about her knickers? For, according to Serguine, the woman one beats should be neither dressed nor standing, but neither should she be naked, that is totally naked. 'It seems to me clear that the purpose and meaning of the spanking depend on the act of leaning over, bending down and on the act of undressing: I mean, to be even more precise, partially undressing the part involved in the spanking.' He is very

demanding too about the fabric and the colour of those 'catastrophic, confusing, overwhelming little knickers.' He wants the fabric to be as thin as possible, but not transparent or barely so, as soft, plain and smooth as possible: that, he says, is what suits his meticulous madness. For in this way it imitates, or at least does not insult the velvety moistness of the skin. In any case, the most erotic colour, in smooth fabric at least, rather soft and silky, remains white.

How should one undress her? First of all by pulling down those tiny knickers, as though one is removing, with exquisite suffering, a layer of skin from one's own heart. Take care not to remove them completely, so that they can go on serving as a frame or a case for the *derrière*. Many other people have insisted on the importance of what surrounds the buttocks, whether it consists of stockings, leather thongs or the garland of thorns as in the case of Sade's Juliette. The surroundings of the buttocks supply them with a halo. 'So,' writes Serguine, 'inserted between the halo and the other little crumpled rolled-up skirt, the dazzling and moist *derrière*, pale and radiant, seems to be offered in entirety, almost tense, at once innocent and provocative, weak and tender like children, and, like them also no doubt, unspeakably proud and perverse.'

After the knickers have been taken down, how should the spanking be administered? As simply as possible, moving from one part to the other of this delightful *derrière*, from top to bottom, from left to right, cheek against cheek and so on. One then reaches, says Serguine, the very moment when the woman one is spanking begins to cry. These feminine tears are the irrefutable proof that the spanking is a success. There are others: the sound first of all. A woman's *derrière* is certainly not a drum, but the spanking should provoke certain sounds. She can respond to them by uttering a brief stifled cry. Then comes relaxation, abandonment, the moment when the woman accepts the spanking and loves it: her behind softens, and opens out too, very calm beneath the stinging rain of blows. Finally, and above all, this graceful and disturbing bottom becomes scarlet, it assumes the velvety and burning hue of a

light-coloured raspberry in the sunshine, which makes
Serguine say that he can still feel this spanking in his hand.

This is the moment when one gathers up the woman in
one's arms, when quickly and carelessly one undresses her,
when one throws her down anywhere flat on her back or on
her stomach, when the man's sex can burrow right into those
dunes of yielding and voracious flesh that the spanking has
brought together.

There is one more resource, the hairbrush. Unlike Erskine
Caldwell in *God's Little Acre*, Serguine regards its use, of
Anglo-Saxon origin, apparently, as totally heretical, whether
you use the handle or the bristles. For the hairbrush only
retains the flagellant and repressive aspect of a spanking,
depriving it thus of its carnal side. No, spanking is carried
out with the hand, everyone agrees on this point (except in
Singapore, where it is still used as punishment with the birch).
Brisk or not, prolonged or short-lived, a spanking should be
somewhere between a blow and a caress, one could allege that
it begins and ends half-way between the two as though it
began and developed on what medicine calls the threshold of
exquisite pain.

The Three Graces

The Three Graces are generally thought to be the three daughters of Zeus. Hesiod called them the Graces with beautiful cheeks: they were Aglaia, Euphrosyne and the lovable Thalia. They personified life-enhancing grace and beauty. That is probably why people lost their heads over these three young women: they were sculpted in marble in the Hellenistic period, and a copy of the sculpture can be seen in Siena; they appear again in a fresco in Pompeii, and Renaissance painters felt passionate about them. In the early stages these nymphettes were shown wearing clothes, but it wasn't long before they gave in and took their clothes off at the first sign of a breeze.

It is uncertain where the idea of the Three Graces originated. It could be that they were once a row of dancers with their arms on each other's shoulders, one facing forward, the next with her back turned, a fairly common motif in Greek choreography. An artist would have then had the inspired idea of just taking three figures from this row and grouping them in a tighter, symmetrical composition and presenting them as Venus's charming companions. With one a little to the left, another a little to the right, these young girls could then have their anatomy admired from every requisite angle, and with their bodies intertwined in various postures: a left profile, a

three-quarter view, a right profile could show off the female form to its best advantage, with the buttocks carefully positioned in the centre of the composition. Of course it was also a clever device for a painter, with only two dimensions at his disposal, to compete with sculpture, by giving the onlooker the illusion of looking at one and the same woman from every angle at the same time, as if she were being reflected by mirrors. For it is quite a tease not to know whether you are looking at three identical women or one woman shown as three different ones. But satisfaction was inevitably achieved the moment they uncovered the most indiscreet and unmentionable part of their anatomy. However, despite the rather chaste treatment they received from Renaissance artists, the Three Graces were most often used in Italy as a brothel sign.

The dampness of the drapery did much to enhance their beauty as one can see in Botticelli's Graces in *Spring* (c. 1478). The folds of transparent material clinging to their flesh accentuate not only their contours but also their swaying movement. The Florentine painter's Graces, which are reminiscent of the Ancient Greek Maenads, have bodies that seem fluid and quite naked. Their buttocks are not magnificent, but rather angelic: the buttery flesh of archangels. Kenneth Clark spoke of a 'melody of celestial beauty'. Maybe. But the fingers of one of them are dangerously close to another's sexual parts. However, it is only a question of the lightest of touches, a cascade of undulations, an ethereal sensuality, for it is a breeze that gives them movement and water that makes them beautiful. These girls are barely touching the ground and their attention is entirely on each other. So it is not such an unworldly music as Clark would have us believe. The bottoms of Botticelli's Graces are bottoms which in themselves seem to be inspiring them with desire. In Raphael's pictures, however, as indeed in Correggio's, the owners of bottoms seem definitely to have abandoned music in favour of food. They are plumper.

Correggio's Graces (c. 1518) still have a certain feeling of movement; with their long twisted tresses flying in the wind, they seem almost like the Furies, but there is every indication

of well-fed thighs and buttocks. Correggio's bottom has the creamy smoothness of a pound cake. Raphael's Graces (c. 1505) are certainly just as carnal, and better in shape than Botticelli's, but they look at each other far less. 'These sweet, round bodies,' Clark enthuses, 'are as sensuous as strawberries.' And indeed why not? Their buttocks do give pleasure. But it all lacks liveliness. Perhaps these Graces are too dolled up—a little affected and artificial. They embrace each other but not with any desire, more to hold a pose. And the apple they are holding is not manifestly a symbol of lust. It simply serves as a pretty colour in a picture. In short, while Correggio's bottom might enjoy a bit of horseplay, Raphael's is visibly waiting for the painter to finish. With Cranach there is a change of scene. His *Judgement of Paris* (1530) boldly puts three new Graces, Hera, Athene and Aphrodite, in a Bavarian setting. These girls, competing for the beauty prize, await Paris's judgement with many different expressions, oblique looks and thighs poised, while he sits in his armour under a tree.

With straight shoulders, high breasts, bulging stomachs and long slim legs, their bodies reveal a nostalgia for Gothic art. They are naked or almost; just a light piece of cloth draped around the hips, heavy necklaces and unbelievable hats which most closely resemble the rings around Saturn. Cranach's bottom, which combines a sinuous line with a weak contour, has echoes of Egyptian bas-reliefs. It is, in fact, the bottom of an adolescent: Cranach had a taste for green fruit and young buds. Some critics have said that the contrast between the smoothness of the flesh and Paris's flashing armour is really meant to reveal 'a similar complementarity between the erect penis and the vagina ready to receive it.' This is an audacious comparison. Naturally, you will find nothing like that in Rubens' painting. His *Three Graces* (c. 1636) must be the apotheosis of bottoms, for everything has now passed into the bottom and all grace has been lost. It is true that the female body, as soon as it has lost its slimness and aridity, becomes less easy to control and soon grows slack. The problem is the

excessive flouriness of Rubens' flesh tones. And if they have a fault it is that they are violently uneven.

The Flemish bottom, you must agree, is a bottom in a state of collapse. It is fat, blistered and cellulitic. These Graces are hardly seductive, dancing under their white veils: all you can see are folds of flesh and stretchmarks. And you cannot help noticing the resemblance between these ladies and the piled-up pumpkins which decorate a village church at Harvest Festival. Curiously though, people were ecstatic about them. They were, it has been said, hymns of thanksgiving for the richness of creation; they expressed the gentleness of flowing water, they possessed that humanity that Thomas Aquinas considered essential in any concept of beauty. Perhaps, but what this lumpy flesh expresses more than anything is the failure of too rich a diet—with catastrophic effects. They are barely able to dance, only flounder. They appear to be made of a strange substance, with a soft, flabby texture and yet quite uneven, which absorbs light yet reflects it at the same time, like buttery paper. Rubens wanted his nudes to give an impression of weight. He certainly achieved it. They have the ideal consistency of a sphere or cylinder. As the critic Taine noted in his *Philosophy of Art* (1865), a propos of Rubens' *Kermesse*, Rubens had obviously enlarged the trunks, lit up the cheeks, twisted the small of the back and thickened the canons' breeches. The worst that could happen, Clark concluded, 'would be an unexpected attack from satyrs', for 'lust is a gift from God'. But such a venture seems more than unlikely.

Greek

It was surely in Greece that bottoms reached the acme of perfection. However, a youthful, sporty Greek bottom was a male asset before it became a female one. It was male, sunburnt and red ochre, the colour of the clay used for vases. Female bottoms, on the other hand, have always been milk-white.

The earliest image of the Greek bottom belonged to an athletic body which would have been proudly displayed in the palaestra—where wrestling and athletics took place.

The *kouroi* were young men who spent an enormous amount of time modelling and developing their muscular powers. Judging by what we can see on vases, their buttocks were spindle-shaped like a fuselage and as smooth as calendered paper. It was, however, very rare for a Greek bottom to be shown full-frontal, except for grotesque or terrifying creatures like hairy satyrs, centaurs or gorgons. For at this period bottoms were judged on their curves and volume; this was demonstrated to perfection in the profiled arc or even better the double arc of the buttocks which makes us think of movement. As we can see in Andokides' *Wrestlers* or Euthymides' *Joyful Guests* (c. 525). 'What I love,' Strato said of Sardus (who was well versed in such matters), 'is a boy in the palaestra, with a body covered in dust and with strong limbs and a supple

skin.' It was only later that some painters endeavoured to depict the body from behind, like Euphronios, in his *Palaestra Scene* (c. 505), but without any real success. The backside is shown at its most advantageous angle, with the skin well-oiled and just about at the height of a small servant who is busy wiping the handsome athlete's feet, possibly removing a splinter, but disappointingly the wonderful curve of the buttocks peters out suddenly into rather flat thighs.

Others, like Makron, placed the ephebe's hand just over the cleft of the buttocks, which glossed over the difficulty but deceived everyone. Dikaios, in *Distractions of Love* (c. 510) knew exactly what to do with the hand: the boy has blandly placed it in the cleft of the buttocks of the young girl he is embracing. However, it is only when woodland nymphs and satyrs are frolicking together, forming what Martial called 'a lusty chain', that the bottom is satisfactorily exposed and appears before us in a very modern posture: resting on one side, it is raised into an almost vertical position in readiness for pleasures of an urgent nature. One thing is certain in any case: in general, the large backside takes precedence over the penis, which is reduced to almost nothing. What sort of interpretation, then, should we put on this ideal Greek beauty which is summed up in the equation: small penis + large buttocks = virile young man? This is what Aristophanes had to say, when he was defending his principles of traditional education in *The Clouds* (423 BC): ' "If you do what I tell you," Just Discourse proclaims, "and you apply your mind, you will always have a healthy chest, a clear complexion, broad shoulders, short tongue, a plump behind and small prick. But if you follow today's customs, you will, first of all, have a pale skin, narrow shoulders, a restricted chest, a puny backside and heavy prick, a tongue that hangs out and a tirade that will go on and on for ever. And then," (pointing out his adversary, "he will make you look upon everything shameful as honourable, and everything honourable as shameful, and on top of all that, he will sully you with Antimachos' unnatural vice." ' This unnatural vice was of course *passive* sodomy. For

the Greeks, an adult male who was passive in an erotic relationship (*pathicos*), or who moved about shamefully, was depraved. And so, a bottom that could be admired and a very small penis put young athletes into the rank of gods, the ephebe was extolled for his vigour and noble form; while a large penis, coupled with flabby, clapped-out buttocks, revealed a lax and lubricious way of life and in paintings were reserved for debauched old men, barbarians, slaves and of course satyrs with hideous faces.

Among all Greek heroes' *derrières*, in marble or oxidised bronze—ephebes of Anticytherea, of Marathon, Hermes, Diadumenes or Poseidon—that can be seen today in Athens, Delphos or Olympia, or the two bronze warriors of Riace, discovered on the Calabrian coast, which are the most memorable? They are all equally splendid, if, naturally, you are able to go and see them *in situ*, for Greek museum catalogues are all the same in systematically omitting this particular part of the anatomy: which really goes against the grain. Take for example the *Antinous* in the museum at Delphos, which dates back to the second century BC. He was a favourite of Hadrian's who discovered him at Nicomedia in Asia Minor when he was only 14 or 15 years old. Antinous was Greek, but 'Asia,' as Marguerite Yourcenar writes, 'had produced in this somewhat strong blood, the same effect as a drop of honey in undiluted wine.' There was in him an indefinable shadowy tenderness, a sullen pout that gave his mouth a hint of bitterness, a wildness from which it was possible to foretell his sad future (Antinous committed suicide when he was twenty by throwing himself into the Nile). But how beautiful he is, with his godlike face, his chest as broad as a shield, and above all his imposing, perfectly sculpted buttocks which appear exactly in a section of the marble which is more dazzlingly white than the rest, and the polishing and waxing by generations of temple attendants have given him the smoothness almost of living flesh.

In the national archaeological museum in Naples, there is also a surprising replica in marble of a Greek bronze of Heracles

dating back to the fourth century BC. Seen from the back, the sculpture is simply one muscle. But it is a muscle which, one might say, is relaxed. The head is gently inclined, the posture leaning with the weight on one hip, the right hand with fingers half clenched lingering at the top of the buttocks. How can such a Greek hero with his prodigious strength, a renowned husband of virgins, whose virility is indisputable (although Plutarch, in his *Dialogue on Love* claimed that Heracles had so many homosexual lovers that it was impossible to list them all) and with such ample buttocks make so much femininity believable? This is the paradox of Greek virility: like the buttock it is muscular, hard, compact and at the same time terribly sentimental. Also it is no coincidence that, in some frescoes at Pompeii or Herculaneum, Heracles is shown from behind, as in the episode when he finds his young son, Telephus: the buttocks are powerful, their flesh sunburnt, but the left leg is lightly flexed in a coquettish way, almost like a pin-up. One cannot help wondering whether it is meant to depict an overjoyed father or a lascivious virgin. However, if Greek art, in the archaic period and at the beginning of the classical period, seems more interested in male academies, it does not mean that women did not exist for the Greeks, that they saw no beauty in them, or that they had no role in their life. But it is a fact that when they began to take a closer look at the female form, they immediately concentrated on the development of the buttocks.

There are many Venuses of the Hellenistic period: the *Venus Anadyomene* with her long coiled hair; the *Callipygian Venus* with her inviting backside—the drapery has been deliberately raised (incidentally, some people have claimed that there was also a Virgin with beautiful buttocks in the Vatican's private collection and that, needless to say, with such pretty streamlining, she would not remain a virgin for long); the *Crouching Venus* attributed to Doidalses, which allows us a glimpse of the sculpted fullness of a pear-shaped behind. They have all been made famous by their showy backsides. As early as 340 BC, Praxiteles, with his *Venus of Knidos*, had given her

charms as convincing as those of Hermes. It is difficult to say exactly whether the goddess is getting out of the bath or getting in, but one thing is certain, and that is that 'she is furtively preserving her modesty'. People have been astonished that she could have caused so much excitement and attracted, for some five centuries or more, poets, emperors and philosophers into her sanctuary on the Island of Knidos, off the south coast of Asia Minor. It is said that Phryne, the famous courtesan, renowned for her beauty, was the model for her. Even so one is hard put to find that 'trembling of sensuality' in her that Kenneth Clark speaks of. Her face is severe, her breasts small and she has a distant look. At least in the replica that can be seen in the Vatican museum, for the original has been lost. There is a delightful little piece by Lucian, entitled *Loves* (fourth century BC) which relates that the best of the statue was not where it was believed to be. And that in order to discover it, you had to go through the *back door*.

It was on Pharos, then, in the middle of a garden of fruit trees, cypress and vines laden with heavy bunches of grapes (for Aphrodite is more voluptuous when she is accompanied by Dionysos) that the famous marble statue was, whose dazzling appearance contrasted so well with its green surroundings. Neither Lucian nor his two friends have any special compliment to utter about it: they were moved, they kissed it tenderly, but in no way could it be compared to what awaited them. Because, for those who wished to see the goddess in her entirety, the warden would take them round the back. And there, Charicles (who had a taste for women), was seized by an almost excessive admiration, and stood rooted to the spot. 'His eyes,' said Lucian, 'floating in liquid languor, wept tears.' Even Callicratidas, an Athenian who preferred boys, was in ecstasy. 'Heracles,' he cried. 'How well proportioned that back is. What a snug little catch she is. How prettily rounded her flesh and buttocks are. They are neither too thin nor too tautly stretched over the bone, nor do they spread into fat. And those two creases on either side of the small of her

back are so sweet. What purity of line there is in that thigh and leg which extends right to the heel.'

It was then that the three visitors suddenly noticed a small stain. At first they believed it to be a natural imperfection in the marble, that Praxiteles had knowingly hidden where it would least be noticed. But the priestess told them an almost unbelievable story about this. That of a young man from a distinguished family who frequently came into the temple. Possessed by an evil genius, he fell madly in love with the goddess. He would spend the whole day in front of her with his gaze continuously fixed on her. He had scratched testimonies of his love all over the walls and on all the trees. Praxiteles, in his opinion, was as powerful as Zeus and everything of value in his home he gave as an offering to the goddess. Finally, his desire turned to frenzy and his daring gave him the means to satisfy his lust. One day, he slipped behind the door, and hid in the darkest of corners. He stayed there without making the least sound and held his breath. In the evening he was shut into the temple. 'Do I need to spell out,' Lucian added, 'the audacious attack on that night of villainy?' At dawn they discovered the traces of his amorous embraces, and the goddess bore that stain as testimony of the outrage she had undergone.

As for the young man, it is said that he threw himself down on to the rocks or into the waves of the sea, and disappeared for ever.

Considering that buttocks could be indiscriminately as beautiful on men as on women, and that they form the most ambiguous part of the human body, the Greeks imagined a creature which would join both sexes together, and thus celebrate the bottom's beauty. This was the Hermaphrodite. Hermes, it was said, was loved by Salmacis, the nymph of the fountain where he bathed near Halicarnassus. One day she held him in a tight embrace and begged the gods to make them into a single body, which they did. In reality, this concept of a double divinity originated in Asia. Cyprus transmitted it to Greece, which rather than accentuate sexual differences preferred to fuse them into an equivocal figure. One can

get a good idea of it from the *Sleeping Hermaphrodite* in the Louvre, a replica of a third-century original, remarkable for the rhythmic undulation of the body, the singular upward motion of the rear, and its face buried in its arms. 'I have and I am all in one,' seems to say this third type of beauty, conceived by Plato as the origin of mankind, as a 'ball in one single piece, with back and sides in a circle'. There is no apter way of saying it than that the Hermaphrodite was born through its buttocks. It remains one of man's prodigious fantasies and, to general surprise, lived on in the elegantly exposed behinds of young libertines in eighteenth-century France.

Gross

There are people who find large, overweight behinds which are wildly out of proportion obscurely compelling. They delight in shamelessly bulging, distended buttocks, provided they belong to women, generally speaking. Only oriental behinds, bums like great suns in antediluvian shapes, great mountains of flesh are what interest them. It's difficult to say what their motivation is: perhaps they have fantasies about losing themselves in these great fleshy pillows, these eiderdowns of happiness, these great yawning, impassive backsides that are so bewitchingly straightforward and inert. Proof of this peculiar longing can be found in some painters' work, like Botero, the Colombian painter, for instance. The inconvenience of it is, though, that the more the buttocks are inflated, the more likely they are to lose their shape. Botero's backsides are like great greedy, glandular mushrooms, and a disaster. The flesh is so superabundant that it vanishes in fat.

Which is a pity. For there is a way of strengthening muscles while keeping the proportions intact, and that is sumo wrestling. This Japanese sport is associated with the Shinto cult. It is a type of wrestling that originated in Korea and China and only took on its present form during the Edo period (which lasted from the seventeenth to the nineteenth century).

Contests were traditionally held on street corners, and there were even fights—of a manifestly lubricious kind—between a woman and blind men. The Sumotori's behind, which today is exclusively male, is unquestionably the fattest on earth. It is titanesque, like an auroch's or demi-god's.

In all, buttocks included, the Sumotori weighs between 180 and 250 kilos (28–39 stone). All the weight is concentrated in the belly and hips where the strength to push and resist their opponent lies. It is said that the wrestler's behind could suffocate him were it not so ferociously powerful and prodigiously supple. Sumo wrestlers never appear totally naked: they wear a *mawashi*, a silk belt eleven metres long which is wound several times around their waist, then down the cleft in their buttocks and underneath like a jock-strap; and as well as hiding their private parts it serves as reinforcement during certain moves.

Their most imposing moment is when they take up their positions for the fight. The two adversaries face one another, with their enormous backsides stuck up in the air. For a moment, they size each other up, before the two great masses of flesh punch, squash, pull each other into contortions, slap each other in the face. The shock is horrific. It only lasts three minutes, but at the end they appear exhausted. You may wonder how they manage this orgy of flesh. Their regime is simple: they sleep for fourteen hours a day and over months imbibe a thick soup called *Chanko nabe*, which is based on fish, chicken, beef and a dozen or so eggs, mixed with a purée of beans and accompanied by a sweetened soy sauce. This in turn is followed by cases of Saporo beer and hot saké. The Sumotori's behind is an unnatural one, fattened by force-feeding, as geese once were by the Romans for *pâté de foie gras*, and they have a limited lifespan. At fifty or fifty-five they are finished. High blood pressure, cholesterol and diabetes are their downfall. Perhaps after all a western backside is preferable; it is undoubtedly skimpier, but to advantage.

There have been women whose lives have been eaten up by their bottom, in a life-long battle. These are women who are

ashamed of their behinds because everyone looks at them: they
turn round to look, exclaim in surprise, laugh hysterically
when they see such farcical bottoms. The enormous rears of
these women are like a permanent accusation. They keep to
the shadows so as not to attract attention, but their behinds
seem to shine out in the darkness. Desperately but in vain
they try to conceal them in oversize clothes, to try to put an
end to attracting everyone's attention. Like thighs that have
gone flabby and suddenly are more difficult to change than at
any time ever before. They try every possible means to flatten
them, reduce them, forget them; their fight is desperate. But
the thighs triumph, they grow even more robustly. And
women let it happen. They allow their body to overflow
through their buttocks until they are no longer women with
large behinds, but rather large behinds with small women
attached. They are lost in their behinds, just as though they
were nothing but a behind with a head growing out of it.
Such is the drama of the cannibalistic octopus behind.

Women with large bottoms, however, do not all suffer the
same theatrical fate. Some, like Niki de Saint Phalle's *Black
Nana* even dare to wear a swimsuit, with bold designs of
yellow petals and bleeding hearts. All her *Nanas* have an above
average corpulence, and heads that are even smaller than one
of their tits; they are gaudy giants, as full of vitality as they
are overflowing with fat. Niki de Saint Phalle is taking revenge
on her slim, unloving mother, by spending her life creating
these enormous women who dance on their cellulite. Which
goes to show that bottoms can be attractive, whatever their
avatars. Who's to say that the behind doesn't have an inbuilt
fatalism that drives it to special centres for desperate women
like the one at Durham, North Carolina, which goes by the
name of Fat City. Here awful bottoms sometimes find a resting
place or at least attempt a last-hope cure.

Fellini loved big women and used to sing the praises of
those with large behinds. 'The arsy woman', he said, is 'a
molecular epic of femininity, a divine comedy of female
anatomy'. There was no sarcasm intended: he liked women

who were monsters, deformed, ungainly, moustachioed. Moustachioed women, 'ticklers' he called them, with their five o'clock shadow and hairy legs, having mounted their bicycle, and lowered their bum on to the small saddle as though sitting on a fruit bowl, were like a dazzling firework display as they rode along, for theirs were the most beautiful backsides in Romagna.

It was at the seaside, Fellini told José Luis de Villalonga, that the mystery of womanhood was unveiled to him for the first time. He was eight years old. At that period, an enormous, pale, dirty woman lived all alone in a hut she had built on the beach. In the evenings, she gave herself to any fisherman who had courage enough to approach her. They paid her by allowing her to glean any remaining tiny sardines from the bottom of their boats. In Rimini these little fish were known as *saraghine*. So she had earned the nickname of *La Saraghina*. For a couple of sous, she would slowly lift her huge moth-eaten skirt and, for a few seconds, expose her immense, white backside, which became a fantasy for generations of boys. For twice the price, she would turn round. But sometimes she leapt up and down like a frenzied animal, cursing and blaspheming.

La Saraghina had a lion's head, slitty eyes, and big rubbery lips fixed in a permanent grimace. She smelt strongly of fish, and of the seaweed tangled in her hair, and petrol and tar from the boats. She had the body of a leopard and a backside as big as the world. One day, La Saraghina began to sing for him. A rumba. She had a little girl's voice, a thin, very pure, very clear, very tender voice. And that day, Fellini discovered sin.

Ideal

We live in an age where bottom admirers are in their element. Huge blow-ups of female bottoms (and even male ones) are everywhere on hoardings like a great festival of bottoms, there to entertain us. The bottom has been used as a symbol for 'yes', for 'no', for Pirelli tyres, Schweppes drinks or super-penetrating oil, Dior Svelte, where it was smothered in a cloud of fuchsia-coloured muslin.

The first bottom to make any impression in the advertising world was in 1970 in *Paris-Match*: this was the Airborne bottom (*Le Monde* refused to publish it and it would be another ten years before they accepted the inevitable). Imagine fifty little squares of buttocks. Perfect squares from the top of the thigh to the small of the back. It was unmistakably a bottom. Nothing else is quite like it. Or rather, it was all the same, but seen from fifty different angles. Which is not all that difficult, for the bottom is inexhaustible.

Certainly M. Airborne must have taken about 500 or even 5000 shots, for an enthusiasm shines through. The photographer, one wonders, must have spent hours and hours on this small backside, but he does not appear to have been bored even for a second. What is most astonishing is not so much that the subject is a bottom, but that there are so many. Rarely

is there such an opportunity to see bottoms so arranged—each in their own little compartment like biscuits in a tin.

Ingres' *Bain Turc* is stifling enough without the emotion aroused by these fifty little medallions. Apparently they depict a woman's bottom but it could equally well have been a large baby's. It is a perfect, ideal bottom which would seem not to belong to one particular sex, but could equally well be taken for an interesting cloud formation or a downy peach. It would be wrong to claim it is definitely this or that. There is nothing realistic about M. Airborne's bottom: it is hairless, has no orifices, has no semblance of sex, nothing. It is a firm, full, harmonious, aesthetically pleasing bottom, its sense of solidity created only by light and shadow, curving lines and the large, delicate cleft separating its two halves. It is a silky, appetising behind, and although a little firmness is a desirable attribute in a *derrière*, this one does not seem to be completely ripe. You could almost say it was like a foreshadowing of a genetic mutation of a behind. A sort of foretaste of the eternal *derrière*.

The female bottom's next public appearance was on a street hoarding and it was called Carolina. This was in 1978. And Jean-Paul Goude was its creator. He put great effort into introducing the black bottom into France. Carolina was a charming young girl from Santo Domingo who had, piquantly, placed a goblet of champagne on her rear-end. And with round eyes and a cheeky little curl on her forehead which made her look like a faun, had had the cork popped, so that the liquid was spurting all over her before finally landing in the said glass, which had the appearance of an immense fizzy crown. It was pretty. Particularly so, as for the occasion her *derrière* had been blown up to twice its size, with the help of decoupage and rejigging of the trannies. But Jean-Paul Goude has always been fascinated by black bottoms and Benin Bronzes. He wanted to show off the bottom's beauty by exaggerating it. 'The dark side inspires me,' he said. 'I love women with powerful arses and necks as straight as a Prussian officer's (I make them up in blue to accentuate their blackness); I love

their musky smell, their perfect skull, their racehorse's behind, and their flat feet.'

Finally, in 1981, Miriam revealed her bottom. It was as if we had always been waiting for her. For Mlle Miriam had a face that was already familiar to us, and now she was offering her *derrière*, full-face as it were, to us for the first time. Her frankness was charming. There was at the time an election going on in Valence at the first socialist congress, and after his election victory M. Quilès was talking of heads falling. Mlle Miriam let her pants fall instead. She had appeared on the first poster fully clad, announcing: 'On 2 September I shall undress the top half.' Then her free and radiant breasts appeared on a second poster which also promised: 'On 4 September I shall undress the bottom half.' France held its breath. But on the appointed day we knew as we stood before Mlle Miriam's pleasing *derrière* that the advertiser, a M. Avenir, was a man of his word. There followed a complicated debate between advertisers on the role of women, bottoms and the soul in the sale of washing powders.

We are grateful to Miriam however for providing us with the most dazzling image of a certain state of grace.

It was not until later that a male bottom appeared and caused more of a storm. It was a more muscular bottom, smaller obviously and harder too. It would never have passed for a woman's behind. As Gilles Lipovetsky in *L'Empire d'Ephémère* (The Empire of the Ephemeral) said: 'The bottom is not the province of androgyny.' There is still no 'radical unisex similarity' in this domain. But at last we had the privilege of seeing this for ourselves, and there was a great difference between a huge rugger-player's buttocks and the svelte ideal of this young Australian swimmer.

Both men's and women's bottoms have changed their shape from a century ago. You have only to look, for example, at the development of a muscular body after physical training was introduced in 1885. We owe our knowledge of this to Edmond Desbonnet who was a contemporary of Baron de Coubertin and nicknamed 'the man with the muscular

moustache'. He had a collection of some 50,000 photographs, made up from glass plates, stereoscopic views and autochromes taken between 1885 and 1950 and it is obvious from a study of them that the behind has changed. Taking his inspiration from male Greek statuary and from women in Romantic painting, Desbonnet first shows us an extremely virile male body: the pose is masterful, and the retouching a bit too visible, but it is a hymn to the gods of Olympus, to all the gladiators, acrobats and fairground strongmen, a grandiloquent setting of trapezes, deltoids and biceps, affected moustaches and puffed out torsos, complemented with a leopard-skin and caveman's club: this is a man in hypertrophied relief.

As to his *derrière*, curiously enough, it seems to have escaped this general hardening. While the rest of the body is arrogantly robust, the bottom is not: it is supple and feline. And while it might look a little tense, it is manifestly not going to suffer the same fate as the biceps. At base, Edmond Desbonnet's bottoms will never yield to the pleasure of just being a behind, not even one muscle. This is even more obvious in the women, who at the time favoured exquisitely rounded vegetable shapes and white flesh. Grace and submission to pleasure roughly summed up what women were thought to represent, and consequently their *derrières* as well. Women were also excessively corseted and their curves made the small of the back spectacular, almost surreal, in relation to the breast. The body was plump and milky, the feet small. Rather more like a fragile ornament than a woman, it was so out of proportion. With their laced corsets, boots and hair gathered into heavy scallops, they looked slightly saucy: in fact it was difficult to say whether they were still in the gym or in a brothel. While the men swaggered about, the women languished in their whalebone corsets. Today, things are different. The ideal male bottom is definitely taking on less masculine forms but has more subtle toning, is more rounded and more mobile. While the female *derrière* is becoming more masculine, its exquisite curves and graceful nonchalance are

giving way to a slim, muscular silhouette. The long muscle is master.

If Desbonnet's photos of naked men (and women) were known only to a restricted circle of bottom-fanciers, we would have to wait until 1967 for the whole of France to discover M. Protopapa's *derrière*. He was a young Greek philosophy student of 25, who posed nude for a front and back view in black and white for Ceinture Noire (Black Belt), a pants brand name. He had a sensual mouth, a 1960s brush haircut, and both hands over his private parts, while his *derrière* jutted out behind. What was so astonishing was that his bottom had a life of its own. This was rare in those times. For some years up until then a Paris agency had specialised in model 'parts' — a hand, a foot, legs or even eyes. Their owners were known as 'body doubles'. The bottom was one of those parts that sold well, in particular to film companies, where they made up for deficiencies in the stars. Men's and women's bottoms came in two models and various flesh tones but were anonymous-looking. Now, with M. Protopapa, the first living bottom was revealed in its entirety and in relief. It was an unbelievable development. 'We have touched a live nerve,' a spokesman from Publicis said. And sales of Ceinture Noire shot up.

In 1972 the singer Michel Polnareff was to make the world fantasise over his *derrière* which plastered walls all over Paris to advertise his comeback at the Olympia Music Hall. For the occasion he wore a pretty woman's hat in pink tulle with a wide brim, dark glasses and a periwinkle blue negligée hitched up over his plump, loose-limbed behind, which sent out faint messages of 'Follow me, young man'. A magazine article gave a psychiatrist's diagnosis of this callipygian artist as having 'an obviously masochistic tendency', while a taxi-driver said that personally he would have preferred Sylvie Vartan tails down. Justice showed no mercy, for all this was happening at the same time that Polnareff was singing, 'I am a man.'

Then there was M. Orly. His story is a gripping chapter in the evolution of the male species over the last decade. He was first seen in 1983 with his bottom resting in a manly way

on the edge of a bathtub, with leg outstretched, and body bent over while he dried his hair. He seemed a little tense, but he had an energetic-looking behind which was also very shapely and solidly secured in his underpants, the cleft between the buttocks perfectly outlined (possibly with the help of some sensitive retouching).

Then, a few years later, M. Orly was seen to be a different man. He had not aged: rather he seemed even younger, but he had definitely softened. He was slumped over the edge of a bed, almost kneeling with his stomach resting on the sheet, while a woman massaged his shoulders. His behind, which had centre place in the photograph, no longer had the shapeliness we had come to know, but was wearing an extremely light almost floating pair of underpants. The atmosphere too was much hotter. This young man was decidedly not drying himself one fine morning, but was more like a tamed beast preparing for a night of activity of a distinctly muscular kind where it would definitely not be he who was underneath . . .

There followed a whole series of impertinent *derrières*: the 'cobblestone-behind' of M. Antaeus, the half-dressed, almost decolleté behind of M. Valentino still crammed into his jeans, or the 'Turkish-bath-*derrière*' of M. Rochas, which was well made, although remote and pouting, and reflected in an ornamental pond so that all its angles and curves could be seen. But the shock came with a bottom created by M. Dim in 1991. It belonged to an Australian (the Americans had all refused to do it), with the body of a decathlon athlete, nonchalantly running in the waves, diving, and revealing a seductive anus rounded off by a tiny jock-strap splashed by the waves. You could even see him from underneath, with his face and open mouth gasping for air. But while Mme Obao's bottom had several years behind it, M. Dim's provoked a general outcry across the Atlantic—it seems there had been no parallel since 1896 when in a small hall in Los Angeles, under the petrified gaze of 73 spectators, two stars of the silent screen, Mary Irvin and John G. Rice, had kissed in close-up for four long seconds.

Advertising now has examples of children's *derrières* that I can draw on for this chapter. However, in his book *The Erl-King*, Michel Tournier described them as being 'as expressive as faces: they are vibrantly alive, alert, occasionally gaunt and hollow-looking, but only a moment later will be cheerful and naively carefree.' If there is a taboo, as there still is today, about virginity, it is surely in advertising that you will find it. And it is just as difficult to talk about bottoms in their intermediate stage, before they have reached their prime but, one senses, are already developing. When seen for the first time it is more bitter-sweet than ever, as tart and titillating as a little midsummer pear, as capricious as the horns of an ibex. A young bottom has skin of an almost transparent luminosity and flagrant elasticity, as well as an awareness that it is something unique, but it is still bashful and self-conscious. It has an almost gentle naivety. 'It was seeing his behind,' Tournier continues, 'that first made me love him, because it was so disarming, so awkward and vulnerable.'

Bronzino's tableau *Time and Folly* (1540–45) gives quite a good idea of an adolescent *derrière*. Bronzino was inspired by Michelangelo's *Venus and Cupid* but in Bronzino's hands, Cupid is no longer a child. He is fully developed, and strikes such an extravagant pose that everyone is enchanted by his small round bottom. And except for his blushing face and this dazzling little *derrière*, the rest of him is barely visible. The subject of the picture is a young man with a mature woman; their lips touch, one of his hands is spreadeagled over her breast, while a crowd of voyeurs, some of them old men, join in the frolics. Since Cupid is Venus's son, what we have here is actually a scene of incest. Cupid is ardently displaying his chubby bottom, as if emulating Venus's heavy, sensual morphology: he would like his to grow as big as hers, and in the picture it looks as though his small bottom is developing like a mysterious mushroom, or a delirious member, out of Venus's curvaceous side, as if this delicious treasure were still made of woman's melting flesh.

Little girls in tutus express this same kind of extension or

'budding'. I call them 'little rats' because they are forced to undergo cruel exercises to make them less shapely. These young girls with their chignons generally exist in a colony and are between eight and twelve years old. The trained eye will detect a forest of pink and white tights, small nut-shaped *derrières*, beautifully curving thighs and fine ankles, like a weasel's. They leap about laughing or stand around in groups like a bouquet of flower stalks, and they give a sense of airiness and spring to the *derrière*—which is rare.

This *tutu* (a child's rendering of *cucu*, meaning backside or silly) looks rather like a corolla or frill on a carnation, or a bellflower, or even the lacy labia minora. This spruce, cheerful costume enhances the behind. Though it hypocritically pretends to conceal it, Tournier notes, its stiff frothy flounces actually flatter it. It transforms the largest fleshiest part of the dancer's body into a vaporous white explosion, a spotless reduction to powder. What a pity it is, then, that some people have said they would like to pull the petals off little girls in tutus, rather like the wings off a fly. Others like Patrick Grainville would love to see them naked, standing on one leg with its bulging muscles, with the other outstretched, the point of the foot resting on the barre. 'With her legs spread out in such a posture one would be able to see her pubic hair and labia, and the tendons of her buttocks. Held firm in this heavenly tortured pose, her smooth, untouched vulva would nonetheless betray her animality.' However, as each of us knows, a little girl who has had her tutu cut off is no longer a little girl, but a crippled dragonfly.

Libertine

The female back view became a common theme in late seventeenth- and eighteenth-century painting, and can probably be attributed to the influence of the Hermaphrodite. The most famous example of this, in the Villa Borghese, has been restored by Bernini. Kenneth Clark sums up the feeling of the period quite well. 'If we look at the female body from the single viewpoint of shape and the relationship of plane and protuberance, it could be claimed that the back view is more satisfying than the front.' The reason for this is that the buttocks are of a more ambiguous nature, and more stimulating with their invitation to a new kind of pleasure.

Such pleasant, licentious distractions were not overlooked by Bernini's contemporaries. In that liberal century, people indulged in the observation of what Brantôme referred to as 'flesh'. 'Such pretty white flesh,' he said, 'that you would think you were witnessing the beauties of paradise.'

So skirts were hitched up, thighs opened wide and enlarged so that the sight of these beautiful limbs hidden by underwear could be shared and young girls happily and gracefully offered their titbits. Boucher and Fragonard provided the public with a whole series of scenes of creamy nymphs, bewitching naiads frolicking in the waves with new abandon, swooning and

wriggling with arms held high, round-eyed, their skin glistening like butter. It was Saint-Victor who said, in 1860, of *The Triumph of Galatea* or *The Bathers* that 'the flesh tones gleam like moist flowers'. But these young sea nymphs did not exist in real life, they came from mythology, that is to say from nowhere. A more genuine sense of realism had to be given to their thighs and bottoms, they needed a face, painted in the intimacy of the boudoir, lying on a sofa, in a relaxed posture of sleep. And that was how Miss O'Murphy came to be the driving force of the period.

Towards the middle of the eighteenth century, women were in the process of changing, or at least the ideal concept of woman was. When Watteau's *Judgement of Paris* showed a woman as cylindrical as a doric column, it henceforth became stylish to be small. And this was how the young O'Murphy girl appeared in *The Blonde Odalisque*, Boucher's painting of 1752; she had a fairly round, childish body, with plaits around the top of her head and tied with a blue ribbon, a creamy skin, and a meek, charming bottom. Casanova recounts in his *Memoirs* (XXXII) that, in 1751, he was presented by his friend Patu to two Flemish sisters living in Paris, the younger of whom, 'the little Morphi', was only thirteen. Lacking the inclination to pay the necessary six hundred francs for her virginity, he nevertheless expended half that sum in the space of two months for the privilege of spending twenty-five nights with her, and also gave six louis to a German painter (F. J. Kisling, perhaps) to paint her portrait. Could this have been the same girl? No one knows for sure, for according to D'Argenson, the little O'Murphy girl was the daughter of an Irish strumpet and a rogue. However it was, this young courtesan almost always posed in the same way: entirely naked, her stomach pressed into cushions just firm enough to show the gentle resistance of her flesh, with painted lips and thighs spread, ready it seemed for anything. Boucher, the first of the king's painters and a protegé of Mme de Pompadour, enthusiastically sketched the girl. He positioned her bottom in the centre of the canvas, her buttocks set indolently apart,

in an ingenuous sort of eroticism heightened even more by the untidy cushions and fabrics. For Miss O'Murphy wanted to be viewed with as little embarrassment as she herself felt. Diderot, Boucher's *bête noire*, cursed: 'This M. Boucher,' he wrote in 1765, 'only takes up his paintbrush to paint bosoms and bottoms. I am quite happy to see them, but I don't want them pointed out to me.' Louis XV felt the same way and preferred to take this enticing child into his bed.

Casanova recounts how the 'little Morphi' was introduced to Versailles through her portrait which the German painter presented to M. de Saint-Quentin. He, in turn, had nothing better to do than go and show it to His Most Christian Majesty, who was a great connoisseur of the subject, and wished with all possible haste 'to be certain with his own eyes that the painter had faithfully copied the original, and, if the original was as beautiful as the copy, this descendant of Saint Louis had a good idea of how he could make use of it.' A search was made for the two sisters who were then locked up in a pavilion in the park. Half an hour later the king arrived, asked the young O'Morphi if she were Greek, drew the portrait from his pocket, took a good look at her and cried: 'I've never seen such a close resemblance.' Then he sat down, took the child on his knees, caressed her a few times, and 'having made certain with his royal hand that the fruit had not yet been picked, gave her a kiss. For the king,' D'Argenson said, 'found barely nubile virgins most attractive because of his fear of contracting venereal disease: he would not have tolerated having a predecessor in the young girl's favours.' Louis XV gave her an apartment in his Deer Park. At the end of a year the little girl gave birth to a son 'who like so many others was farmed out no one knows where', Casanova noted. Then at the end of three years she was disgraced following an offensive remark on the part of Mme de Pompadour.

The craze, in any case, for this light-hearted bedtime stuff and lively flesh tints was such that Fragonard, who had been Boucher's pupil, also began to dash off a succession of lovely little bottoms, painted with much gusto. 'How will Fragonard

manage to save these nude medallions, these small paintings that are so lively, and so full of poetic freedom?' the Goncourt brothers wondered. 'What charm he puts into them to make them acceptable. It's unique: he only half shows them. His lightness of touch isn't offensive. He's not at all heavy-handed.' Whatever the Goncourts' thoughts, these dreamy young girls with their sleepy smiles really did have blushing behinds. It is curious that in Fragonard's canvases, in particular *The Raised Shift* (c. 1765), their bottoms are as rosy as their cheeks. Or rather the cleft is vermilion. You may wonder why he painted this area with such hot colours. Was it from modesty or naughtiness? Was it simply a shadow? Actually it was blood. Had they been whipped, then? Did this unexpected inflammation result from prior make-up, or from more clandestine activities? These delicate, fiery stripes caused bewilderment and sometimes amazement. For it was rather as though once the shift had been removed the bottom lit up.

If the painter has exaggerated the red in certain places, it was quite simply to make them look more alive. And in order to avoid the green flesh tones Rubens favoured, he would irritate and redden the skin. It was a way of activating the blood. For the amorous bottom always needed a little preliminary warm-up. This one lost its reputation in the process.

Swimsuit

The Brazilian swimsuit, popularised by Mlle Schweppes, has recently appeared in Europe. This leaves the buttocks entirely bare and its inspiringly fluid shape gives women who wear it the rangy allure of a gazelle. So in one go you can see the *derrière* mounting upwards and never-endingly it seems, disappearing perhaps under the armpits, in any case very like an immense dewdrop or even better a long, beautiful, succulent pear. It's difficult to say whether we are looking at the bottom's downfall or its takeoff. This amazing bottom has varying effects, however. For some people, who are, initially, enthusiastic about a swimsuit which reveals nothing in front and everything behind, believe that women who display their unruly buttocks in this way have also confined their feelings to this area of their anatomy. Which they strongly deny. A swimsuit like this produces an entirely new concept of the behind, not least because of the way the gathered material at the front all disappears into the crotch, clearly indicating to impudent little men that that door is closed. The Brazilian swimsuit is to nudity what the innuendo is to confession. The less material there is, the more potent the symbol. Exposed organs have the same effect as a raised shield. They are not so much body parts as pure ideas. The backside seems to be on

offer, and immediately accessible, but the provocative casualness of it renders it untouchable. This swimsuit, then, must be viewed as a bastion of morality. And it will bring a sense of nostalgia to some for what was once one of the pleasures of the beach: the wet swimsuit.

'When the girls emerged after their bathe', Patrick Grainville writes (in *Le Paradis des Orages*—Stormy Paradise), 'their behinds were so wet, and the material clung to them so tightly that their bottoms looked like two split wine skins.' The wet swimsuit's transparency makes it ultra-sensitive so it picks up and outlines cleavages and curves. 'The centripetal force of a driver forces its seam into the crotch and secretly pins back the labia, so that the whole bottom is forced to inhale through this central abyss': this, according to him, goes straight to a man's heart. But worse is to come: this is a bottom that has been soaked under the costume. As it emerges from a wet swimsuit, the bottom has acquired a very special pallor: it is more pliant and compact; it bobs about stupidly, having acquired an adolescent awkwardness. But, nowadays, it has disappeared in favour of a tanned bottom—with desperately smooth skin, so taut it might split, covered by an impalpable, uniformly tanned film. 'Naked man is a mollusc,' Jacques Lacan said. However, that is no longer the case. Gone are those great sponges of damp flesh, those huge rather undefined soft fruits which sprang out as if they had at last discovered daylight for the first time in their existence. Gone is the hesitant bottom which had the same equivocal charm as a newly discovered secret. Gone too is that inexpressible surprise of white skin, which had a gentle, impenetrable quality; it was like a permanent reserve of white, a white of distress, still confused, childlike, chaste. A white that made you want to bite into it.

What is also lacking now is what created the poetic element in black and white film. This produced a version of flesh that was at once perfect, diaphanous, spiritualised. 'Colour film gained in enchantment (when it gained anything) what it lost in charm', Edgar Morin said. While black and white film

denudes the skin, colour makes the skin opaque, it blends the body in with the landscape. Black and white formed a startling contrast, and revealed flesh that was full of delicacy. Colour has killed the erotic quality of whiteness, film spreads and blurs colours as grey once had done. The *derrière* in colour has become synonymous with a grey bottom. And a grey bottom has lost all its magic. It seems morose and frightfully flat. One cannot help wondering when one sees bottoms that are so successfully tanned that they appear quite dead, whether it would not be better to turn them inside out so that we could make the beauty of the organs visible and at last discover what gave the buttocks life. If you want a true idea of the bottom's pulpy flesh, muscles and nerves, then perhaps you should go back to the *écorchés* of the Renaissance, to the studies made by Alleri (1535–1607), for example, where the buttock was carefully skinned to reveal the exciting masses of flesh and spindle-shaped muscles. You may be interested to know that man's behind was almost streaky like the flesh of a ray. Which perhaps indicates that in the distant past man originated in the sea or that the origins of man began in his behind in the depths of the sea. If the bottom was present at the beginning of the world it would not be the least surprise in its capricious history.

Hand

It's a shame that the bottom has always been a source of crude humour. It has given rise to many colourful, mostly derogatory expressions: 'It's a bummer', 'He's a real bum', 'What an arsehole', etc. Rabelais used it to indulge in Spoonerisms (Panurge says, 'there is very little difference between a woman *folle à la messe* or *molle à la fesse*' (mad at mass or with a pliant arse. *Pantagruel* 16). Much of vaudeville, comic patter and dirty jokes depends on it. A woman's behind is the supreme source of humour and, at one time, just a glimpse of one caused mirth. Smacking a neighbour's bottom not only produced great satisfaction, it was screamingly funny to put your hand on their backside. So the behind is worth a detour. But how to go about it precisely? When confronted with a bottom for the first time, some people can, quite rightly, feel anxious or even embarrassed. Let me reassure them. Only a minimum of dexterity or technique is required, it is all a question of fingering.

Take pinching, for example. This can be an amorous gesture, although it is generally misunderstood. This small pressure of thumb and index finger is worth examining in more detail. The Italians, who have turned it into a sport, say that bottom-pinching comes in three varieties: the *pizzicato*, a

brief, quick pinch with two fingers, and reserved for beginners; the *vivace*, fairly forceful, using several fingers in rapid squeezes; and finally the *sustenuto*, a prolonged, sustained, rotating pinch, intended for 'living panty-girdles'. Others have made a simple distinction between the straightforward pinch (like drawing up a fold) and the rotating pinch; in the first, you take the skin between thumb and all four fingers—a proper handful—to obtain a large fold, like picking up a rabbit by the scruff of its neck. The pinch is therefore always a delightful thing.

'Monsieur Presle,' Sally Mara said, 'has never touched me. Nothing more than his hand on mine. Sometimes he slips his hand down my back, and lightly pats my tutu. He is simply being polite.' (Raymond Queneau, *Oeuvres Complètes de Sally Mara*—The Complete Works of Sally Mara). A pat, like a pinch, is ideal material for an entrée, what used to be known as a *petit oie*—a bit of a goose. They are small flirtatious liberties, amorous preliminaries.

Having what is known in France as *la main au panier*— 'your hand in the basket' is more daring, but it is a bad move to push it too far or too firmly. The basket in question is the posterior, only rarely the fanny. As Raymond Guérin has said, 'from having your hand in the basket there is only one short move left for those in a roused state'. No one knows exactly how this expression arose and what the original basket was. It might have been the eighteenth-century whalebone panniers worn underneath the dress to widen the hips. Or the small fruitseller's basket—shades of 'Cherry ripe, cherry ripe'. Or a distortion of the word *panil*, already in use in the thirteenth century and meaning both bum and fanny, from which the French word *penil* (pubis) derived. Lexicographers are perplexed. Especially as an expression 'to have one's basket entered' existed as far back as the sixteenth century (but only in the sense of losing one's virginity).

With your hand well in position, you can, without too much resistance, progress to *patinage*—'skating'—over the bottom. Skating dates back to the fifteenth century, and as

the French words indicate, if you 'manipulate' with your hands (*mains*) you skate with your feet (*pattes*). Which undoubtedly would not be very polite but might be interesting. 'Skating' is a very free, somewhat indiscreet caress. 'The provincials,' Scarron wrote, 'are quick movers and skate well.' Nowadays skating has been replaced everywhere by petting (or as the French say, *pelotage*). Bottom-petting consists of running the hand hither and thither over its contours and gradually deepening the movement. In the seventeenth century *pelote* was a term used in tennis: it meant exchanging balls in a pleasurable warming-up process, before an orderly match.

When you seize someone by the *derrière*, some say that the buttocks swell with pleasure. When you take them by surprise like this and squeeze them in your hands, you sense their exhalation, you can feel them escaping, extending, swelling. They say then that the bottom actually grows in size. Although sometimes some bottoms are so large and the sum of their curves so voluminous for the hand to grasp that they are, in no uncertain terms, impregnable. Then you must leave well alone. But if the buttock does not become too big, you can, as one used to say, 'embrace' it. That is to say put your arms around it and squeeze it. In a recent poster for *Valmont*, a film of Milos Forman, the viscount has his eyes shut and is devotedly embracing the exposed bottom of Cécile de Volanges, under her pretty cherry-patterned dress. And as *embrasser* has come in French to mean 'kiss', the young man is taking advantage of the language change to do that as well.

'I had my hands folded on her buttocks', you can read in *L'Histoire de Dom Bougre, portier des Chartreux* (1741), attributed to the lawyer Gervaise de La Touche. 'She had her hands folded over mine, and I hugged her with delight, she hugged me in the same way, our mouths were glued to one another, she was two cunts, our tongues fucked each other, our gasps urged each other on and melted one into the other, and produced a sweet languor which was soon consummated by an ecstasy

which transported us to oblivion.' This type of kiss of the hands as it were can then be used anywhere. Its power comes from the fact that you can hold the bottom securely in place and be sure of its capture. However, there is another way of joining together, bottom to bottom, which by definition will mean no kiss will take place. This is known as the *quatrain* or foursome. Which supposes two couples piled on top of one another. And this curious position can be found in *Histoire de Dom Bougre*: 'My father never gave my mother one that she didn't return threefold, and as her bum fell again on mine it forced me into Madelon's cunt, which caused a ricochet of farting that was quite diverting for the spectators.'

In its chapter on the art of scratching, the *Kama Sutra* indicates that clawing and scratching with the nails in passionate ardour or to show strength are one thing, but if enthusiasm is lacking, these are 'signs of anger, joy or intoxication, but are not done in every circumstance.' Among the nailmarks left on the buttocks, we could mention the tiger's claw, the half moon, the peacock's foot or lotus leaf. The *Kama Sutra* specifies that you can use your teeth to bite just as you can scratch with your nails as a sign of aggression. In a painting by Hans Bellmer (*Untitled*, 1946), there is a woman in black stockings burrowing her varnished index finger into her copious arse, without one knowing whether she is defending the entrance or stimulating the organs. Anyway, Bellmer felt that 'the image of a desired woman' is finally only a 'series of phallic projections which move progressively from the detail of the woman towards the whole of her, so that the woman's finger, hand, arm, leg are the man's penis' (*Petite Anatomie de l'image*). But, you may wonder, is it any comfort for a woman to know she is a mere excrescence of man's genital functions?

There remains the famous photograph by Arthur Tress of a hand, emerging, fingers spread, from a man's backside covered in rubble. It was of course produced by using an artificial technique. The emerging hand appears to be crying out for help as if it were being swallowed in the course of a cataclysm.

Which, again, is discouraging and is an ironic counterpoint to scenes of 'fisting', current in homosexual sado-masochistic circles. It does at least prove one thing: that any fist that is pushed up a backside, can't wait to get out quick enough.

Male

Some women say that they just don't like men with handsome bottoms. This is because they don't welcome rivals; they wouldn't then be the only ones with large, curvaceous behinds. Also what they are almost saying is that if you admit you prefer a man with a small bum there's an implication that the lack of bulk may be made up for in another area—the penis—which is much more flattering in their eyes. These women, however, do not form the majority of their battalion. According to a recent survey (1992), if women are asked to assess an assortment of men, then muscles, mouth, strong build, nape, torso, Adam's apple, ears, ankles and penis, as well as height, are of absolutely no significance; what counts are the eyes and bottom. They hold the promise. The advantage of a beautiful backside is evidently that you can admire its shape and hold it.

Therefore, although Doctor Waynberg, a sexologist, may say that if someone 'chooses a certain type of bottom, she wants a desexualised masculinity', a virile bottom generally makes a woman happy. Françoise Xenakis has always liked men's bottoms. The Discus Thrower's, for example. 'I spent hours,' she said, 'in that torrid museum in Athens, eyes fixed on the small of his back. The hips are wonderful, and that

right buttock which is just a touch higher than the left one.' Alas, the men with whom she works rarely have bottoms to match the Discus Thrower's. Walking down the street, on the other hand, 'there are wonderful, miraculous behinds. True, but (a) the owners of those bottoms never work where I'm working, and (b) most of the men who've achieved that type of behind prefer men anyway.' In other words, sooner or later a woman is going to be deceived by a man's bottom. That is doubtless why in general she prefers ankles or ears.

The history of painting has been almost totally colonised by the female bottom. The male bottom, while not completely absent, makes a rather more episodic and seasonal appearance. It's difficult to pinpoint why, for example, there is a sudden outbreak of them in sixteenth-century Italy or why they disappear almost completely in the licentious eighteenth century. Almost all the paintings were by men. But the male bottom is one of those things rarely on display in the best circles. Because it symbolises nothing glorious for masculinity or virility. What is glorious is the sword in front, the taut thigh, the outstretched arm. Not what Roland Barthes calls 'the oblation'. High society was divided into men with swords and women with curves. So much so that men shared an intervening period when the bottom was round but not so round as a woman's; it was muscular and taut, but not a sword or phallic symbol. In the end, it satisfied no one, except of course Michelangelo, and all the Italian painters of the Renaissance, particularly Luca Signorelli, who gave the bottom a diabolical triumphant energy. Then there was Pontormo and Andrea del Sarto. But with Michelangelo the male bottom achieved its apotheosis. Never again would it be endowed with such prestige, except perhaps in the arrogant colossi of the Foro Italico, built in the 1930s by Mussolini on the banks of the Tiber.

It is sometimes said that Michelangelo's bottom is like Apollo's, but not totally. It is forceful, colossal, quick-tempered, thunderous, unbridled. It is a bottom that makes you tremble. Never has a bottom had such life, such emphasis. 'Michelangelo', Vasari said, 'considered the male nude divine.'

In fact it is quite difficult to find any human interpretation of the male body, from *The Battle of Cascina* to *The Last Judgement*, unless you take the surfers of Hawaii or Waikiki as prototypes. Few artists have shown such an unruly passion for male shoulders, knees and bottoms, all those protuberances that characterise the spirit of Florence. Buttocks appear in his paintings like two powerful masses of flesh being catapulted with unprecedented fury. Sometimes, as in *The Archers*, they are propelled into the air as if they are about to explode and sometimes they are diving into the flames like two coupled dogs (as in *The Last Judgement*, in the group of the damned with Minos). These bottoms have no sideways movement but rather an up and down one. They rear up like a cock's comb or a Phrygian bonnet. Legs and thighs reinforce their sense of power. They engage with each other and the whole body is inflamed. The cleft not only separates the buttocks but sweeps along up the back, cutting it in two right up to the head. The cleft in the buttocks breaks their primitive union and carries the bottom's intense excitement right up into the thinking head: man appears to be split from top to bottom as though with an axe. Buttocks in Michelangelo's work are not only the focal point of the body, they give it a spiritual momentum.

The Italian behind has spread all over Europe. You can see it in Flanders, for example, in the work of Frans Floris (1515–70). His *Gods of Olympus* contains the best backside of Jove that you will ever see, even though it is seated.

The seated bottom is certainly the most popular pose in painting, although it may not qualify fully as a bottom when so much of it vanishes from view in the sitting. In its squashy, collapsed state, flattened like a pillow, the seated bottom has nothing of the roguish charm of a bottom seen full view. For all that is visible is a light depression in its surroundings, just a hint of the cleft, a dark triangle signalling its unseen presence, swallowed up in shadow. What is so painful about the seated bottom is this simultaneous presence and absence: almost like simultaneous birth and death. But Frans Floris's Jove is no

still-born bottom. It has a curving back, and the hollow is so deep and high that it appears entirely open. Also it is the only behind in the painting, since Zeus is facing the whole assembly of gods on Olympus. A colossal, prodigious backside like this is what is expected of a god.

Another astonishing bottom was painted by the Dutch artist Cornelis van Haarlem (1562–1638). This one is doing the splits. Georges Bataille, in *Les Larmes d'Eros* (The Tears of Eros) suggests two other quite similar versions in *The Flood* and *The Massacre of the Innocents*. While keeping his balance on his right foot, the man leans on his left knee, drawing it forcefully back so that his bottom becomes the centre of a fantastic arc, the two compact, dense blocks of his buttocks divided by a magnificent cleavage. His bottom is sticking up in the air, motionless, and yet it gives the impression that it could take seven-league strides. It is in the foreground of the painting, but still relatively modest.

In *The Baptism of Christ* in the Louvre, on the other hand, Christ is certainly the least visible character in the painting; only one thing stands out in this sacred scene, and that is a muscled blond giant who is completely naked and sitting on his left buttock, flaunting his backside and his superb thigh right down to the heel of his dirty foot. It is even more surprising that no one seems to know who he is meant to be (he might possibly be an apostle—though there is nothing to indicate this); it is also surprising that this great mass of flesh eclipses everything else and that the rays of light intended to symbolise grace are travelling on a diagonal straight on to this Batavian athlete's milkwhite bottom. So much so that it is fairly hard to believe that the painting is set in Palestine on the banks of the Jordan, or, looking at such a majestic behind, even to imagine it as an episode from the Bible.

The most beautiful male backsides most often belong to athletes, heroes or slaves, henchmen or executioners. Edward Lucie-Smith (in *Eroticism in Western Art*) observed that unlike Judith, Salome—although demanding John the Baptist's head—has no part in the beheading. She calls in an

executioner. Who, in almost every version, for example in Bachiacca's or Guercino's paintings, is shown, he says, as a rival capable of outclassing this female castrator. In any case he is half naked, seen from behind with a quite staggering sort of gluteal animality, his sword in his right hand and holding up the martyr's head by its hair in the other. His pose shows off to advantage his shapely bottom and taut calves in their tight breeches. Edward Lucie-Smith maintains that there is a manifestly erotic link between the masochistic victim and his vanquisher, and that this outstretched arm unites the angelic face and barbarian backside in a similar offering to Salome.

Up until now it was believed that the twisted, slightly idiotic smile of the *Mona Lisa* was the result of a 'semi-atrophying of the body's right side', or an excess of cholesterol, or an asthma attack, or even, according to Freud, a raging Oedipus complex. Latterly, a New York professor, Ellen E. Morrison, has even sworn that she has seen 'the Gioconda's smile on the lips of a pregnant whale'. Well, not at all. This inexplicable smile, which has sometimes been described as equivocal, archaic or Aegenetic, would, it seems, according to Suzanne Giroux of Quebec, conceal a boy's behind. The astute critic will turn the painting on its side, and square off just the smile: the line of the lips will correspond to the dorsal spine and the corner of the mouth to the two plump globes of a magnificent pair of buttocks. Who would have believed it? In a dimple! Leonardo worked for four years on the *Mona Lisa*, possibly from 1503 to 1507, when he was living in Florence for the second time. It is estimated that he spent ten thousand hours working on this plank of Italian white poplar: eight hours a day for four years just to hide a secret. According to Vincent Pomarède, Leonardo would even have kept the work for himself. And that is not all: Leonardo was left-handed, he wrote in mirror writing, from right to left and using the letters in reverse, like Lewis Carroll. A mirror was needed to read it. In his notebooks he said himself that a painting looks better in a mirror than in real life. It was precisely when

Suzanne Giroux did this that the smile, tilted at 90 degrees, then reflected in a mirror, showed two different back views: the image and its reflection. Those enigmatic lips, therefore, in reality concealed the buttocks of two different boys.

Why this travesty? Leonardo was a homosexual. He was accused of active sodomy and at the age of twenty-four appeared before a tribunal in Florence on 9 April 1476. But for lack of evidence he would have been condemned to be burnt at the stake; instead, his case was dismissed. He was never known to have had any friendships with women, and surrounded himself with a host of not very talented but quite presentable apprentices who were often changed. And he made them pose for him. He drew a great number of male nudes and showed a certain predilection for the small of the back, buttocks and thighs, while he was interested in women for their faces, busts and hands. What, in these circumstances, could be more ingenious than slipping one into the other, concealing a boy in a woman and translating a behind into a smile. In 1540, Vasari had this to say about Mona Lisa's smile: 'The modelling of the mouth, joined to the fleshtints of the face by the red of the lips, appeared to be living flesh rather than paint.' It has also been noted that this back and rear are in perfect homothetic proportions to the painting as a whole: that is to say, if you blew them up, you would find that they were precisely the same dimensions as the Mona Lisa: 76.96 by 53.08 cm. In any case, you will not find any bottoms in paintings of other mouths. In 1919, Marcel Duchamp had the inspired idea of giving Mona Lisa a moustache, along with the unique title of L.H.O.O.Q. which pronounced phonetically in French would read *'Elle a chaud au cul'*—'She has a hot behind.'

French art never celebrated the male bottom to any great extent, apart from Géricault or Rodin, for example in *The Falling Man*, a detail in bronze from the *Gate of Hell*, in which, however, Edmond de Goncourt saw only 'a bank of coral'. Certainly in Fragonard's *The Bolt* the young gallant's torn pants leave no cleft, shapely buttock or dimples to the imagination, and yet, bizarrely, there is nothing to be seen of the charms

of the desperate young lady, 'her upturned face, frightened
supplicating eyes, despairing of herself and weakly pushing
away her lover's mouth'. She is struggling to resist him but it
is her lover's backside that attracts our admiration. Its thrilling
charms, however, were very quickly challenged by the Repub-
lican bottom, the incarnation of innocence and virtue. It was
a wildly proud backside, which would never have risked the
voluptuous abandon and promiscuity so typical of the liber-
tines. David was its creator. The men in his paintings are
magnificent but there are few bottoms. David's naked warrior
is a full frontal standing nude. Except in *The Sabine women
enforcing peace by running between the combatants* (1799). Taking
his inspiration from Plutarch's *Life of Romulus*, David does not
describe the more popular subject of the rape of the Sabine
women, but the moment when the Sabine women come to
separate the Sabine and Roman armies three years later, when
Tatius, the Sabine chief, fell on Rome to 'exterminate the
rapists'.

Hersilia, who had become Romulus's wife, exhorts the
Sabines to make peace. Romulus then hangs up the javelin
that he was preparing to throw at Tatius and the general of the
cavalry replaces his sword in its scabbard. 'Soon afterwards,'
Plutarch notes, 'the Romans and Sabines joined together to
form one people.' It is therefore this precise moment in the
suspension of arms that David chose, as a symbol, he said, of
reconciliation for the French after the rifts of the Revolution.
What is there to see? To avoid the carnage Hersilia, in a loose
white dress, and with arms extended, has come between her
brother (Tatius) and her husband (Romulus), entirely naked
athletic warriors (there were so many nudes in this picture
that Napoleon refused to purchase it). She is trying to make
them join forces rather than be enemies. Their position and
attitude are such that, if they move a few steps closer, they
will be in each other's arms. Hersilia is making a tremendous
effort, but there is not a single movement of the head towards
her. Tatius is looking straight ahead, his private parts can just
be glimpsed behind his scabbard (although David retouched

this area in 1808). As for Romulus, whose back view can be seen behind his shield, only his plumed helmet, his lance and his perfect backside are visible. And it would be difficult to make anything more male or more sensual than this posterior.

One might have thought that since women painters appear to be so fond of this part of the male anatomy, they would be rushing to paint it. But not so. Tamara de Lempicka (1898–1980), who is known as 'The Siren of Art Deco', is better known for her beautiful prostitutes with their nacrous skin and her inimitable cubist style than for her male bottoms. Almost none can be found except in her *Adam and Eve* (1932) where a male bottom appears, though not at its best: it has been labelled 'Cubo-Ingresism' but in fact it more closely resembles a goitre. That said, all Tamara de Lempicka's women are goitrous. Apparently women with a hypertrophic thyroid gland are predisposed to an extremely active sex life. I wonder if a man's goitre, if lodged in his behind like this one, would have the same virtues? All we know is that Tamara, not having any Adam in her entourage, went down to the street to find one. She happened upon a policeman, who followed her to her studio, took off his uniform, folded it neatly, placed his revolver on top, and, naked, took up a pose on the podium, then turned round. It was the backside of the century. No one could claim it was easy to forget.

More ferarum

Backside fetishism is described in confessor's handbooks as
'love *more ferarum*'—love the animal way. This coitus *a retro*
which might wrongly give the impression of being a travesty
of nature, has the great advantage, as Apollinaire said (in *Les
Exploits d'un jeune Don Juan*) that just for once the 'backside is
used for something beautiful'. Lucretius noted (*De Rerum
Natura* IV) that women, in the animal position, are generally
thought to conceive better 'because, with the rest of the body
at a lower level and their bottom in the air, their organ can
thus absorb the sperm.' But the Church as one knows has only
ever recognised 'one natural way of coupling'. 'That is with
the woman lying on her back and the man lying on top of
her, making sure he ejaculates into the vessel provided for
that purpose', as Father Thomas Sanchez recommended in
1602. Any other position was considered bestial. The Church's
main reason was that it increased pleasure, which until the
seventeenth century was considered wicked during the act of
procreation.

Even if this coitus *a retro* was performed using the 'legiti-
mate vessel', the sight of the podex might occasion unknown
heights of sensual pleasure and 'intoxicate a man's libido'
through these 'lubricious, lust-provoking caresses', enticing

him foolishly to perform coitus 'outside the accustomed vessel'. The only permitted exceptions to this rule were if the husband were too fat or the wife pregnant, in which case Albert the Great authorised a sideways approach, or a sitting position or taking from behind 'like a mare' (these are placed in the order of increasing gravity of sin). This way of doing it was not only bestial, but dangerously changed perspectives: for the woman turned her back on the man, and if he saw the mad look in her eyes, she in turn could not see him. It was therefore, in a manner of speaking, a way of moving the eyes to the backside and ultimately promoting a blind relationship with a faceless, unknown body: a most infamous thing to do.

After all, what is the *derrière*, if not a part of the body considered extremely shameful? The word, which appeared in 1080, came from the vulgar Latin *deretro* which in turn was based on the classical Latin *retro* (behind, from which the English 'rear' also comes), and it had been appropriated into military vocabulary to mean the zone or base behind an army: it was therefore a base for reinforcements. But after 1230, it was also used to describe an animal's posterior, and in common parlance, a man's. The words 'derrière' and 'behind' have produced many jokes. Jules Renard, in his *Journal*, used 'behind' in very direct fashion when he wrote of 'astonishing women with squalid behinds, like the hanging behinds of hamadryads, that they held up with their hands.' The hamadryad is a type of baboon and even if it was the sacred baboon of Ancient Egypt, its *derrière* has over the years caused much mirth. Vulgar talk has produced many mocking allusions to the rear location of the behind: the rear entrance, the back door, the artists' entrance.

Negative ideas of the *derrière* are in fact linked to negativity about lower orders and leftness: these are the bad sides of things. The *derrière* combines negative ideas about both 'behind' and 'bottom'. Roger Caillois pointed out in his book on dissymmetry (*La Dissymetrie*) that the symmetry of left and right (known as sagittal or mirror symmetry) is what we have come to expect and is the only one which, when absent, makes

any façade or structure appear abnormal, lopsided or incomplete. People often add a symmetry of front and back to the sagittal one. But this is often only supplementary to the main one. It occurs, for instance, in a tower of fortifications, so that it is equally protected on all sides by identical walls, with the same narrow openings, whereas buildings for residential purposes, having only a pacific purpose, will have a façade provided with numerous large windows in contrast to the 'blind' side at the back of the building, analogous to the human body. As well as the opposition of front and back there is the symmetry of future and past, earliness and lateness, progress and regression. There is no doubt about the preeminence of the forward side (for sight, movement, initiative, courage) over the disdained and troubling world of the back— the dorsal, blind, abandoned, rejected side.

As for 'transversal symmetry' produced by top and bottom, this would simply be against nature: gravity does not allow it. So the superiority of the high over the low is confirmed, as is that of ethereal over coarse, spirit over matter, noble feelings over base instincts, lightness over heaviness, rising over falling. 'But to the girdle do the gods inherit,/Beneath is all the fiend's,' said King Lear (IV, 6). At one pole, there is reason and disinterest, at the other the unworthy sensual appetites. At the extreme, sublimation (so well named) becomes the antipodes of anal fixation, the ideal as opposed to the dregs. In short, simple gravity, the opposition between root and branch, between the thinking head and the intestines, between the sensitive, eloquent opening, the organ of nutrition, of singing and speech, and the excremental sphincter which provokes distaste and suspicion, naturally provides associations that have discredited the bottom.

This pessimistic view of the behind bristles with medieval hierarchy and its model of a unilaterally vertical world, a world that Rabelais so vigorously and joyously rubbished. Today we wonder if in fact the preference given to the top and front, in other words the face, is so legitimate. Making a portrait, the photographer Jeanloup Sieff observed, most often consists in

showing a face or a bust. The face, however, is the most exposed part of the body, the most used in social life and it has become a hypocritical mask on which almost anything one wishes can be expressed. This was one of the reasons why he became interested in the behind. It was for him 'the most protected, most secret part, the part that keeps a childlike innocence unlike the face or hands which lost it long ago. It is also the part of the body which is the most moving, in a sculptural sense, made up of curves and promises, it is the part that looks back since it is turned towards the past, while we move inexorably forward. It is like a child on the back seat of a car looking out of the rear window on to the world that has passed by.' So, unlike the face with its mixture of trickery and pretence, the behind has a genuine sincerity that comes quite simply from the fact that we cannot control it. The behind remains our instinctive, animal part, incapable of concealing its true nature, its joys and torments. It is the underside of the personality. And no matter whether it belongs to an individual, a house, or a town even, the same applies. 'At Roanne,' Michel Tournier writes (in *Les Météores*) 'there was an overgrown dump known as The Devil's Hole.' It was a sewer 'where in the emptied contents of the rubbish trucks, the town revealed its most intimate matter: its very essence.' And Alexandre, one of the novel's characters, is seized with an intensely emotional curiosity that leads him to explore inside the hole all on his own. 'There was the misunderstanding that separated us,' he said. 'For my town councillors, rooted as one in the social fabric, refuse was a hell equivalent to nothingness, and nothing is abject enough to be thrown there. For me, it is a parallel world, a deforming mirror, made from the very essence of society, and a variable but completely positive value is attached to every turd.'

Slang

'What do you call a behind, when the words for it are so charmingly concealed?' asked the singer Georges Brassens. There's a simple answer: you can look it up in dictionaries of slang or eroticism, and you will see that, besides its more common names—posterior, rump, rear, arse, ass, bum, *derrière*, behind, backside, seat, fundament—it possesses a host of other colourful names that evolve from three basic ideas: its situation (from being at the back or the bottom of the body), its similarity to the moon (in French, at least), and farting (emphasising its musical role).

Some see the bottom as a face, a face of the underside. A rather incoherent, disturbing face which is distorted and anarchic. It is entirely round, and split right down the middle, with a minuscule eye-mouth and full cheeks on either side. Hans Bellmer imagines the buttocks are two immense eyes smiling blindly on to the opening of the anus.

Faced with such a strange visage, the imagination runs riot: 'Here's a good one,' Paul de Koch cried. 'He has mistaken Petronilla's moon for her face.' An unpardonable mistake, in French, though in English we do not use this lunar analogy, except in the expression of 'mooning'—exposing the bum to public view, a speciality of students and rugger players.

In French nineteenth-century slang the bottom was 'the noseless face' (Larchey 1872). It is jawless too and in moments of fear or anguish, its cheeks clench and contract, but unlike jaws they cannot chatter. The idea of the bottom as a face is reflected in English nineteenth-century slang for a chamberpot: a looking-glass.

The anus was referred to as 'the impure mouth' by the French writer Alfred Delvau in 1864. A mouth with murderously foul breath. In *Dictionary of the Vulgar Tongue* (1811) the fundament is called 'the round mouth' with the explanation: 'Brother round mouth speaks: He has let a fart.'

The French for farting, incidentally, is *péter*, a word that has been incorporated into many French surnames, including, as James McDonald points out in *Wordly Wise*, that of Maréchal Pétain. And no book about bottoms would be complete without a mention of the famous French Pétomane, a music hall artist who could not only blow out candles but also play tunes by this ingenious method.

Not only does the fart have auditory qualities but olfactory ones too, which may have given rise to the derogatory description of 'old fart' for a bumbler.

The anus is also a mouth that looks at you, like the eye of a Cyclops. Quevedo speaks of 'the bottom's eye' and Jean Genet of 'the bronze eye'.

However, the first question that must be addressed is exactly where the behind is situated: at the bottom or in the middle of the body? In English we say 'bottom', 'nether regions', 'lower regions'; in French they also talk of the *'petit centre'* or *'juste milieu'*—the exact middle, which applies equally to front and back.

Some people have pointed out that the rear is our centre of gravity (which it is), but if the belt is worn on the strategic dividing line between top and bottom, mouth and anus, noble and ignoble, then you have to admit that the bottom is not in the centre of the body, but 'below the belt'. On the other hand, the bottom, or 'cull' as it was once known, is exactly opposite the front bits. (As an aside, we might mention that

there is some transatlantic confusion here over the naming of parts. Americans find the word 'bottom' not very nice, and call it 'fanny' instead, but in English 'fanny' refers to the front bits and not the behind.)

Some French writers indulge in far more elaborate imagery. Béroalde de Verville in 1612 described the posterior as a 'suburb' situated near the real gateway of the town.

The main image in the mind, however, is the roundness and softness of the bottom, the way it projects. Its rounded sides remind the French of millstones, cymbals, sundials and, as we have said, the moon, half-moon or full moon, depending on what the situation has to offer. In early nineteenth-century English, the bottom was called 'the wind-mill', as opposed to the woman's private parts which were called 'the water-mill'. There are other rural expressions for the buttocks: the owner of large projecting ones was labelled 'hopper-arsed'. And sometimes similes were reversed. Instead of having a bottom like a downy peach or a rosy apple, the slang name for a medlar was 'open arse'—'of which,' the *Dictionary of the Vulgar Tongue* says, 'it is more truly than delicately said that it is never ripe until it is as rotten as a turd, and then it is not worth a fart.'

Buttocks were also known as 'pratts', hence the technical expression used by comedians: 'pratfall' meaning a sudden fall on the buttocks. At all events, buttocks are round and cheeklike. Apollinaire put it well in *Les Onze Mille Verges* (Eleven Thousand Pricks): 'Show me your behind. How big it is, and round and chubby, like an angel puffing his cheeks.'

Since we have become more sanitised as a nation, certain expressions, which might be termed 'appendages' to the behind, have fallen out of fashion: 'fartleberries' and 'dilberries' are no more. Although we have been informed that the word 'clingers' now has the same meaning.

While 'to land arse upwards' means to have luck, most other expressions connected with the bottom are derogatory and many are connected with homosexuality. 'To kiss someone's arse' or 'lick someone's arse' (both eighteenth century), like the modern expressions 'brown-nosed' or indeed 'brown-

tongued' all refer to the servile flatterer. The magazine *Private Eye* makes a fortnightly award of the O.B.N. (Order of the Brown Nose) to the previous two weeks' worst sycophantic grovellers.

As a general rule 'arse' usually refers to women. To say that 'there was plenty of arse there' means that there were (attractive) women present. In Quebec, as children, it was normal to say that we were going to *jouer aux fesses* (play with arse), meaning our little girl neighbours.

It has been observed that *fesse* and *femme* begin with the same letter, which must indicate something. Alfred Delvau (1864) even punned that *femme* and *fesse* (meaning 'buttock', in the singular) were both halves: *fesse* being half a bottom, and woman being 'the other half'. In *Mort à Credit* (Death on Credit), its author Ferdinand Céline says of Mme Vitruve and her mother 'that they were both a good bit of arse', meaning that they were hot stuff. They flaunted (literally 'drummed') their arses when they admitted a man. From saying that to saying they were prostitutes is but a short step. A *magasin des fesses* (an arse shop) has quite naturally come to mean a brothel.

The word '*cul*' (cull in old English), which in French can also mean woman, has a Latin origin *culus* which is related, so one is told, to *cunnus* from which our word 'cunt' is derived. So it is not surprising to find the Ivory Coast expression *boutique mon cul* (exposing my bottom), when someone is a prostitute. It's somewhat in her nature.

'To get up someone's arse'—a more severe irritation than 'to get up someone's nose', is a not too oblique reference to homosexual practitioners, known in the eighteenth century as 'madgeculls'—'madge' being slang for a woman's private parts—or 'indorsers', and sometimes referred to now as 'shirt-lifters', 'pillow-biters' or 'bum bandits'.

'Stick it up your arse' is often now modified into such euphemisms as 'You know where you can stick it,' or just 'stick it', and 'up yours'.

An old expression, 'he would lose his arse if it were loose', and the American expression, 'he couldn't hold his ass in two

hands', have been replaced by 'thumb up bum and mind in neutral' and refers to someone not quite with it along with the remedy: 'He needs a firework up the backside'.

While 'arsing around' means innocuously playing about, to go 'arse over tip' has taken over from the archaic 'to go arsy-varsy', and has given rise to expressions to describe confused people: 'he doesn't know his arse from his elbow', and 'he's all arse about face'. Or just 'an arsehole' describes someone particularly 'prattish'.

'Bottoms up' has no reference at all to the human anatomy, and is an expression favoured by drinkers, who often end up 'rat-arsed'.

By the way, 'arse' (from the Old English 'aers' meaning ears) and 'bum' (from the Middle English 'bom') were both perfectly respectable words in the distant past.

Odalisque

Up until 1765, an odalisk or odalisque was a female servant in a Turkish harem, but after this date the word came to mean a woman of the harem, a concubine rather than a slave. Seventeen sixty-five also marked the beginning of her career in the world of painting. Miss O'Murphy, who had nothing Turkish about her, enacted the role very nicely for François Boucher, but it was with Ingres, Delacroix, Modigliani and Matisse that the odalisque found employment to match her new pretensions. Naturally what interests us is the odalisque's back view, a version when all is said and done that is more exquisite and rarer than a front view.

The odalisque is always seen lying down, never standing. She lies totally inert. She has the triumphant, radiant, satisfied grace of an inactive woman. You can imagine her, as in the Master of Flora's *The Birth of Love*, with tiny feet that seem to have shrunk from underuse. Sometimes she looks out of the picture, sometimes at her own body which is invariably naked. Sometimes she leans on an elbow showing off her behind, or lies flat on her stomach in a state of extreme lassitude or drowsiness. She looks as though she does not know what to do with her body. As though she is always trying to find the best way to avoid total numbness. The odalisque is, then, a

sluggish sort of person who believes that time is there to be wasted and that life improves by going to the bad. It is a concept that leads on to another. If you notice, in the art world you rarely see paintings of naked men asleep, in this Turkish fashion, just as you will see only a few women standing, virgins in armour (like Kleist's *Penthesilea*), wild female warriors of Asia Minor, with the thighs and buttocks of indomitable Amazons.

For many men, the odalisque would appear to be their inaccessible dream of the passive, languid, insatiable woman she should always have been. Only in the photographs of Helmut Newton is she endowed with a haughty, swaggering, quite muscular backside, enormous legs and heels. Her bottom, though slender, is androgynous and is a good match for the half-shaven pubis on the reverse.

Velazquez was the first painter to discover the odalisque. There was nothing Turkish about her since he called his painting *The Toilet of Venus* (c. 1650—and more familiarly known as The Rokeby Venus, in the National Gallery, London). This is more an allegory of vanity than anything else. He shows her back view, stretched out prettily on a black sheet (one of Sade's fantasies) looking at her face in a mirror held up by a *putto*. Considering how stilted the court of Philip IV of Spain was at the time, this shows some style. There are at least five nude paintings by Velazquez which have a similar theme and also display a personal taste. But what gives this painting piquancy is that it was inspired by a man or rather half a man, since it derives equally from the Hermaphrodite in the Villa Borghese. This young woman, however, does not have a particularly voluptuous bottom: if she appears beautiful it is because she is slim, her buttocks are still young-looking, and her skin is wonderfully luminous (on the black sheet); she does not yet have the flab that will come with age. She is a tender young girl. Some critics view this painting as 'the first pagan nude—a philosophical nude almost'—which is perhaps excessive. She is certainly looking at herself, or rather she is watching us looking at her, and between her look and ours

there is her bottom. Which is why the painting rouses our enthusiasm. It is not the first backside in the history of painting, but this one has something original, inspiring pleasant reverie. However, in 1914 an exasperated suffragette stabbed this daring painting seven times.

Ingres' pictures, whether drawings or paintings, are more disturbing. There are bottoms everywhere but nowhere. Ingres was clever at sketching in a behind and making us believe that it was there. His odalisques' bottoms could be mistaken for swan's necks, an invertebrate arm or a hand that is half octopus half tropical flower. And what might sometimes pass as a long, spiralling liana turns out to be a cartilaginous, extendable woman. In short she is deformed. Monsieur Ingres did perhaps have a Raphaelesque purity and a sense of sin, but he stretched everything to extremes. His contemporaries could not resist counting the vertebrae in the *Grande Odalisque*: in fact there were three too many. Thetis's sinuous arms in *The Apotheosis of Homer* were also far too long. 'No woman's neck can ever be too long,' he retorted. Even so, none of his women look remotely human. As the poet Paul Valéry remarked, 'Monsieur Ingres' charcoal extends grace into monstrosity.' His odalisques more closely resemble plesiosauruses, leading one to think that careful selective breeding had produced a specialised race of women of pleasure over the years, rather like the English racehorse.

Baudelaire may have been wrong here, for he believed (in 1846) that Monsieur Ingres had taken a black girl as a model in order to achieve the slender effects. Baudelaire's own liaison with Jeanne Duval, 'the incontestable mulatress', went back to 1842 and he had been able to establish certain points of comparison. Only Ingres stretched everything. It was all artificial. He had no particular woman in mind or he may have had every woman in mind at the same time, because they all look the same. They are fairly solid, ineffably smooth and supernaturally ethereal in their voluptuousness. Which might have seemed monotonous had the painter not had the inspired idea of piling them all in a heap. This was in *Bain Turc*

(Turkish Bath) (1862). Looking at such a sensual whirlwind can be suffocating. For *Bain Turc* is presented as a semi-exhaustive anthology of women in every conceivable position (except standing, or back view): they are sprinkling perfume, displaying breasts, caressing themselves or their neighbour, ravished by the memory or the intoxicating promise of giving themselves to the sultan. In fact it was one of his contemporaries, Théophile Silvestre, who revealed the painter's secret mania: he liked plaiting, knotting and interweaving lines 'like willow wands in a basket'. It was not then a snake-woman who attracted him but a basket-woman. As for the bottom, naturally, it hadn't been an essential requisite in this sort of painting for donkey's years.

The odalisque bowed to every demand and every contortion. Corot's *Roman Odalisque* (1843), known as Marietta, was cara-melised beforehand (to make her the colour of burnt sienna). Van Gogh's *Sleeping Nude* (1887) was quite young and robust but her backside is out of true with the rest of her body, and the black plait twirling down her back gives her the appearance of a chestnut filly. Modigliani's *Large Sleeping Nude* (1917), entirely red and boringly hieratic, looks like one of man's great fantasies: the hare-woman. But, at last, for the first time in the history of art (with the exception of Courbet's *The Origin of the World* (1866), this painting did show pubic hair timidly appearing between the buttocks, and the public was outraged. Then, with all those animal women, we lost sight of the Great Languid Oriental. It was Matisse who took up this interesting subject again in his *Back View of Reclining Nude* (1924). And what a backside! In the intervening period it had tripled in size. As the model has placed all her weight on the right side, the buttocks appear one above the other in two storeys as it were; it is phenomenal. Matisse thought that this looked like a Moorish woman. Whatever the case, this woman was heaviness that is alive. Furnished with the equipment she has, she can probably only exist lying down, for it is difficult to imagine her resisting the immutable laws of gravity.

An indescribable bottom in the form of a crucifix was pro-

duced by Clovis Trouille (1889–1975) entitled *Oh! Calcutta! Calcutta!*. It is perhaps one of the finest female backsides of all time, quite simply because that is all you see, the rest being miraculously rolled into a snakelike tunic. A few sacred flowers are discreetly impressed into each buttock, like columbines around the altar of repose at the Feast of Corpus Christi. Between the buttocks is the outline of a cross, in the centre of which the orifice could perhaps be mistaken for a bleeding heart. Clovis Trouille has turned the entirely round bottom into a votive offering which, for him, epitomises all man's aspirations.

Egg

You may be wondering when the bottom can be seen at its best and from what angles? The answer is: usually the simplest. The standing position, for example, can be entirely beautiful with the legs firmly supporting it. It is even more beautiful when walking, with the subtle rolling motion of its two great fleshy swaying breasts. Or again one of the pleasantest experiences you can have is to watch a woman's (or a man's) rump rise into the air when she or he stoops down to pick up something. Or there may be a neglected *derrière* dispiritedly waiting at a bistro bar, or a behind revealed in passing, particularly when it is done furtively. Audacious poses of acrobats and stuntmen, or ingenious set pieces are not necessarily the best, even though modern art has now accustomed us to the unexpected.

In 1958 Joseph Beuys exhibited his *Couple*, painted on writing paper in shades of chestnut brown. There were two silhouettes, one above the other, with their thighs spread-eagled, so that they looked rather like spider's legs. The painting was a cross-section of the behind, with its irregular double arch. But if such a position were copied from real life, the woman would have been lying down, and her bottom would not have been open to view. Why Beuys' bottoms are splendid

is because they are stuck up in the air; their joints are perfectly drawn, and he has put in all their deep hollows.

The bottom can also be seen in a more stylised rendering in a painting by Max Ernst of 1923—*The men will know nothing about it*. This subject is also a couple and all one can see are their legs wide open and meeting at the centre, as if the arc of the backside were stretched out of proportion in order to be outlined against the entire leg. It is obviously magnificent, though improbable, to see two lovers thus absorbed into a cone-shaped moon-bottom.

Something unusual is suggested in an untitled, undated drawing in Indian ink by André Masson: male and female private parts *in coitus* are seen from below and considerably enlarged, as if one had glimpsed them by surprise through a window. The buttocks have been deliberately and almost entirely flattened to highlight the vulva, which looks like a piece of grass, along with the penis, balls and dilated anus. It is a viewpoint which is much more surreal than the two bodies suspended in the air as though levitated.

I much prefer the more realistic detail of Parma cathedral, painted by Correggio, in which a man is falling from the sky. Seen from below, the body seems to be headless, the limbs spreadeagled, the penis hanging loosely, and the bottom looking somewhat stunned. Seeing a man falling like this into the void, and, *in extremis*, yielding all his riches, cannot help but be disturbing. But any backside raised in the air is always a success. Witness, in 1984, the Paris exhibition of Ernest Pignon-Ernest's *Arbrorigènes*, seen hanging from trees. These were truly vegetable creatures, made up of microscopic algae which had been trapped inside a polyurethane mould in the shape of a man. Thus immobilised the algae continued to live but were incapable of modifying the shape of the sculpture. Because the algae were constantly reproducing themselves in the light, moist atmosphere, the sculpture had turned green naturally. Ernest Pignon-Ernest had succeeded in creating a sort of chimaera: a hybrid bottom.

'In the presence of God,' Michel Tournier noted in *Vues*

de Dos (Back Views), 'man kneels with shoulders hunched, foundering in his modesty. And so has less hold over divine wrath.' The *derrière* at prayer can also be very beautiful. On Fridays in Paris, you can see whole streets littered with the backsides of Muslims at prayer. As if they were praying to God by offering themselves to man. The Catholic *derrière* has never offered us such visions of paradise. In Clovis Trouille's *Confessional*, you can hardly distinguish the two charming girls, kneeling on their prie-dieus with their little puffed-out farting bums. It is all very perky and likely to produce some miraculous vapours in the confessional.

In a photograph that has done a world tour and is called *The Prayer* (1930), Man Ray shows a pair of woman's buttocks resting on her heels: the cleft is lightly stuck together and folded hands carefully mask the anus, but it is a dazzling vision. The woman is shown as a split sphere, with four short-ened limbs and a considerable quantity of fingers. This was a triumphant moment for the egg-bottom. Recently the pho-tographer James Fee photographed a bottom sitting in the middle of a stony desert, using a wide-angle lens. He trans-formed the black, compact egg-bottom into a monument.

At Port Lligat it is said that Dali surrounded himself with the most sublime *derrières* imaginable. 'I get the most beautiful women to undress. I always say that it is through the behind that the greatest mysteries can be fathomed, and I have even managed to find a significant similarity between the buttocks of one of my female guests at Port Lligat whom I got to undress and the four-dimension or space-time continuum that I call the "four-buttock continuum" (i.e., the atom).' Dali had a love-hate relationship with his sister Ana Maria. And in the period between his *Christ of Saint John of the Cross* and his version of the *Last Supper*, he painted perhaps the most erotic of all his paintings, *Young girl sodomising herself on the horns of her own chastity* (1954). During his 'scatological' period, he had already done a portrait of his sister viewed from her behind and had entitled it, so that no one could be mistaken as to what it was: *The Image of my sister / her anus red / with*

bloody shit. Twenty years later, however, he embellished his memorial to Ana Maria: this plump, rather squat young lady can now be admired for her blonde curls, black silk stockings, huge nipples and staggeringly vast buttocks like ostrich eggs. It is assuredly, as Gilles Néret has said in his *Erotique de l'art* (The erotic in art) a 'lyrical feast'. Dali has surrounded Ana Maria's beautiful bottom with curious cylindrical-conelike excrescences. Its glacial firmness, however, would be more fitting in a painting of rhinoceros horn.

Sport glorifies muscle development, which in turn flatters the bottom. In Greek and Roman fights, for example, the bottom developed rather like an accordion: it contracted, expanded, spread in a truly gluteal choreography. But the bottom's great sport, without which it would be nothing, is of course rugby. The rugby player's bottom is broad and hefty, and when viewed in a rugby scrum it is the behind of a blockhead. Especially the full-backs' bottoms, since they are the ones one can see best. A scrum is nothing less than a cohort of stacked behinds in the shape of a two-ton tortoise, or a sort of infernal rosette. It becomes a gigantic, incoherent, living, anal monster moving rapidly in fits and starts until it finally explodes, only to regroup again some thirty-five times a match. Most curiously, Michel Tournier notes, the players knot together like this to expel an egg, which is then passed from hand to hand. And this egg emerges from their behind. 'These fresh, muscular youths,' Alexandre says in *Les Météores*, 'yield to a curious ritual not unlike marriage. They are bunched together like grapes, and immediately one of them shoves his head between the buttocks of the one in front, with all the force he can muster, holding on to his neighbours on either side, so that this nest of males sways and wavers under the mighty crush of buttressed thighs. Finally a great egg is laid in the heart of the nest and rolls between the men's legs, who then disperse to fight over it. The mighty forest of legs now seems more like a lover's thicket.'

In *Le Paradis des Orages*, Patrick Grainville writes of twin sisters who went up to the bathroom door and pressed their

bottoms against the steamed-up glass, leaving the impression of two symmetric bottoms or four squashed buttocks on it. This kind of hallucination about bottoms is quite common. And reminds one slightly of Max Ernst's *Two young girls in beautiful poses* (1924). It seems pleasing at first to have them presented in twos, like a team, then piled in a heap like bunches of acorns, or a necklace of bottoms.

In Walerian Borowczyck's *Immoral Tales*, there are similar groups of young girls, entirely naked, captives of Erzsebet Bathory, 'the bloody countess', clinging together as they clamber up the stacked tables to watch an orgy through a hole in the wall. But the real spectacle is of course this stack of behinds that looks like a bank of coral or sponges.

Large groups of bottoms encourage the eye to wander and can even turn one's head, but more than a few, I am sure, have dreamed, as Ramón Gomez de la Serna did, of breasts, of an island of bottoms, where superwomen lie with their bottoms in the air. The moon, like a great voluptuous Sappho, shines directly down, spreading her gentle rays over meadows strewn with bottoms upraised to her.

I am reminded of Germaine Greer at the launch of *The Female Eunuch*, when she shocked America by flashing her *derrière* to the world. The world recovered but the incident set a precedent. Although in the 1920s, it is true, George Grosz had exhibited in Berlin a whole series of obscene and grotesque caricatures of pre-Nazi German bourgeoisie (labelling him as a degenerate artist). He showed these small pink piggy characters indulging in orgies (perhaps at a brothel), most often one man to two women, and always slightly ridiculous and artificial. Invariably the women were exposing their enormous backsides, and, worse, wide-open vulvas. The flesh is flabby and faces tired, indeed even disappointed when a woman in mink, fed up with waiting, turns round to see a little man in pince-nez enjoying himself, whose reddish tool is as gross as his torso.

More recently, Jeff Koons's *Ilona with her bottom in the air* (1990) shows us that the same situation is just as popular

today and can inspire monumental compositions (this one measures 247 × 366 cm). Ilona Staller, better known under her name of Cicciolina, is on all fours, *more ferarum*, her back arched almost to breaking point, so that she can display her poignant behind in Genoese lace. She fully satisfied her electorate, without so much as compromising her seat as a radical member of the Italian parliament. 'We had underestimated the consequences of registering this kind of phenomenon as a parliamentary candidate,' the federal secretary of the Partito Radicale said soberly.

Andy Warhol had already multiplied close-ups of the male bottom, making details slightly iridescent, for the cleft amounts to a smear of sweat, a dirty mark on a train window. Finally Mapplethorpe, seeing an exposed bottom, opportunely stuck a whip into it and produced a famous photograph; the artist's biographer comments upon it as 'the tangible object of a masochist fantasy'. Others malignly concluded that the devil's tail was but a whip whose shaft had entered his anus.

Stake

In his painting of *Manao Tupapau* of 1892 (translated variously as 'She thinks of ghosts', or 'The Spirit of the dead awakens') Gauguin showed Tehura, his vahiné, lying on her stomach, naked and terrified, her body rigid, her eyes hallucinating, because she has just witnessed the Tupapahus, the spirits of the dead with phosphorescent eyes who come down from the mountain at night. It is quite rare to see the effect that fear, and particularly fear of death, has on the bottom. Tehura is usually painted lying on the bed in a posture of animal innocence, gentle and welcoming (generally on her back, but a child of Nature has neither front nor back); now we see her as nervous as a cat, galvanised by this black ghost standing behind her, whom she cannot bear to look at as he haunts her. Gauguin recounted in *Noa Noa* how one day when he returned late to their hut, he lit a match so that he could see in the gloom. Tehura saw the spirit of the dead in its flame. Several years before Pierre Loti had been astonished that there were so many words in the Maori language to express the terrors of the night. 'It is a dark enchanted country,' Loti wrote in *Le Mariage de Loti*, 'where there seems to be a lack of life.' At night-time, when they heard the metallic sound of rustling leaves in the coconut plantations, it was as though

they were hearing the laughter of the Tupapahus, tattooed ghosts, accompanied by the lugubrious crackling of branches. 'It was the soul of Polynesia that had been disturbed,' Loti said.

And then there are the bottoms of the dead. I could almost say that death leaves the bottom intact but that is not quite true. Dazzling perhaps. Death gives it a luminescence. If you look at recent photographs of blacks martyred in the townships of Soweto with their scarred flesh, they bring to mind images of feathers, mud and milk, the great tracks of wild animals, meat hooks. Or the corpses of the Tutsi killed in the forest between Kigali and the Tanzanian frontier, during the recent massacres in Rwanda—splendid blue bottoms under a blue sky. Or the dead lying in the chariots in Peter Greenaway's film, *Drowning by Numbers*—large solemn bottoms, with elegiac fleshtones and an aura of grandiose impassiveness. Inevitably, the flesh colours are those of a corpse, but the buttocks themselves remain intact and alive. And they even grow on the dungheap of death, like zombie bottoms with frighteningly lurid, purple highlights. As if such a resolute, sumptuous shape could not consent to rotting.

Inspired by Byron's tragedy of the story of Diodorus of Sicily, which had been published in 1821, in 1827 Delacroix painted one of his best known canvases, *The Death of Sardana-palus*. Sardanapalus was a legendary king of Assyria, famous for his unbridled lifestyle, who committed suicide when he set fire to Nineveh in 874 BC. When the insurgents attacked his palace (after a two-year siege) and he saw that all was lost, the king, it is said, lay down on his ceremonial litter on the top of an enormous bonfire, and gave the order to his eunuchs and palace soldiers to slit the throats of his women (among them Myrrha, his favourite Greek slave), his pages and even his horses and dogs. Nothing that had contributed to his pleasures was to survive him. In this general massacre, Delacroix chose to show Myrrha's last moments, sacrificed in all her splendour. For it is, of course, the suffering of the

stabbed slavegirl that arouses and excites her young, opulent, gleaming behind as never before. And is all that to go to waste now? Not at all, the painter Cueco will tell you. He has noticed that her sexual parts are mischievously concealed inside her sandal, or rather mule, in a small, nacreous, whitish-pink mark, forever yawning under the threat of the dagger. And her majestic buttocks themselves are disconcertingly displayed in the shape of an oriental slipper, and have a viperine movement of lascivious abandon under torture. 'The livelier our resistance to the ordeal,' Novalis wrote in the *Encyclopedia*, 'the livelier the flame will be at the moment of pleasure.' Which explains why this woman is contorted into such an expression of voluptuous suffering and, though trembling with terror, she has taken on the undulating shape of the flames flickering around the catafalque. This kind of sadistic obsession, however, is very much of the Romantic school. And the fantasy of bottoms finding pleasure and beauty in violent torture could only come from a man. It reappears in the sculptor Auguste Clésinger's *Woman Bitten by a Snake* (1847). This time the recumbent body is arching up in desperate fury. Clésinger used Apollonie Sabatier as his model for this. She was a *demimondaine* nicknamed the Présidente, and both Baudelaire and Théophile Gautier were among her lovers. She obviously merited their homage. She is arching in pleasure with her body and rebellious bottom in the shape of a crescent. It was a scandalous pose, but Apollonie profited from it as a result. And Baudelaire, I believe, found the *mot juste* for the subject: 'Cherished poison, prepared by angels'.

Perhaps some people might have thought that torture was an effective way of arousing a similar arching of the bottom. Two types of instruments were envisaged for this. First there were those that cut and split, like a saw: a drawing by Cranach shows a tortured man hanging by his feet, in the process of being sawn through with a long saw, starting at the cleft between the buttocks. This is evidently the perfect torture for the bottom, not so much because it is raised into the air, but rather because the bottom has the perfect shape and fit for this

type of sacrifice. The upside-down position ensures that there is sufficient oxygen going to the brain, and prevents rapid haemorrhaging: the victim would only lose consciousness when the saw reached the navel. So the bottom is still living when it is being severed in two.

The second type of instruments are those that pierce and make holes in flesh, such as implements with a pointed end, or the stake. The executioner would first prepare a pathway for the stake by greasing the anus. Then he would take it in both hands and ram it in as deeply as he could, perhaps using a mallet, to a depth of twenty to twenty-four inches. After which the stake was stood on end and set into the ground and the victim left to his own devices on top of it.

As there was nothing to restrain the body, it would gradually be dragged down by its own weight, so that the stake eventually emerged through an armpit, or the chest or stomach. As a refinement to this terrifying torture, the point of the stake was not sharpened to a fine point but left slightly blunt. So instead of piercing the organs, it would push them to one side and only penetrate the softest of tissue. Life could then be prolonged for some time in spite of the suffering caused by the compression of the nerves. Also, instead of sinking in in the direction of the axis of the body, the stake would move at a slight angle: avoiding the ribcage, and prolonging life for up to three days. It was this type of torture that Edward II (1282–1327) came to experience when he had the misfortune to marry an energetic wife, while being unable to give up indulging his taste for pretty young boys. As he had to surrender the crown and a deposed king is an embarrassment, the queen decided to impale him. He was pierced through on a red hot spit that had been stuffed into a horn so that, Michelet said, he could be killed without leaving any clues. But, as Apollinaire says in *Les Onze Mille Verges*, 'when the point slowly enters the fundament, an indirect consequence is that the penis has an enormous erection that reaches breaking point'. So there were certain advan-

tages, and a little Japanese prostitute, Kilyemu, profited from them. Her name in Japanese means 'flower bud of the medlar tree'.

However, the worst form of torture for the bottom involves a rat. There is a very detailed account by the Chinese executioner in Octave Mirbeau's *Jardin des supplices* (Torture Garden), written in 1899, a summary of which is given here:

You take a man condemned to death, as young as possible, and strong and muscular. You undress him and when he is quite naked, you make him kneel down, and keep him there in chains, handcuffed around the neck, wrists, shins and ankles. You then introduce a very large rat into a big pot, with a small hole at the bottom. The rat will have been starved for two days to make him more ferocious. Now you apply this pot to the condemned man's buttocks, making sure that it is hermetically sealed all the way round like an enormous cupping glass, and securing it with solid thongs attached to a leather belt around the man's waist. Next you push a red hot poker through the hole in the pot. The rat will do everything to avoid being burnt by the poker. It will scramble everywhere, running up and down the walls of the pot, leaping and bounding, and galloping over the man's buttocks. At first the man will find this ticklish but then the rat will start to tear him with his claws and bite him with his sharp teeth in a frantic search for a way out through the bleeding clawed flesh. But there will be no way out. Or at least not in those first minutes of panic. And the skilfully manipulated poker will continue in its slow process of threatening the rat, occasionally singeing its skin. And as the condemned man will be screaming and thrashing about, this will only increase the rat's fury. Then it will become intoxicated with the taste of the man's blood. Finally, still menaced by the red hot poker, and spurred on by a few opportune burns, the rat will discover a natural exit. It will burrow up the man's backside, enlarging the hole with its claws and teeth as it digs frantically. It will die just at the same time as the man does, but

only after half an hour of superlative torture. If he has not already died from a surfeit of suffering or terrifying madness, he will die of a haemorrhage. 'In every case, milady,' the Chinese executioner concludes, 'no matter what he finally dies from, believe me, it is extremely beautiful.'

Peacock

In his *Historiettes*, Tallemant des Réaux (1754–1835) tells the story of a Baron du Moulin who in his youth had had quite a lot of fun as a lawyer. He used to arrive in court wearing a mask over his behind. And he would ride along in his carriage, with his masked bottom peeping out from behind the window-curtains like a face. It became an obsession with him, and he found he could not give up the habit. It had all started one day when he wanted to get rid of a woman who was pestering him for money. He had put his backside out of bed, and as he had his head between his legs, it sounded as though his voice, coming from under the sheets, belonged to someone really sick: he was coughing and farting at the same time, and the woman said: 'I can tell Monsieur is quite ill; he has such bad breath.'

The point of this tale is that there is a tradition, which is more common than one might think, of waggish bottoms, bottoms which like to take centre-stage and be the life and soul of the party.

'Flashing' your bottom, or 'mooning' is generally done as a protest or rebellion against authority. British hooligans will do it at the drop of a hat, on the football stands in front of a whole crowd of people. There are some rock musicians, too,

like the guitarist of AC/DC, for example, who have achieved fame by exposing a sorry-looking bottom covered in a constellation of red spots, to open-mouthed young audiences.

Then there were the Munich housewives, incensed at seeing the rent for their apartments continually rising, so they unanimously decided to flash their bottoms at their windows, thus inventing what *Quick* magazine described as 'the striptease of revolt'. 'They may have revealed everything but they have proved nothing,' the property developer who had just bought the building commented.

For many centuries this gesture was seen as an insult or an obscenity, but things have changed a lot. However, not in Switzerland. About ten years ago the Federal Court had to fight a lawsuit to determine whether or not exposing a bottom could be construed as offensive or indecent. During a quarrel between neighbours, a woman had in fact 'exposed her naked bottom' and as children were watching, she was arrested, charged with indecent exposure and sentenced. But after deliberating, the Supreme Court overruled the verdict; they considered that although this gesture was undoubtedly insulting and reprehensible for what it was, it could not be construed as indecent, for no reproductive organ was displayed. Probably, had she squatted lower, the court would have found her gesture gravely offensive.

In 1993 a group of about forty totally naked Australians demonstrated at Narrungar in the south of the country against the installation of an American military base. The Associated Press agency photo, however, only showed a back view, but without a doubt, the number of behinds lined up was a measure of their anger. They ended up at a police station for asserting their very intimate convictions.

In 1661, a certain Jacques Chausson, who lived off his writings and the copies he made of them for various people, was condemned to be burnt alive in the Place de Grève in Paris, for acts of sodomy, but more especially for gossiping about the gentlemen at Court (notably Charles du Bellay) for whom he had supplied young boys who were often 'abducted

and violently raped'. Naturally, none of these gentlemen got into any trouble about this, but Chausson and his accomplice Jacques Palmier known as Fabry, on the other hand, were led to the stake. The poet Claude Le Petit, who was an atheist, libertine and gay, and who had been present at this atrocious torture, wrote some verse about it:

In vain, as the flames encircled him
His confessor standing by, crucifix in hand, dreaming of
his soul
As he lay on the pyre and the fire consumed him
He infamously turned his vile behind to Heaven
And died at last as he had lived:
Mooning to the whole world.

The way Chausson had turned his behind to Heaven obviously impressed Le Petit. Having come from an obscure background, and penniless, Le Petit was also burnt alive the following year, for having shown the same independence of spirit by writing *Le Bordel des Muses* (The Brothel of the Muses) or *Les neuf pucelles putains* (Nine Virgin Tarts). So this epitaph could just as well have been his own. As Joseph Delteil would say later: 'I am a Christian, see my wings; I am a pagan, see my arse.'

You may recall the photograph that was secretly taken in October 1982 from a rooftop in the heart of Santiago in Chile. Dozens of political prisoners, surrounded by police, were lined up naked against a wall, hands tied behind their backs, their clothes strewn on the ground. 'The humiliating punishment of Pinochet's enemies', the caption in *Paris-Match* read. The humiliation was this white wall, which looked as though it were sucking in dozens of brown-skinned, black-haired bodies, their virginal bottoms exposed in the sun as if they were in a slave market in the Ottoman empire. Pinochet's soldiers systematically ignored them, apparently unmoved by the male nude in all its variations.

However, among themselves, men have always liked to exhibit their naked bodies, and give each other the once-over

in a sort of competitive assessment, whether it is the *garimpeiros* in the heart of the Amazon, as they clamber one after another up the steep sides of their opencast gold mine, displaying their dirty bottoms through tattered shorts, or British soldiers in the Gulf, taking a shower with a bucket of water in open desert, or football players in the changing rooms. But you never see similar concentrations of naked female bottoms. So what is it in this display that men value so highly? It is like a passport to brotherhood. Undoubtedly this is why the army used to make recruits strip when they came up before the review board. As the poet Guillaume Apollinaire put it so neatly in *Les Exploits d'un jeune Don Juan*, 'They looked at each other in the same way as couples on their wedding night, but they didn't have erections because they were afraid.'

So any intimacy between men is focused on their behind. They take pleasure in flaunting it, exposing themselves; they can give each other the lowdown without having to spell things out. It is a kind of disguised exhibitionism in an ambiguous situation aimed uniquely at whoever is looking at you, but whose meaning is never openly stated. That is why temptation remains so strong and attraction is inevitable. Many men, in this type of situation or not, arrange it so that their bottom is interestingly displayed.

Contrary to what one might think, bottom-displaying is quite manly. It shows pride. It is as though the male once upon a time had instinctively borrowed the seductive artifice of the female, and vestiges of this still linger in the bottom. There is something disturbing about a war dance, and the way men strut about like peacocks. A peacock was an attribute of Venus, and is the most appropriate symbol for this mute eroticism. And when the peacock fans its tail, as Michel Tournier says: 'You can see it displaying its behind. And in case any doubt persists, it raises its skirt of feathers in the air and daintily circles round on the same spot to ensure that everyone is aware of its anus hidden within the corolla of mauve down.'

Pin-up

In the 1850s numerous daguerreotypes were made for a secret clientèle and put into the first saucy pin-up album. In it you will find a woman holding a parrot, one foot lightly resting on the other and a fabulous backside that has been retouched so that the line of the cleft is very distinct. These amenable models were generally prostitutes (just as the models who posed for Ingres, Courbet and Degas were), but it was easy enough to turn them into inaccessible creatures, a little flighty perhaps, but possessing an ethereal grace and little pubic hair. The exception was *Mona Lisa in the Harem*, priced at 120 francs, which innocently revealed curly pubic hair: a detail that was admissible in extreme circumstances, such as here, inside a Bedouin tent. But such animal details were most often confined to black-forested armpits, or hair coiling like a snake down the back, gleaming like black marble and languorously brushing against the bottom.

Thus posed, these creatures nonchalantly blossomed in their aura of salaciousness, a slight smile on their lips, as distant as the rest of them, their bottom peeping from behind a fan, one hand pressed against a bosom, the other sometimes lost in nature.

But they looked as though they were made of real flesh,

not painted with a brush. They had too much awkwardness or submissiveness about them for them not to be real. They lowered their gaze, their breasts were left loose, without any fuss—such things had never been seen in a painting: breasts on daguerreotypes betrayed them more than their bottoms. They were quite heavy and impossible to retouch because they hung languidly, with their large nipples pointing downwards—a sign, characterologists will tell you, that signifies indolence and obtuseness.

A century later, from the 1950s to the 1970s, the girlie magazine was in great vogue, magazines like *Paris Frou-Frou*, and *Paris-Hollywood*. This was quite a lively review. It had been started in 1947 and looked fairly discreet, but even so anyone who bought it would hastily slip it inside a more sober newspaper or magazine. The sepia photographs inside gave the curious impression that the ink would come off on your fingers. The focal point of the magazine was the breast—very large, opulent breasts, and of course bottoms. This came about from the simple fact that pubic hair was forbidden. So, when the nymphette had removed all her clothes, there was nothing to be seen but a statue of white marble; there wasn't even a cleft where the fanny was. Some people believed it had become fossilised. The retoucher's job was systematically to erase every trace of pubic hair with an airbrush, spreading a layer of mist up over the bottom, so that any fantasy harboured in *Paris-Hollywood* was veiled in a cloud of steam.

In 1974, when censorship was lifted in France, retouching was dropped, and it was all such a surprise. Women were reinvented in their entirety: a rare example of censorship in reverse. Hair sprang up everywhere: it even grew artificially. But it was too late.

All shapes and sizes could be found in the magazine. All sorts of faces too—mutinous housewives crouched in front of the fridge, Parisiennes on holiday riding tree trunks, or ravishing widows in Chantilly-lace French knickers with vents, which said a lot for their grief. Professional models did not exist. These beautiful seductresses were secretaries, dancers at

the Crazy Horse, a mannequin at Mayol's; they posed in their own underwear (wasp-waist corsets, black embroidered or net stockings, high-heeled sandals, knickers with vents), but they played brilliantly at being bimbos or 'really good fun'. One was throwing herself into the clutches of a bear ('My head is spinning, I don't know what's happening to me'); the adorable Sylvie knelt on a chair nibbling on her necklace and asking anxiously, so it seemed, if the camera was working properly; a 'Girl who was fearless' was sucking her thumb, while another, under a lampshade, was murmuring with eyes closed, 'Chéri, look at me'.

In *Mad about Me* (Part Two), the model had saucily placed the spray of the shower into the cleft of her buttocks, and water was running everywhere—in front, behind, in an unexpected flood that looked just like urine. Sylvie's reappearance was a great success: as she could no longer wait for her husband, she offered us her large *derrière*, her parted lips, and her pretty hat set jauntily on the back of her head.

The current craze is no longer for smutty bottoms, but rather 'the virtual behind'—synthesised images of bottoms. The Cybersex bottom. Although you cannot touch it, you can see it and you can also make it move, although it can be very bad-tempered. Since this bottom is naturally flat like the screen, it really negates the whole idea of a bottom: it is the opposite of what it should be, and the opposite of pleasurable. On CD-ROM, a laser disk offers sound and pictures to enable you to talk to Virtual Valerie. This young lady does not appreciate men who lose their *sang-froid*, and if you fail to make the correct reply to a question, she will reject you by brutally turning off your Apple Mac. When she says 'Please take off my bra, it's a bit too tight' to you as she relaxes on her bed, you must have good reflexes. And if you do, she will pleasurably unveil her cybernetic charms and even allow you to play with her anatomy, with the help of appropriate accessories. Also on CD-ROM are the interactive adventures of Seymour Butts, a boy whom you never see, but whose place you step into. It is up to you to take advantage of the situ-

ation—for example, when a pretty Californian girl has a puncture in the street. If you follow the same principle and press the right keys for the answers to questions on the screen, either you advance, or you are rejected. But the images are digitalised; in other words these are proper animated video images, and therefore are more attractive. When she displays her charming sunburnt behind, this affable young woman on the screen also has all the necessary requisites to satisfy a Cybersex player: she has the absent gaze of a zombie, tactile euphoria, the same effect as a light narcotic. But to believe for one moment that this is a kind of voyeuristic experience is evidently wrong, because voyeurism does not presuppose the existence of programming. It calls for just the opposite. This is simply an amusing animation of old playmates from magazines, but it can have a calming effect on some impatient people, deprived of a glimpse of the gardens of Allah.

Sodomites

In France it was the eighteenth-century Libertines, particularly Sade, who first brought sodomy out of the closet where it had been hidden for centuries . . . and turned it into a subject for philosophical debate. The bottom came to be idolised and turned into a fetish, not least by Sade. 'Kneel before it,' Saint-Fond says to Juliette. 'Worship it, congratulate yourself on the privilege you have been granted in being allowed to offer my backside the homage that the whole world would like to offer it.'

There is no striptease in Sade's writings. Nothing but a brutal 'Up with your skirts': a command to the Backside to pose so that it can be admired. There is one exception—young Rose—who has been taken to Saint-Fond's house. 'Prepare her bottom for me, Juliette, raise her shift up to her waist, and pull her drawers down over her hips: I love it when a behind is offered to me this way.' The Behind is then immediately prepared and delivered: 'Here's my bottom: have it, all of you,' the tart cries.

Despite its marvellous, and sometimes grandiloquent appearance, the object would be scrutinised with the closest of attention—hence there are visits to behinds and multiple examinations and inspections of them to be found throughout

Sade's work. For the first humiliation is a visual one: it is the eye that signals the crime. 'Oh, what a beautiful backside, Juliette,' cries Noirceuil ecstatically when he sees it. 'How delicious it will be to fuck and torture all that.' In Rome, 'Backside inspectors' were the magistrates responsible for public morals. The libertine would take exactly the opposite stance from these functionaries. His purpose in visiting bottoms would be the better to debauch them; for example, at the time of his entrance examination to the Society of Libertines at Silling (in *A Hundred and Twenty Days of Sodom*), he goes round checking bottoms to ensure that they are in the state that he has encouraged their owners to make them, or he organises competitions between boys and girls, like the Christian poets of Byzantium, to see who has the most beautiful, perfect well-shaped bottom, which does suggest repeated visits. The libertine also liked to surround himself with a superb collection of bottoms. And often resorted to using mirrors to multiply his enjoyment.

So the sight of a bottom inflames passion. In Sade's works, there is always a moment of ecstasy at the sight of that superb piece of flesh and a compliment after a skirt is lifted. 'I am about to see this divinely precious *derrière* that I have lusted after so avidly,' Dolmancé cries. '*Sacredieu*, what a beautiful shape and freshness it has, what dazzling elegance.' Sometimes, it is true, the praise is more concise: 'Ah, *sacredieu*, what beautiful buttocks,' or other compliments of a similar nature. But the libertine knew how to reward the object of his love. His bottoms always gave rise to exclamations.

Pierre Klossowski has said that for Sade 'the act of sodomy is the key symbol for every kind of perversion: It is *the* major outrage, the very worst way of transgressing normal behaviour. The most effective way for him to sin against God, society, morality and the laws of man. While it simulates the act of procreation, it is also a mockery of it. "What superiority we acquire over men," Clairwil says, "by breaking every rule that controls them, transgressing their laws, profaning their religion, denying, insulting, rubbishing their execrable God,

defying everything, including their frightful precept that dares to say that Nature dictates our principal duties."' The libertine is defined as a depraved criminal or a blackguard, but certainly not a pervert.

The word did not exist in Sade's vocabulary; his terminology belongs to the realms of moral psychology. It was the philosophers and libertine novelists of the eighteenth century who most violently attacked Saint Thomas Aquinas's old idea of a 'crime against nature'. Such a crime either involved sinning with oneself, with other men, or with animals; it had no meaning, for example, for Boyer d'Argens in his book *Thérèse philosophe* (1748) or for Sade in *Philosophy in the Boudoir* (1795). 'Begin by starting from one point, Eugénie,' says Dolmancé, 'nothing in libertinage is frightful, because everything inspired by libertinage is inspired just as much by Nature.'

'Sade's completely monstrous behaviour,' Klossowski adds, 'has the effect of changing the special qualities of the sexes. For him sodomy is by nature indifferent to what is being sodomised.' 'Rest assured that it is as simple to take pleasure from a woman one way or another, as it is a matter of absolute indifference to take pleasure from a girl or a boy' (*Philosophy in the Boudoir*). This is the libertine's creed. And it is because he idolises the Behind that the libertine can move so easily from one sex to another, as he mixes his pleasures. As Panckoucke says in his *Grand Vocabulaire français* (1700–53), sodomy is a crime against Nature, which consists of using a man as if he were a woman, or a woman as if she were a man.' And is the crime then greater with a girl or a boy? That is not the main issue for Sade. It could be said that the transgression is greater with a woman, since she is the only one offering a choice of two sites, and a precise choice is made of one rather than the other. Which, as a corollary, might legitimise the practice of dishonouring a virgin in this way, since it would leave her intact, and what is more outwit Nature in the process. 'But,' Dolmancé explains, 'with a young man, the libertine has a double pleasure, for he can be both lover and mistress at the same time, while a girl promises only one pleasure.'

Canon law distinguishes between two types of sodomy: *imperfect* sodomy (when perpetrated on a girl) in the 'unlawful vessel' and *perfect* sodomy (when performed with a boy). In fact, said Sade, what matters for a person indulging in this sort of erotic casuistry, is not so much its purpose as the mastery one has over the victim: it is enough for the victim to be possessed by you. 'It is just for the evil of it that one fucks,' the Duke concludes energetically in *The Hundred and Twenty Days*. Whether the libertine finds himself in turn husband or wife or even both simultaneously is a simple question of posture or role. The sex of each becomes variable, transitory data.

This heretical concept of sodomy would not survive. Ever since the development of forensic medicine at the beginning of the seventeenth century numerous works had drawn attention to this 'unnatural vice'. Following reform of the penal code in 1791, sodomy was decriminalised in France, and the 'infamous crime' forgotten. Not by forensic scientists, though, who, like Casper and Tardieu, published a series of authentic case studies of what they considered a monstrous aberration. Now that the libertine had no other purpose than to commit outrages against Nature, the infamous sodomite whose vice is etched into his very flesh was downgraded to the level of an animal. For forensic medicine, this frenzied debauchery, this craving for pleasure, could only have a totally damaging effect on the anatomy. Sade, it is true, admitted that there was a conformation of the anatomy that was peculiar to men whose taste was exclusively for sodomy, among other things, buttocks that were white and more rounded. 'Not a hair,' said Dolmancé, 'will cast a shadow on the altar of pleasure whose interior, carpeted with the most delicate, sensual, titillating membrane, is without the slightest doubt in the same class as the inside of a woman's vagina.' But for Sade such a conformation was not the outcome of any monstrous behaviour, but simply a natural trait, or shall we say 'a slight deviation, a mistake of nature'. On the other hand, for Ambroise Tardieu in his *Étude médico-légale sur les attentats aux moeurs* (Forensic

study of offences against public decency) (1857), their vice is etched into the person's protuberance and the manner in which he offers himself like a woman. For him a bottom betrayed turpitude. And just as once upon a time the inquisitor had examined a witch's skin for telltale signs of her guilt, the infallible doctor administered his anatomical tests to detect this chaos of sexual appetites. 'I constantly find,' he said, 'that many men who take up homosexual prostitution reveal an excessive development of the buttocks: they are large, protruding, sometimes enormous, and of a very female shape.' He mentioned that he had even seen 'a very singular and certainly exceptional disposition in a homosexual whose two buttocks were completely joined so that they were one united spherical mass'. Apart from these monstrous buttocks, with overstated curves, Tardieu dwelt lingeringly on the penis. 'Very tapering like a glove finger' or the glans had 'the almost pointed shape of a dog's nose'. He lingered too on the 'funnel-shaped anus' (the *infudibulum*), 'a unique sign,' he said, 'the only true mark of pederasty'.

And so, a cobbler of forty, apprehended in the Place de La Bastille, was discovered during Tardieu's examination to have 'a canine member' and was, as he parted his two muscular buttocks, also discovered to have a 'long deep cavity at the bottom of which the anal orifice opened, and which constituted a sort of wide-mouthed, vase-like *infudibulum*'. He also noted that he had observed among homosexuals crooked mouths, with very short teeth, and thick upturned, deformed lips 'in accordance with the abject use for which they were reserved'. 'The sodomite, in fact,' Jean-Paul Aron and Roger Kempf note, 'was purely and simply a reincarnation of the beast.'

Despite these minute investigations, Dr Tardieu's conclusions were rapidly abandoned. If the forensic expert was interested in the physical consequences of sexual activity, the interest moved in the 1880s to the psychology of the 'perversion'. A Hungarian (Benkert) invented 'the homosexual' who became a peculiar species of creation—that is, the symptom of a psychic illness and a social evil. Krafft-Ebing's *Psychopathia*

sexualis (1886) was to become a reference book for this new science. And the homosexual bottom, which had certainly enjoyed its most dazzling epoch, would be dismissed as nothing more than an epiphenomenon in which all interest had now faded. The Belle Époque preferred society life and small talk.

Orifice

What can be said about a hole?

People rather tend to skirt around the subject. The word anus comes from the Latin. Plautus and Varro used it in the sense of a 'ring', but Cicero used it in the particular sense of the ring or sphincter in the human bottom, and said that one mustn't be ashamed to call it by its real name. Everyday language, however, is more revealing. At first the hole was small and quite sweet and in French was called the *troufignon* (trou-fignon = neat hole). 'With the two index fingers,' counselled Canon Béroalde de Verville (1612), 'you open up the neat little hole, pushing the buttocks aside.' The clergy of this period enjoyed their freedom of speech.

The *Précieuses*, Molière tells us, however, were disgusted with 'dirty syllables contained in the finest of words, which outraged people', and had forbidden the use of the word *cul* (or cull in eighteenth-century English), substituting elegant paraphrases such as 'the face of the Grand Turk' or 'the inferior crafty one'. Who could blame them? After all, Sade had spoken of 'the entrails of his Iris'—that is, 'his bottom's rainbow', and the poet Paul Verlaine would talk of the 'adored throne of shamelessness' (in his poem: *Femmes*/Women). But this hole was round, and in this way could be distinguished from the

oval vulva. 'Ah *sacredieu*,' Dolmancé cries (in *Philosophy in the Boudoir*), 'if [Nature] did not intend us to fuck backsides, would she have made our orifice to be an exact fit for our member? Aren't they both round? What enemy of good sense could possibly imagine that Nature could have created an oval hole for a round penis? This deformity is a betrayal of its real purpose.'

The anus was referred to by seventeenth-century preachers as 'the illegal vessel' as opposed to 'the natural vessel'. Because it *is* a question of a vessel, whether it was in the shape of a vase or a sweetmeat dish, it was still a receptacle. When they called it an evil vessel, it was because, as we have seen, it led to infamous sin, so infamous that it could not even be named, and so horrible that the Devil, having incited a person to commit it, withdrew immediately for fear of seeing it.

As was said in the seventeenth-century *Parnasse Satyricon*:

> God made the cunt, an enormous ogive
> For Christians
> And the arse, a deformed arch, for pagans.

This orifice had other peculiarities. It could have its outer layers removed like a shallot or onion skin, be gathered up or puckered like a buttonhole or sea anemone (Grainville writes of the 'bronze puckering of the anus'), or even pleated: it has been nicknamed *gongonneur* (or puckerer) in French. The playwright Jean Genet in *Funeral Rites* says that the anus has thirty-two folds or pleats, no doubt because the compass has thirty-two points, but it is touching to see Erik frightened by the idea that once his anus has been untowardly stretched, it cannot regain its old shape.

If the female sexual organs are 'dumb', in contrast to the mouth which can talk, the anus can also be termed 'sonorous', in an allusion to its acoustic properties: for it is also known as the farter, or in French the onomatopoeic *'pouet-pouet'*, the whistler, the cannon of cannons, or the windmill. Some have called it 'a faun's pipe' or small horn. And William Burroughs

(in *Naked Lunch*) recounts that he once knew a little Arab rent-boy in Timbuctoo who could play the flute with his bum, but in a much more ingenious fashion:

'He could play a tune up and down the organ hitting the most erogenously sensitive spots which are different in everyone, of course. Every lover had his special theme song which was perfect for him and rose to his climax.'

In spite of this organ's image of uncontrollable farting we must not forget that in former times the anus was likened to a hellhole. It was as such in Henri Estienne's *Apologie pour Hérodote* (Apologia for Herodotus, 1566) where the author recounted the story of a preacher in a village in Lorraine, who had remonstrated with his congregation, threatening that they would go to hell if they did not mend their ways. 'What do you think Hell is?' he said to them. 'You see this hole here. It stinks a lot, but believe me, the hellhole is even worse.' The hole he had been showing them belonged to the *derrière* of the village bellringer who had prearranged with him to play this farce. But of course it wasn't a farce. And if the hellhole was in the form of an anus, then they set about exploring all the caves, caverns, natural gullies and even volcano craters looking for the Earth's anus. They discovered quite a few, which left them somewhat perplexed. For example, the Gourgue Grotto in Haute Garonne, accessible only by mule track and known locally as *Goueil di Her* (The Eye of Hell), or a hellhole hollowed out by the sea in Finistère, also known as Madame Night's Cavern. Peucer said that from time to time you could hear the groanings of the damned in the neighbourhood of Hekla, the volcano in Iceland generally covered in thick fog.

The opposite of an infernal anus can be found in Lautréamont's *Chants de Maldoror (V)*, where the author imagined a gigantic anus of the Cosmos, the exact counterpoint to Parmenides' sphere. And what, he thought, if the universe were only a huge gaping hole, a sewer of uncertainty? He was lost in conjecture. 'If instead of a hell, what if the universe had only a vast heavenly anus, look at the gesture I make near my

belly: yes, I would have sunk my shuddering prick into it, through its bleeding sphincter, shaking its very walls. Misfortune would not then have blown entire dunes of moving sand into my blinded eyes; I would have discovered the underground resting-place of Truth, and the viscous waves of my sperm would thus have found an ocean into which they could flow.'

Sartre, happily, leads us back into a world that is more in proportion. The orifice had always much intrigued him. He returned to dwell on it on several occasions—in *Being and Nothingness* (1943) and even before, in *War Diaries: Notebooks from a Phoney War, 1939–40* (1940). Freud had maintained that for children all holes were symbolic anuses and attracted them because of this association, but Sartre wondered if the anus was attractive for a child simply because it was a hole. And what was the hole in the bottom if not 'the most living of holes, a lyrical hole, which blinks like an eyelid, tenses like a wounded beast, and finally opens up, vanquished and ready to reveal its secrets.' Sartre followed this with a long argument in which he attempted to demonstrate that the attraction of the hole predates that of the anus, applies to a great number of objects, and lasts throughout one's life. For the world is a kingdom of holes.

Vertigo that comes with looking down a hole arises from the feeling of obliteration and oblivion that a hole suggests. It is true, Sartre went on, that the hole's void is coloured, but it is a black nocturnal void. Which also gives it a murky, mysterious, sacred character. For a long time, however, man resisted the void. And if going into a hole by breaking and entering seems like a violation, it also offers the possibility of blocking it up. As for the rest, for Sartre every hole is an obscure challenge to be overcome. On this occasion, he described the terrors that Castor (Simone de Beauvoir) experienced when she was reading a book called *The Jungle Trappers*: two prisoners discover the entrance to a narrow, dark subterranean cave and escape by crawling into it on all fours. The further they advance, the narrower the tunnel becomes, until

finally the one in front, a nice, happy, plump young man, becomes wedged between the walls, unable to move any further forward or back. At this juncture, a boa constrictor appears and despite his horrible screams swallows him up. It is his companion who tells the tale—he had to watch help-lessly as his friend was eaten alive. All the horror of the story, which often gave Castor sleepless nights, Sartre said, evidently came from what had once happened to her down a hole. In the end he said, 'I have a feeling that at the depths of her terror there was in fact an obscure sort of enjoyment, because this swallowing followed by disgorgement, this fat man who had been swallowed by the power of shadows, have something intellectually and emotionally satisfying about them.'

Be that as it may, the best way to close the anus would be to sew it up. This is an operation that is performed several times in Sade's work. La Duclos, for example, in *The Hundred and Twenty Days of Sodom*, tells the story of a libertine who followed her about for more than five years 'for the unique pleasure of letting me sew up the hole in his backside. He lay flat on his stomach on a bed and I sat between his legs and there, armed with a needle and a reel of thick, waxed cotton, I sewed his anus up all the way round.' This pleasure was not always so refined, and in *Philosophy in the Boudoir* it is not certain whether Mme de Mistival was all that happy when her daughter carefully sewed up her bum and cunt, so that the virulent secretion from the pox that a valet had so knowingly distilled—thus making it more concentrated and less likely to evaporate—literally burnt her bones.

One can see that sewing up the anus as a way of keeping it full is a way of acknowledging that the buttocks have a right to their own identity: for they are no longer seen simply as doorkeepers to a convent or the sphinx guarding the tomb, since they would no longer serve uniquely to hide the anus in the way pubic hair conceals the vulva. They would be returned to their mute, shining, opulent chastity and their purity of marble.

Some people find it difficult to accept this sewing-up idea—

it seems stupid to them. Because a bottom without an orifice is no longer a bottom, but a wall. And Patrick Grainville has some harsh words to say on this subject. 'The anus gives even the purest of bottoms its clandestine focal point, its obscure vitality, its aroma of mystery, its small symbol of intelligence, its indiscreet musk, its diabolical intimacy. May God preserve us from behinds that have no hole.'

Bottom-Watcher

If you place a mirror behind you, you can see your back, bottom and thighs: all you have to do is turn your head round. You won't be able to look at the back of your head, though, unless you use two mirrors. This back view of our body is the one we see least, yet for other people it is the easiest part for them to look at. It is the intimate part of our body that we least own. In François Truffaut's film, *Jules et Jim* (1962), the day Jim moves out of the small chalet room, he sits on the bed with Catherine and says to her: 'I've always loved the back of your neck.' Catherine lifts up her hair and Jim kisses her nape and adds: 'The only morsel of you that I can look at without you knowing.' Almost the same can be claimed for the *derrière*, for even though you can touch your bottom just as you can the nape of your neck, you can only ever see an image of it (here I am thinking of the bottom in terms of its architectural whole).

As far as your bottom is concerned, the eye is blind and not only to your own bottom, but to the bottom of whoever you happen to be embracing, for example: as you feel for the bottom and press it, only instinct guides your hands, it's rather like groping in the dark. So between the bottom and the eyes there is always a game of hide and seek. Your eyes

only ever watch a behind when its owner is not thinking they are.

That is perhaps its principal role: to attract the bottom-watcher's attention. He will always be on the lookout, snatching, catching or indiscreetly grabbing a glimpse of it as it passes by.

This unknown facet of oneself becomes a privileged target. In his letter of 2 September 1811 Stendhal wrote to Champagnole: 'Before going to bed I spent a long time intently watching the room of the woman opposite where I supped. She appeared quite amenable. Her door was half open and I hoped for a glimpse of a thigh or breast. If such a woman were lying entire on my bed, however, she would do nothing for me, but, as it is, she gives me charming sensations when I catch a glimpse of her by surprise. She moved around quite naturally, I don't have to worry about putting on an act, and everything is sensation.'

In the painting by Edward Hopper called *Window at Night* (1928), a woman in a red petticoat (or it may be a red towel) is leaning out and unwittingly revealing part of her bottom. Everything indicates that a bottom-watcher is lurking about (even though he can't be seen). On the other hand, in Picasso's *Minotaur watching a sleeping girl* (1933), and especially in Poussin's *Couple and a Voyeur*, he is in the foreground: seen side view, clinging to a rock, with a rather violent, sombre expression on his face, blond hair and muscular thighs. His own beauty highlights hers; it is he who makes this story come to life, a story which is, ultimately, banal—a couple embracing. Only their shapes and beauty have become magnified through the fact that he is watching them. But he is also unaware that he too is being observed.

The pleasure of bottom-watching, then, occurs without the other person perceiving it. It comes precisely from the fact that you might be seen. Sometimes, it is true, you can get pleasure from the fact that the other person knows you are looking at him or her, as may happen in certain complicated games with mirrors. 'I moved her head slightly forward,'

Patrick Grainville wrote in *Le Paradis des Orages* (Stormy Paradise), 'for in the mirror opposite at the foot of the wall I could see a couple reflected. They had magnificent curves, pugnacious thighs, like snow-white fighters. She knew that her behind had just risen up in the mirror. I had told her. And she was thinking about her bottom without seeing it. She could see it in my oblique gaze, and she was concentrating on my confounded squint. And she gabbled at me, panting: "I love you. You have that look of lust." '

But perhaps women are getting a bit tired of us wanting to hitch up their skirts so that we can view their behinds. In Godard's early films, it was obvious that filming an actress's backside wasn't going to cause her much offence. A more serious threat to her intimacy would have been to photograph her breasts. Things have changed a great deal. And women today at the seaside have decided to show the two alternately, which almost makes the bottom-watcher want to give up and go away.

One of the greatest joys still remaining, however, is to look at the eyes and behind at the same time, or rather continuously, which may give a contorted image of the human body, but it is more exciting. It's as though the bottom can make sudden unforeseen moves, leap up and threaten you, develop jaws and eat you up: it's this aura of anger the behind takes on when the eyes turn to look at you, that is beautiful. For the buttocks are like vacant eyes, eyes that are rolled upwards, which all at once begin to smile or flash with anger, at last revealing their soul.

Some people collect vaginas, like the Italian artist, Henri Maccheroni, who has taken more than 2,000 photographs of a woman's private parts—the same woman's in every conceivable state of mind. And there are breast collectors too, like Michel de Landesen, who took huge photographs of 1,200 breasts, but no one to my knowledge has yet produced a photographic album of bottoms (or the anus), with the exception of Yoko Ono, in her seven-minute film *Four*, made in 1966, which is rather like a gossipy notebook of 360 fairly

famous bottoms. So why is there such a lack of interest? Possibly it is because, except for the vertical cleft, this is an uninterrupted area of flesh, and its two cheeks are monotonously sad and all a bit similar. In fact the universal bottom only comes to life when it is in motion. This is why it arouses the watcher's interest more than the collector's, for what he is spying on is not so much the object itself as its to-ings and fro-ings, the way it changes and metamorphoses. Also, unlike the breast, the vagina or penis, the bottom is much more accessible; it is often naively turned to you in a move to hide the other more private parts, without any conditions or complications.

A bottom is no big deal. And the bottom-watcher can nowadays glimpse bottoms almost at will, his eye roving from bottom to bottom, in a fickle, frivolous manner. The bottom-watcher acts with such lightness of touch, such impunity, when he plunders the world's bottoms, each with their own legends, sub-titles, whispers.

Louis Calaferte in *Septentrion* tells us how the bottom-watcher always has a behind in view. It can belong to the switchboard operator whose pleasant *derrière* he sees every morning at the switchboard through the bay window at the entrance to the factory. Or the bottom of someone suffering from dropsy, which has spread sideways, upwards and downwards and belongs to Mlle Nora Van Hoeck. Then there are the dear little bottoms in their black miniskirts which belong to the waitresses (an ensemble which stirs both your balls and your appetite); the beautifully moulded behind of a piece of dynamite on a platform of the Métro, like two balls under her dress, mare's buttocks. 'She stands nonchalantly, with one leg slightly flexed, showing her curves to advantage. What would it be like to play with a body like that? What terrific pleasure you would get out of her. And the way she has of looking as though she doesn't give a damn. Her air of total serenity, as if it were quite natural to walk this pair of buttocks under the gaze of passers-by. She would drive you to distraction.' How many people would look at her in one day? Impossible

to calculate. Then there are the bottoms of all the girls in the street, every single one. 'Sumptuous, exciting, scowling bottoms, swirling around slowly, slowly, as though rocked by some inner gale. Living, animated, semaphore bottoms that become lascivious or powerful depending on the time of day and quite distinct, quite separate from all the rest. As free and independent as shooting stars. Emitting their own morse code from the thalamus. Like a spell. The bustling street offers a secret invitation to abduct. Violence. The velvet majesty of great wild beasts.'

History shows that there are certain particularly propitious circumstances in which to display the *derrière*—to the watcher's delight. Somersaulting, for example, or falling from a horse, or leapfrog. These are among the most joyous examples in its history. The French verb 'to somersault'—*culbuter*—which dates back to the sixteenth century, is a tautological combination of *culer* (to push the bottom) and *buter* (to bump). In all the great literary classics there are somersaults, from Rabelais' Old Woman of Popefigland who showed the Devil her 'what'sitsname', to little Martine in Romain Rolland's *Colas Breugnon* (1914), who, to save her sheep, tumbled all the way down the bank, 'proudly displaying to all the soldiers besieging the town her east, west, in fact all four points of her firmament and her star shining in the heavenly sky'.

The history of somersaulting is inextricably entangled with the history of knickers. During the Renaissance Catherine de' Medici and her ladies at court tried to impose the wearing of drawers, under the name of *bride à fesses* (a bridle for the bottom). These drawers were a tight adjustable costume which moulded the bottom down as far as the knees, above which a garter attached them to the stockings. Attempts were made to explain this novelty by a change in equestrian style, which meant that women, instead of sitting astride a horse, were sitting side-saddle, so that one leg was resting across the saddle, exposing a knee. The drawers were invented to add an aura of decency to this rather revealing posture. But the fashion

failed to take off and seventeenth-century women continued to ride their horses knickerless like Amazons.

Drawers kept out the dust as well as the cold and prevented women from exposing their thighs if they fell from a horse, Henri Estienne (1578) said; they also protected them from being assailed by over-curious young men who would not hesitate to put a hand up a skirt; but, then, Estienne himself began to wonder if drawers did not in fact 'encourage dissolute young men to behave badly, even more than protecting their wearers against their impudence'. So drawers disappeared and cavorting continued to enjoy its best years. Skirts flew above heads and the most charming posteriors of the time were involved in a host of incidents which gave gallants opportunities to gaze at bottoms. No one thought any more about the frightful fashion for knickers; what is more, Marie Antoinette wore none under her dress when she went to the guillotine.

The Comte de Caylus maintained that everyone had a right to profit from fortuitous falls, and in the *Memoirs of the Comte de Gramont* (1715) we learn how, thanks to just such an opportune somersault, Mlle Churchill seduced the Duke of York, who married her in spite of her extreme ugliness. 'The duke rushed to help her,' Hamilton cried. 'She was so stunned that she never thought to pay heed to the proprieties on this occasion, and those who pressed around her found her in a very dishevelled state. They could not believe that such a beautiful body could be paired with a face like Mlle Churchill's. Since this accident one could not help but notice how all the care and tenderness the duke bestowed on her only increased, and by the end of winter it was also noted that she had neither tyrannised his desires nor tested his impatience.'

Saucy prints profited from the fact that under her panniered skirts a woman was totally naked; they made her into a creature who could, at any moment, be at the mercy of a gust of wind or sleight of hand. Never did one see so many women on their swings, allowing a glimpse of knee, a garter, or a flash of thigh. A passage in the *Journal* of the actor Charles Collé reports that the Receiver General for the Church Estates, a

bishop by the name of Baron de Saint-Julien, had recently contacted the painter, Doyen, to commission a portrait of his mistress which was to be as flattering as possible. That year Doyen had had great success with his *Miracle des Ardents* (Miracle of the Fervent Believers), done for the church at Saint-Roch, and although this composition was very pious and spiritually elevating, he had recently been at the centre of a scandal caused through his liaison with a Mlle Hus, an actress at the Comédie-Française. Doubtless the Receiver General had thought that in view of the painter's lax morals he would appreciate the subject of the picture. The painter was intrigued by the offer of a commission and turned up at the *petite maison* where Saint-Julien entertained his mistress. Saint-Julien was full of flattery and told Doyen what he wanted: he would like him to paint his mistress on a moving swing, while he, Saint-Julien, would be hidden in the bushes, watching the beautiful child's skirts 'and it would be even better if the painter could enliven the painting a little by . . .'

That the suggestion came from a bishop was shocking enough, but Doyen was scandalised by such a request. With dignity, he refused the offer and suggested to Saint-Julien that for this 'peculiar work' he approach a saucy painter like Fragonard, who in 1760 had already painted his *Seesaw*, which depicted two people of that equivocal age when 'love becomes entangled in our games' (to borrow the title of one of his engravings). And so, in his *Hasards heureux de l'escarpolette* (known in English only as *The Swing*), Fragonard carried out M. de Saint-Julien's wishes point by point, and *le tout Paris*, who knew of the Receiver General's passion for the beauty with fine legs and troubling bottom, had great fun. The painter's enthusiasm was infectious. The young girl's half-sketched smile says much for the charm of the swing while she sat on it thus, with a handsome boy lying at her feet. Some women took to the part very readily with daring displays, so much so that a rakish story appeared in 1793 entitled 'Coquettes' knickers of our day' informing the reader that bottoms were now decorated like faces, with beauty spots, powder and rouge

to 'put on a good face' if one dare say it, in front of these gallants.

Nowadays, there are no more girls on swings and falling from a horse is no longer a public entertainment. But when the weather is inclement, we can hazard another look when dresses cling to the skin in the rain, and then the wind ingeniously unsticks them (the use of draughts was a classic in musical comedies), but even intemperate weather has lost much of its charm, for, when dressed, the modern bottom is either too revealing or totally unrevealing: the intermediary stage no longer exists. To achieve a shapely bottom there are latex cycling shorts which display the shape despite an absence of rain and give it a fluorescent, but undeniably false appearance. Otherwise the shape is totally lost in full, floating fabrics: you might as well be in a convent. It is desperately sad to see the *derrière* so packaged.

When fashion hides its shape, the bottom is mortally wounded, and must be seen while it is being extricated from its bag. What a retort, what enthusiasm, what revenge!

There remains the very rare occurrence of bottoms that yawn. It can yawn timidly or with a certain panache, allowing us to see that long disquieting apparently endless stripe like a chasm emerging after an earthquake. Which sets one's nerves on edge. How far will it gape? As the catastrophe never happens, the bottom-watcher remains disappointed and thoughtful.

Herodotus said (*Inquesti*, 35) that it was a custom among the Egyptians for women to piss standing up, but Egyptians were inclined to do the opposite from the rest of the world. In any case, since the time of the ancient Greeks, women have squatted down to urinate (but more and more rarely in the open air), while men stood up and turned their backs: the point of view is different, but the bottom is always seen to advantage. This is shown in a drawing by Rembrandt in 1631—*The hidden woman*. It is a rustic scene. A shapely woman is squatting, leaning slightly forward, legs apart, with her skirts hitched up, so that we can admire her pretty thighs

and large derrière. She is looking straight ahead, but not seeing you, and is pissing heavily and fast, revealing her situation and her buttocks even more so. What is more surprising, Gilbert Lascault notes, is that the jet of urine is suggested by a ray of light similar to the one used by some religious painters to symbolise the rays of divine grace that emanate from the wounds, the stigmata of the dead Christ, for example. Here the ray of grace emanates from the behind to the ground. The jet is like a flash of fire. Any bottom-watcher can only rejoice at having been present at such a firework display. It is as though the woman had positioned her bottom, like a sumptuous belvedere, precisely for this spectacle.